THE
SPLENDOR
of GERMANY

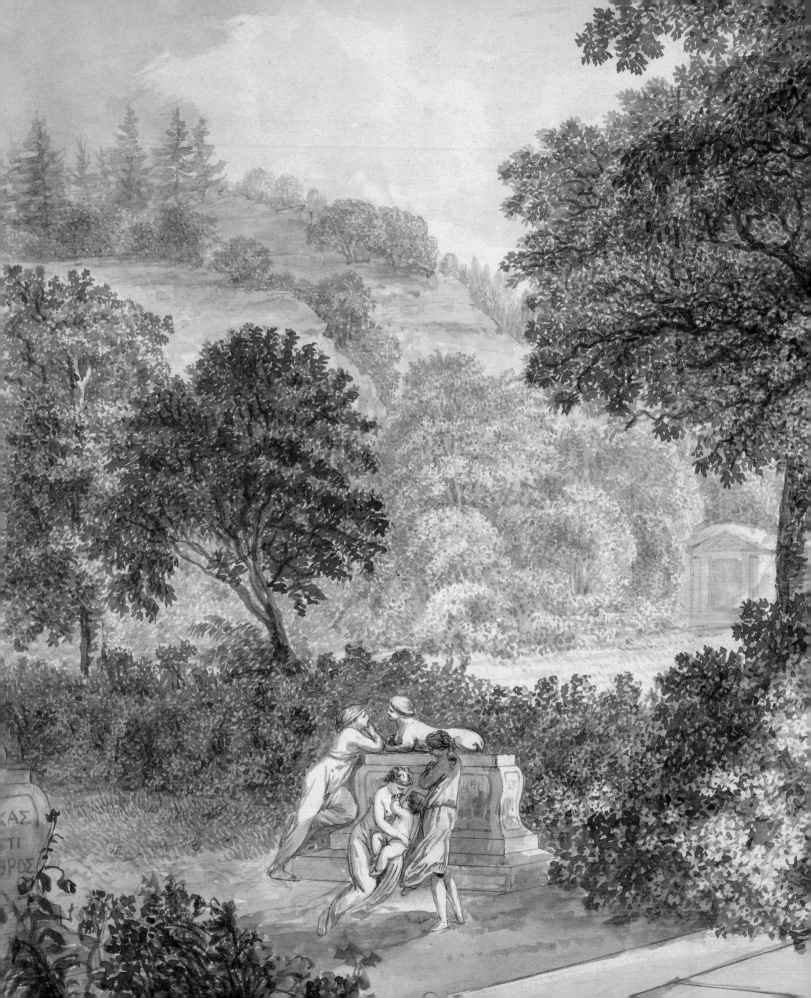

THE SPLENDOR *of* GERMANY

Eighteenth-century Drawings from the Crocker Art Museum

William Breazeale and Anke Fröhlich-Schauseil
translations by William Breazeale

CROCKER ART MUSEUM
2020

ISBN 978 1 911300 77 9

British Library Cataloguing in Publication Data

A catalogue record for this book is available from the British Library

This catalogue is made possible through the generosity of Alan Templeton.

Paul Holberton Publishing
89 Borough High Street, London SE1 1NL
WWW.PAULHOLBERTON.COM

Designed by Laura Parker
Printing by e-Graphic Srl, Verona

FRONT COVER detail of cat. 1; BACK COVER detail of cat. 8;
FRONTISPIECE detail of cat. 36; PAGE 6 detail of cat. 7;
PAGE 8 detail of cat. 15; PAGE 11 detail of cat. 35; PAGE 38 detail of cat. 9;
PAGE 97 detail of cat. 33

NOTE TO THE READER

In this catalogue the term Germany refers to the German-speaking lands of the Holy
Roman Empire before 1789, including parts of Bohemia and Switzerland.

Initials at end of entries indicate authorship. Measurements are given height before width.
In provenance, semicolon (;) indicates direct transfer, full stop (.)
indicates a possible gap between owners.

CONTENTS

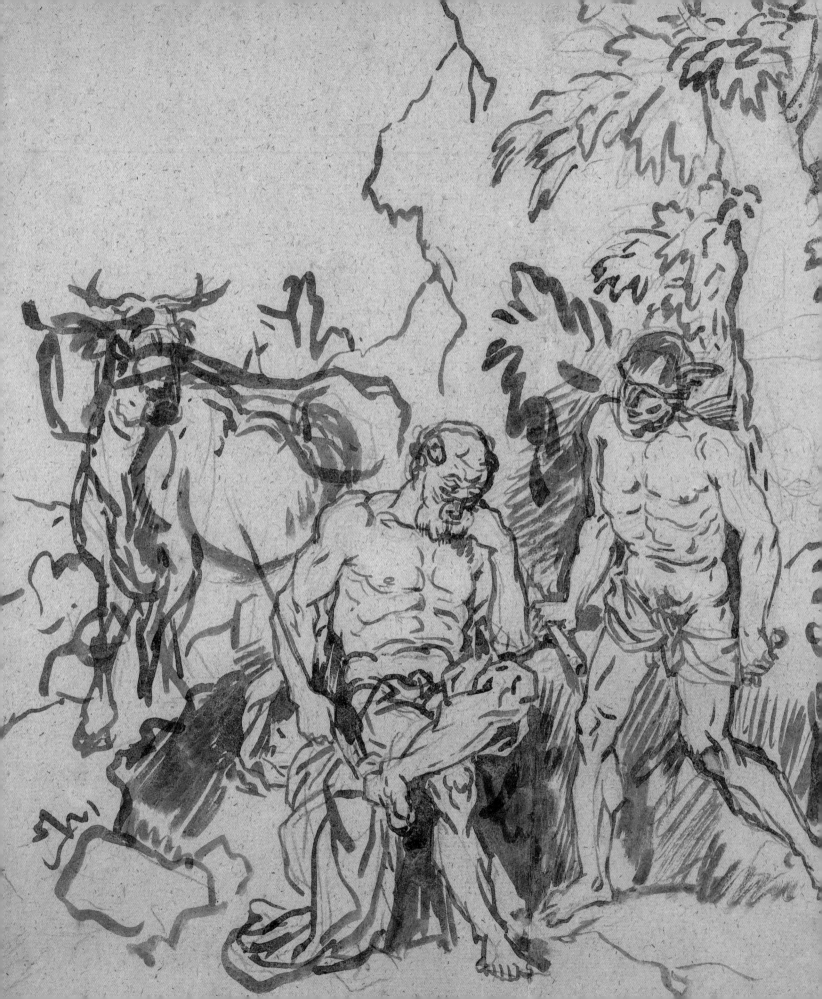

DIRECTOR'S FOREWORD

An exhibition of eighteenth-century German drawings from the Crocker Art Museum is timely in many ways. In the late twentieth and early twenty-first centuries, exhibitions and major acquisitions of German drawings, both in the United States and Europe, have given new impetus to scholarship. This exhibition, in contrast to many others, focuses on the eighteenth-century world in a way that does not present it simply as a prelude to the Romantic period that emerged near the end of the century. The exhibition also celebrates the 150th anniversary of E. B. Crocker's Grand Tour of Europe where he purchased the nucleus of the Museum's collection.

With such artists as Johann Wolfgang Baumgartner, Anton Raphael Mengs, and Johann Heinrich Wilhelm Tischbein, the exhibition celebrates the inventive beauty of German art, from the flowering of the Baroque to measured Neoclassicism. The depth and breadth of the E. B. Crocker Collection, already very strong in regards to Germany, is supplemented by new acquisitions of drawings by major figures such as Johann Georg Wille, as well as a travel sketchbook by Johann Christian Klengel that gives new meaning to the artist's process.

I would like to thank the many supporters who have added to the collection over the years, especially Alan Templeton, whose generosity has made this catalogue possible, and the late Anne McHenry and her husband Malcolm McHenry. In addition, I would like to recognize the contributions of the Crocker's curator William Breazeale, a longstanding advocate of the drawings collection and its importance to scholars and the public, as well as his colleague and co-author Anke Fröhlich-Schauseil, a dedicated scholar of eighteenth-century German art.

LIAL A. JONES
MORT AND MARCY FRIEDMAN DIRECTOR & CEO

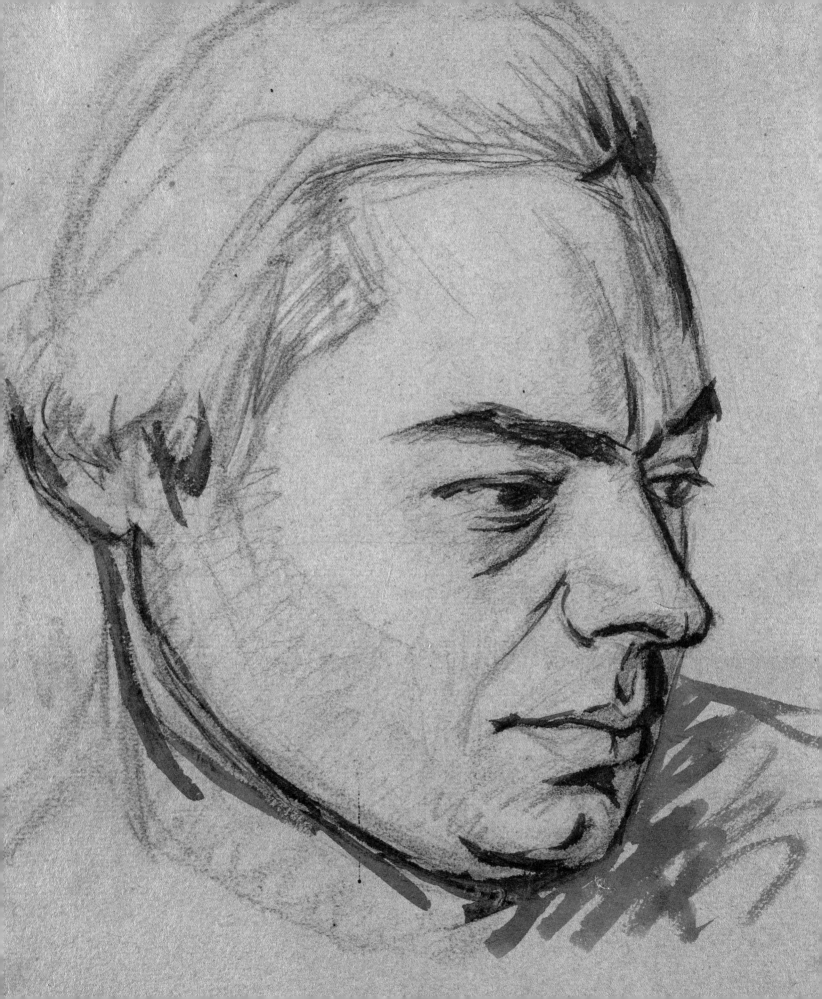

PREFACE

The riches of the Crocker Art Museum's collection of Old Master and nineteenth-century drawings provide many possibilities for exhibitions. The decision to focus on eighteenth-century German-speaking lands (the Holy Roman Empire, including parts of Bohemia and Switzerland) came about for three main reasons. Firstly, the beauty, condition, and quality of the Crocker's eighteenth-century German drawings collection make it one of the finest in the United States. Most of the objects in this exhibition have not been exhibited before, and, of the exceptions, most have not been seen by the museum-going public since 1989, the year of Thomas DaCosta Kaufmann's *Central European Drawings 1680–1800*. Likewise, the strength in landscape allows us to explore the beauty of Germany and to trace networks of artists related by family or profession. Secondly, the growing importance of later German drawings in past decades has meant that this early collection has gained a new context. Advancing programs of acquisition and scholarship among American museums mean that a larger public has come to know and appreciate the subject. Thirdly, the depth and breadth of the Crocker collection allows a selection exclusively of eighteenth-century objects. In this way the German eighteenth century is freed from its successor, so that the drawings in this exhibition are considered on their own terms, rather than playing their usual role as modest precursors to a more glorious Romantic period. The result, we hope, is an exhibition that will give pleasure and a catalogue that will contribute significantly to the literature on eighteenth-century German drawings, rather lacking in English for the past thirty years. In this project we build on the work of others, from those who organized exhibitions from the Crocker drawings collection in the 1940s, such as Annemarie Henle, later Pope, and Numa S. Trivas, to their colleagues of the 1980s, such as Thomas daCosta Kaufmann. The final motivation for this exhibition is the celebration of the 150th anniversary of the acquisition of the E. B. Crocker Collection, which, along with certain more recent acquisitions, provided the objects in the show.

WILLIAM BREAZEALE
CURATOR

ACKNOWLEDGEMENTS

Along the way to the present exhibition and catalogue, both authors have incurred many debts. We are grateful for the invaluable support of Lial A. Jones, the Mort and Marcy Friedman Director and CEO of the Crocker, and Scott Shields, the Assistant Director and Chief Curator. In addition, Alan Templeton's generosity has made this catalogue possible, complementing his kind and longstanding support of the European collection in general. The memory of Anne McHenry, and the good humor and support of her husband Malcolm, have lifted our spirits along the way. Many members of the scholarly world have proved patient and generous with their time and materials: Alexander and Emanuel von Baeyer, David Bassenge, Hans-Martin Kaulbach, Armin Kunz, Brigitte Laube, Agnes Matthias, Jochen Rascher, Petr Šámal, Petra Schniewind, Freyda Spira, Sabine Weisheit, Petra Zelenková, and the staffs of the Bowes Art and Architecture Library at Stanford University and the Getty Research Institute. Anne Rosenthal's skill in conservation, Jesse Bravo's and Brian Suhr's in photography, and Matt Isble's in exhibition design have brought the objects in the exhibition to their current splendor. The friendship and kindness of Cara Denison, Helen Fioratti, and Susan Hill will not soon be forgotten. And William Breazeale would like to thank Greg Jecmen for his understanding and encouragement.

WILLIAM BREAZEALE
ANKE FRÖHLICH-SCHAUSEIL

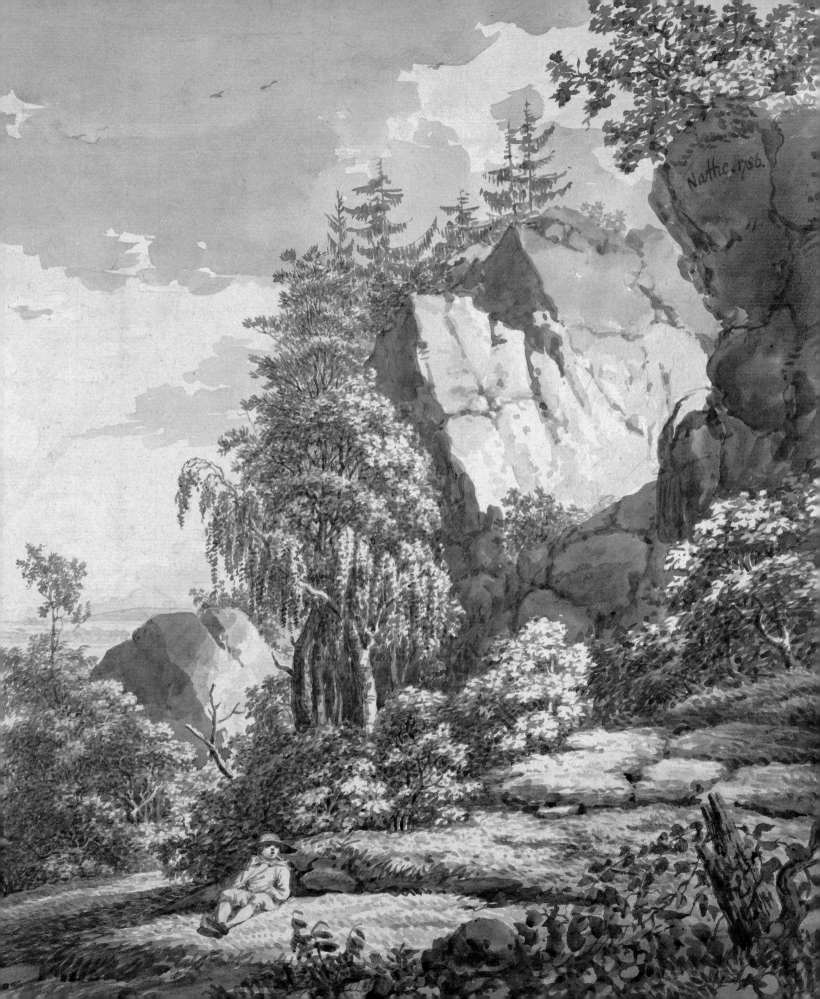

Artists' Networks in the Eighteenth Century
The Example of Saxony

ANKE FRÖHLICH-SCHAUSEIL

Saxony until the middle of the eighteenth century
In the eighteenth century, Europe was spanned by a network of artistic relationships, kept in motion by personal contacts as well as a lively exchange of letters. The artistic centers had developed in the seats of princely courts and in port and merchant cities. The links across Europe that artists from Saxony, at the time a kingdom in eastern Germany with Dresden as its capital, enjoyed can be taken as representative of other German artistic centers such as Berlin, Augsburg, Munich, and Frankfurt. Besides proximity, the web of relationships linking Saxony with Europe resulted from family ties as well as from bonds between master and pupil, friendships, disputes, study trips, collaborations, and trade.

In Saxony, there were two major art centers. Leipzig, a trading city, benefited from the many collections owned by merchants. Dresden was the seat of the Elector's court, making it one of the most splendid centers of the eighteenth-century art world in German-speaking lands.

In Leipzig, the city councilors and bankers, for example Gottfried Winkler and Johann Thomas Richter, assembled valuable collections of paintings, with the active help of the printmaker and art dealer Johann Georg Wille in Paris (fig. 1). He not only provided them with French works, but also brought their attention to German—and Saxon—artists.[1]

Dresden's appeal, on the other hand, lay in its status as the seat of a court. Splendid architecture, complemented by harmonious decorative complexes of painting and sculpture, and the city's picturesque surroundings enhanced its appeal as much as the rich art collections. The Electors of Saxony, with their advisors, art agents,

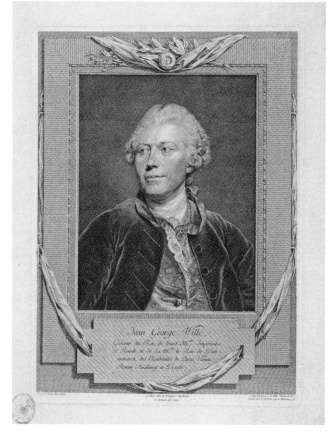

FIG. I
Johann Gotthard Müller after Jean-Baptiste Greuze, *Johann Georg Wille*, 1776. Engraving, 29.0 × 21.6 cm. Herzog-Anton-Ulrich Museum, Braunschweig

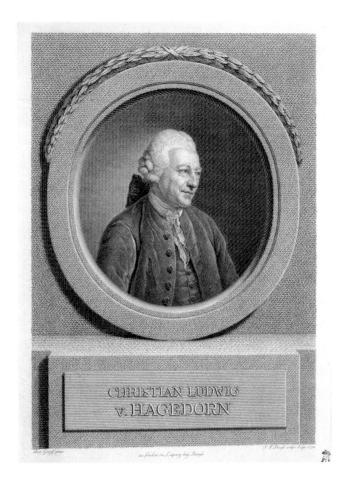

FIG. 2
Johann Friedrich Bause after Anton Graff,
Christian Ludwig von Hagedorn, n. d.
Engraving, 26.1 × 19.4 cm (plate). Staatliche
Kunstsammlungen Dresden, Kupferstich-
Kabinett, inv. no. A 19047

heavily damaged and the state was deep in debt. Foreign artists left the city of Dresden; there was no one to teach young artists. The death of Friedrich August and von Brühl in 1763 put an end to the activities of court painters and sculptors. But this decline set the stage for a flourishing merchant-class culture after the war ended, which had a significant effect on the network of artists.

After the Seven Years' War, 1756–1763

Already during the war, the Elector Friedrich Christian and his wife Maria Antonia Waburgis had come to a binding agreement with Christian Ludwig von Hagedorn (fig. 2) about the idea of a systematic art academy comparable to the institutions in Copenhagen, Bologna, but above all Vienna and Paris.

Hagedorn, in service to the court of Saxony since 1735 as a diplomat, art scholar, and collector, had acquired his skills as a collector of seventeenth- and eighteenth-century German and Dutch painting. He became famous as the author of *Betrachtungen über die Mahlerey* (Observations on Painting), expounding his own theory of art, which represents the beginning of art-historical literature in Saxony.[2] In it, he describes the elements which give a painting its aesthetic effect and are capable of touching the viewer: clever composition, the arrangement of details in accord with the "Maschine des Gemäldes" (the painting's 'machine', or the overarching complex of the painting), "correct" draughtsmanship, and the conscious use of color. These artistic devices were teachable and now were to be taught in the context of the new institution.

For this project, Hagedorn looked towards art academies already in existence. His friend Adam Friedrich Oeser (fig. 3) could inform him about the statutes and teaching methods of the Vienna Kunstakademie, as he had studied there before moving to Dresden and, after the war, Leipzig.[3] Oeser himself had thought about establishing an

and collection curators, as well as the city's connoisseurs, scholars, and authors, encouraged a favorable climate for the arts.

Artists came to Saxony from Italy—as indicated by the biographies of Rosalba Carriera, Giuseppe Galli-Bibiena, Giovanni Battista Casanova, Bernardo Bellotto, and Pietro Rotari—and Paris, the birthplace of Louis de Silvestre and Pierre and Charles-François Hutin. Frequently, however, it was the province of Saxony that provided its artistic centers with young native talent. Thus, many good painters came from the Meissen porcelain manufactory, the damask manufactory in Groß-Schönau, and the Friedrich oil tapestry manufactory in Dresden.

But with the outbreak of the Seven Years' War in 1756 the brilliant age of great court festivals, rich collections, and inspired decorative programs came to an end. Elector Friedrich August II, who was also king of Poland as August III, and his prime minister Count Heinrich von Brühl moved their court to Warsaw. Dresden and other cities were

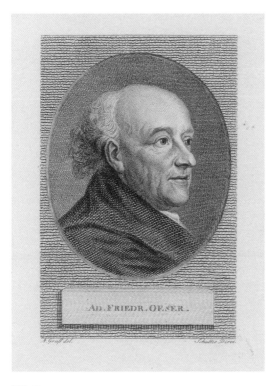

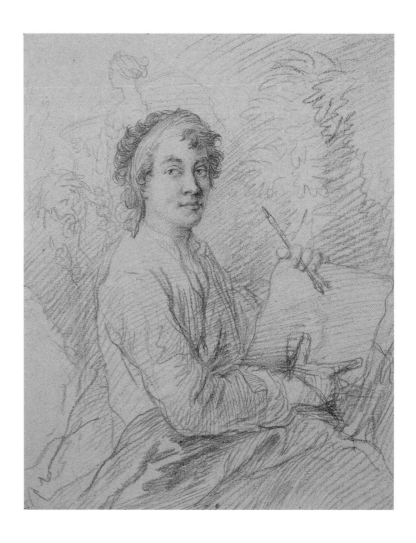

FIG. 3
Christian Gottfried Schultze after Anton Graff,
Adam Friedrich Oeser. Engraving, 19 × 12.5 cm.
Leipzig, Universitätsbibliothek Leipzig,
Porträtstichsammlung, inv. no. ICI, 648 Bl. 39

FIG. 4
Christian Wilhelm Ernst Dietrich,
Self-Portrait with Drawing Tablet, 1740/42.
Red chalk, 37.6 × 30.7 cm. Albertina, Vienna,
inv. no. 3952

educational institution in Leipzig even before the founding of the Dresden academy, as indicated by a letter of January 28, 1764, in which he speaks of his "Dream of a drawing academy to be established in Leipzig" (*Traum von einer in Leipzig anzulegenden Zeichnungs-Academie*).[4] Hagedorn exchanged information about the Paris Académie royale with the printmaker and art dealer Johann Georg Wille, with whom he had been corresponding since 1756.[5] Wille, resident in the French capital, followed the development of art in Saxony with interest—and with an eye to the Paris art market. Hagedorn would gladly have employed him, or, after Wille turned him down, his pupil Franz Edmund Weirotter, as professor of engraving, but his efforts were in vain. In the end he hired Johann Friedrich Bause, who became one of the most important printmakers in Saxony.

In addition, Hagedorn wanted to bring the painters Joseph-Marie Vien and Jean-Baptiste Greuze to Saxony, but the negotiations fell through, partly because of their salary requirements. Hagedorn then devoted his efforts to finding artists already active in Dresden, and presumably more affordable, to be instructors at the Kunstakademie. Support for art, artistic practice, and art instruction in Saxony gained a new and higher status with the founding of the Electoral Saxon Academy of the Fine Arts (Kurfürstlich-Sächsische Akademie der schönen Künste) at the beginning of 1764.

The Nöthnitz circle of artists and scholars
In the conceptual phase of the Academy's development Hagedorn relied on friendly relationships that stretched back to pre-war times. Among these contacts, the so-called

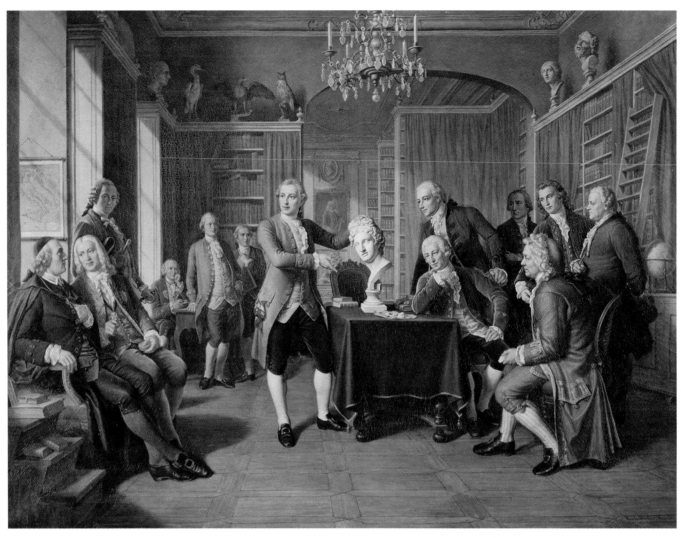

FIG. 5
Theobald von Oer, *Winckelmann and Scholars in the Nöthnitz Library*, 1874. Oil on canvas, 105 × 140 cm.
Dresden, Sächsische Landesbibliothek, Staats- und
Universitätsbibliothek Dresden, inv. no. 130.17

Nöthnitz circle stands out, named for the group's meeting-place, the castle south of Dresden owned by Count Heinrich von Bünau. Hagedorn had come to know not only the librarian and art theorist Johann Joachim Winckelmann and the draughtsman Philipp Daniel Lippert, but also artists such as Christian Wilhelm Ernst Dietrich (fig. 4), Bernardo Bellotto, and Adam Friedrich Oeser. A historicizing painting by Theobald Reinhold von Oer, done in 1874, shows that the influence of this gathering of scholars and artists lasted well into the next century (fig. 5).

Besides the host, the minister and historian Heinrich von Bünau, art dealers such as Francesco Algarotti and authors such as Gotthold Ephraim Lessing and Gottlieb Wilhelm Rabener are among the guests depicted.

However, in the center stands Winckelmann who, influenced by the collection of antiquities in Dresden, had developed his theory of "noble simplicity and quiet grandeur" (*Edle Einfalt und stille Größe*) in ancient works and recorded it in his *Gedancken über die Nachahmung der Griechischen Werke in der Mahlerey und Bildhauer-*

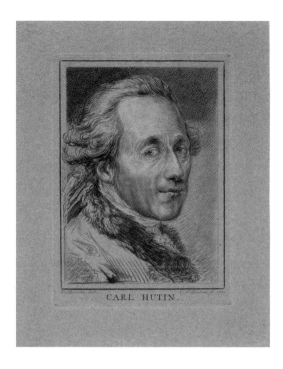

FIG. 6
Christian Friedrich Boetius after Charles-François Hutin, *Charles-François Hutin*, 1771. Crayon-manner etching on blue paper, 18.5 × 13.5 cm. Herzog-Anton-Ulrich-Museum, Braunschweig

FIG. 7
Crescentius Seydelmann, *Giovanni Battista Casanova in the Act of Drawing*, n. d. Brush and brown wash, 80.3 × 60.1 cm. Staatliche Kunstsammlungen Dresden, Kupferstich-Kabinett, inv. no. C 1961-129

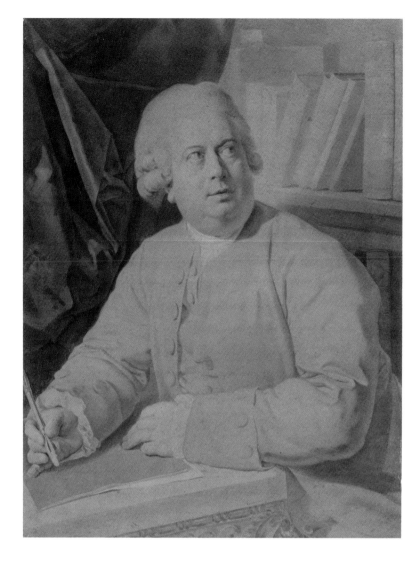

Kunst (Thoughts on the Imitation of Greek Works in Painting and Sculpture) of 1755. In this work, as well as his *Geschichte der Kunst des Alterthums* (History of Ancient Art) of 1767, he laid the groundwork for Neoclassicism. His ideal of beauty in ancient Greek art was available to the public from 1786 through his friend Anton Raphael Mengs's collection of over 800 casts after ancient sculpture, displayed in the Japanisches Palais in Dresden.

The first members of the art academies in Saxony
The Academy's founding was thus the result of considerations that had their origins long before. Hagedorn named Charles-François Hutin (fig. 6) "General director of arts, art academies and the galleries and rooms belonging

to them" (*Generaldirektor der Künste, Kunstakademien und dahingehöriger Galerien und Cabinets*), more simply Director, of the Dresden Kunstakademie. Hutin, already living in Dresden in 1748, had created ceiling frescoes, overdoors, and panel paintings, as well as copying works in the Gemäldegalerie. Below him were professors such as Giovanni Battista Casanova (fig. 7), a former student and housemate of Anton Raphael Mengs (fig. 8) in Rome. Casanova distinguished himself as a draughtsman but even more as an art theorist.[6] The printmakers Giuseppe Camerata, Giuseppe Canale, and Lorenzo Zucchi were also active under Hutin's direction.

The founding staff of the Academy thus consisted of artists already working in Dresden. The court painter

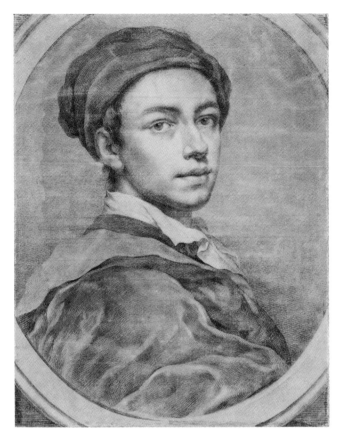

FIG. 8
Anton Raphael Mengs, *Self-Portrait*,
circa 1750. Black chalk, brush and gray
wash with touches of white opaque
watercolor, 56.3 × 44.4 cm. Staatliche
Kunstsammlungen Dresden, Kupferstich-
Kabinett, inv. no. C 2465

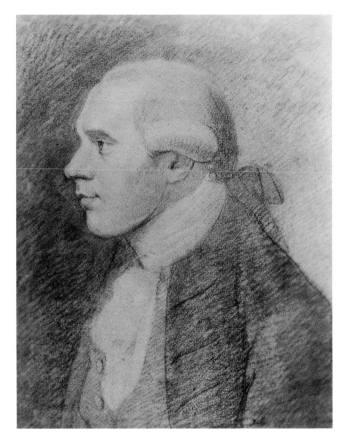

FIG. 9
Christoph Nathe, *Self-Portrait Facing
Left*, n. d. Black, red, and white chalks
on blue paper, 23 × 29 cm. Staatliche
Kunstsammlungen Dresden, Kupferstich-
Kabinett, inv. no. C 2356

Christian Wilhelm Ernst Dietrich, in Dresden since 1741,
was named professor, as well as director of the Zeichenschule
(drawing academy) at the Meissen porcelain manufactory.
The fledgling art school then had at its disposal an instructor
whose name was known throughout Europe and who had
been courted by the academies in Copenhagen and Paris.
"His name alone is worth half an academy in the eyes of
others, and his show with the local artists surely contributed
the most to their early fame" (*Sein Nahme gilt allein auswärts
für eine halbe Academie, und seine Ausstellung beÿ der hiesigen
hat wohl anfänglich das meiste zu ihrem Ruhme beÿgetragen*),
Hagedorn emphasized.[7] Dietrich's artistic output ranged
from etchings in Rembrandt's style to room decorations in
Antoine Watteau's manner, and from genre scenes in the
Dutch mode to French-inspired history paintings.[8]

Hagedorn also supported the Dresden Kunstakademie's
subsidiary in Leipzig. In autumn 1764 the city's
Zeichnungs-, Malerey-, und Architectur-Akademie
(Academy of Drawing, Painting, and Architecture) was
founded under Adam Friedrich Oeser's direction. As
Hagedorn reported, Oeser was the motivating force for the
school's significant achievements in drawing instruction
as well as the training of printmakers, sculptors, and
architects.[9] One of Oeser's tasks was to create a pragmatic
drawing and mathematics curriculum for future architects
who could then rebuild war-torn Saxon cities in the new
style. However, his instruction method became best known
for producing famous landscape painters, such as Jakob
Wilhelm Mechau, Johann Sebastian Bach the Younger, and
Christoph Nathe (fig. 9).

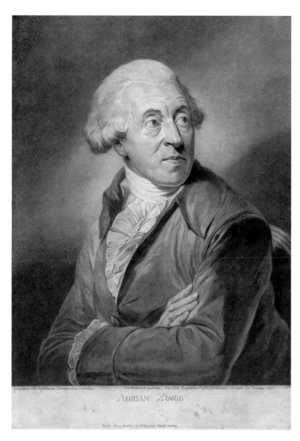

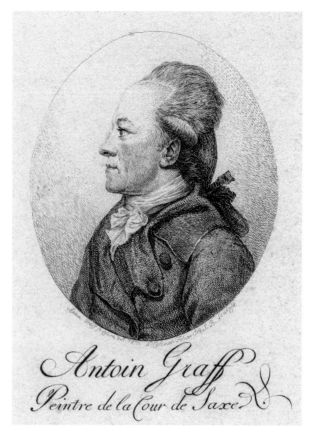

Young artists from abroad

Besides his contemporaries, Hagedorn was able to
attract young, talented artists from abroad as Academy
instructors. In July 1766, Adrian Zingg (fig. 10), warmly
recommended by Johann Georg Wille, came to Dresden
as instructor for landscape etching, just a few weeks after
his fellow Swiss artist, the portraitist Anton Graff (fig.
11), arrived.[10] It was especially important to Hagedorn
to make use of Zingg's knowledge because, as he wrote,
"introducing the French method of engraving is perhaps
the main object of my efforts" (*die französische Art des
Kupferstichs einzuführen, ist vielleicht der Hauptgegenstand
meiner Bemühungen*).[11] In 1770 Johann Eleazar Zeißig,
called Schenau, also recommended by Wille, moved from
Paris to Dresden and soon gained a foothold as a portrait,
genre, and history painter (fig. 12).[12] Later, Bernardo

Bellotto arrived as an instructor in perspective. Gottfried
Knöffler, a bit older, was made instructor for sculpture,
and Friedrich August Krubsacius came as instructor for
architecture and also perspective. Sculpture instruction
only gained a certain prominence after 1780, under
Knöffler's successor Count Camillo Marcolini, since
before then commissions were few.

Hagedorn thus gathered around him a group of
contemporaries and younger artists. He had set his eye
on Johann Conrad Seekatz for figure drawing and the
Viennese Johann Christian Brand for landscape painting,
in addition to the general painting instructor, Dietrich.[13]
Even if he could not convince them to join the faculty,
he nonetheless assembled a team of reputable artists as
instructors, such as Joseph Roos as landscape painter,[14]

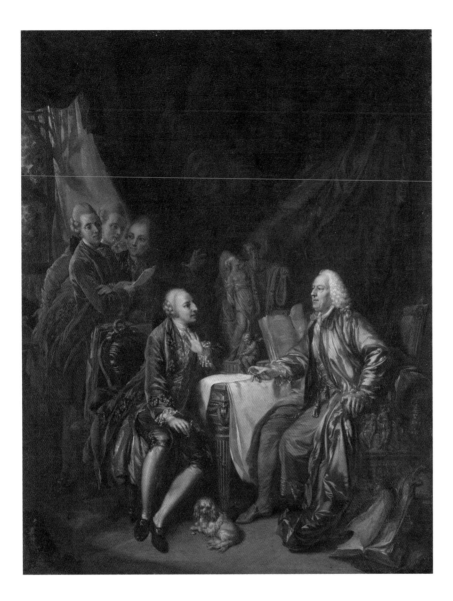

FIG. 12
Johann Eleazar Zeißig, called Schenau,
Das Kunstgespräch, 1772. Oil on canvas,
80 × 63.5 cm. Staatliche Kunstsammlungen
Dresden, Gemäldegalerie Alte Meister,
inv. no. 3161

Hutin, and Casanova, as well as Schenau, Graff, and Zingg, who already knew each other before joining the faculty.

By now, view painting, perspective painting, and decorative painting played only a minor role in Hagedorn's educational program. Instead, he trained history painters, portraitists, landscapists, and architects. He promoted a modern concept of art, in which easel paintings represented specific artistic categories. From today's perspective, this was a forward-thinking innovation. By creating a separate category for landscape, for example, he subverted the hierarchy of French art embodied in the Académie royale.

When the Kunstakademie's leader Hutin died in 1776, Casanova and Schenau inherited his office as alternating co-directors. But they had become involved in disagreements about various procedures in academic instruction as well as questions of style. Casanova refused Schenau's suggestion of hiring Graff and Zingg as professors, since he insisted on the idea of the preeminence of history painting over other genres. By doing this he likewise defended a concept of "pure art" in the Neoclassical style. Schenau, Graff, and Zingg, on the other hand, supplied works for an accessible, practical context: they exploited the public's desire for portraits and colored landscape etchings for domestic settings, as well as book illustrations, furniture, porcelain, monuments, and buildings in a contemporary style.

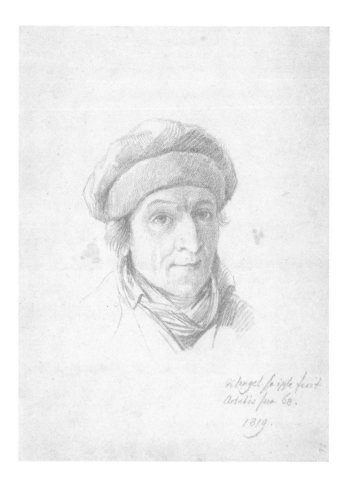

FIG. 13
Johann Christian Klengel, *Self-Portrait with Beret and Cravat*, 1819. Red chalk, 16.6 × 22.6 cm. Frankfurter Goethe-Museum, inv. no. III-15167-021b

Kunstakademie had become well-established and distinguished. It continued under Schenau and Casanova, until Crescentius Seydelmann took Casanova's place after his death. Unlike Hagedorn, who, in accordance with his art-theoretical reflections, had the goal of advancing general taste as well as establishing a new, clear style in Saxony, his successor Marcolini led the Academy with mainly economic concerns in mind. But from today's perspective Marcolini performed a great service by giving a new aesthetic impetus to the Meissen porcelain manufactory, which was also under his management, and promoting a new style there, which came to be called the Marcolini style.

One of the few female instructors at the Dresden academy was Caroline Friederike Friedrich, who taught flower and fruit painting from 1783 onwards. History painters also came to the fore in this period, for example Josef Grassi, professor from 1799, and Johann Friedrich Matthäi, professor from 1810. But Marcolini passed up the chance to add important artists such as Jakob Wilhelm Mechau to the faculty, and named the landscape painter Johann Christian Klengel (fig. 13) as professor only late, in the year 1800. In accordance with this tendency, the rise of early Romantic landscape painting, from our current point of view a central painting genre of its time, took place mainly outside academic institutions.

Female artists as networkers

From the age of sentiment in the eighteenth century and well into the nineteenth, networks played an especially important role for women. Even more than their male counterparts, women artists were dependent on supporters, promoters, and patrons, and there were fewer role models for their activities.[16]

The still-life painter Caroline Friederike Friedrich had good prospects due to her background. She came

In Leipzig, it was necessary to overcome the resistance of the painters' and masons' guilds in order that the competence of Academy students should be recognized. Hagedorn summarized the result: "The master builder's jealousy changed to favor. Now he willingly gives jobs to Academy students on real buildings, and gets in return charming façades, which his own youthful associates likely had not been taught to build, and certainly not in today's style. A noble simplicity is coming to dominate the new houses being raised up from rubble and ashes" (*Die Eifersucht des Maurermeisters verwandelte sich in Zuneigung. Willig giebt er ietzt den jungen Academisten Aufgaben zu wirklichen Gebäuden, und gewinnt dabeÿ hübsche façaden, zu welchen seine Jugend vielleicht nicht, wenigstens nicht nach dem heutigen Geschmack, angeleïtet worden: Eine edlere Einfalt herrscht allmählig an den neuern Häusern, die aus Schutt und Asche empor steigen*).[15]

By the time Count Camillo Marcolini was named general director after Hagedorn's death in 1780, the

FIG. 14
Johann Christian Fiedler, *Johann Alexander Thiele*, n. d. Oil on canvas, 40.3 × 32.8 cm. Staatliche Museen Kassel, inv. no. 1875/1590

Electoral Gallery for engravings contained in the *Recueil d'estampes d'après les plus celèbres tableaux de la Galerie Royale de Dresde* published between 1753 and 1757 under the patronage of Karl Heinrich von Heineken. A third volume appeared in 1780 under the direction of her husband Crescentius Seydelmann.

Sophie Friederike Dinglinger, the daughter of the court jeweler Johann Melchior Dinglinger, created miniature portraits. Also, Maria Dorothea Wagner, who was the sister of the court painter Dietrich, and the Leipzig artist Johanna Marianne Freystein, both painted landscapes. Like Marie de Silvestre or Theresa Concordia Mengs, most of these women had access to the artistic world through their fathers, brothers, and husbands. The painter Dora Stock, who lived in the Dresden household of her relatives the Körner family, was a friend of Goethe and even Charlotte and Friedrich Schiller. She received her training from her father, the printmaker Johann Michael Stock.

However, there were also female painters who had to make their way without the support of family members. Among them were Johanna Marianne Freystein, who had moved to Dresden from Leipzig, and the portraitists Luise Seidler and Caroline Bardua. All of these educated women contributed much to Dresden's cultural appeal, as participants in the salons of the Körner or Kügelgen families or as promoters of younger artist colleagues. Thus, Freystein supported the career of the landscape painter Friedrich Christian Klass and obtained commissions for her teacher Johann Christian Klengel. Wilhelmine Seyfried made reproductive engravings of the latter's paintings. It is characteristic that several of them, finding themselves in the same exceptional social position because of their sex and their interest in art, became friends. For example, Dora Stock, Caroline Bardua, Apollonia Seydelmann and the painter and musician Theresa aus dem Winckel all were friends of Luise Seidel.

from an artistic family originally from Großschönau in Upper Lusatia that enjoyed the support of the Dresden court painter Johann Alexander Thiele (fig. 14). With her masterly brush drawings in tempera of flowers, fruits, and insects, she became the most important member of her family. In addition, Schenau, the Academy director who also came from Upper Lusatia, was a close friend and promoter. She could therefore play an outstanding role in her field: an honorary member of the Academy since 1774, she was the only female instructor—"Unterlehrerin"—from 1783 onward.

In the first half of the century, Anna Maria Werner, née Haid (fig. 15), painter to the court of Saxony, worked with other colleagues on the artistic record of the Electoral marriage celebrations of 1719. She created copies of works by other masters as well as landscapes. Maria Theresa Riedel, the daughter of the Dresden painter and Electoral Gallery inspector Johann Gottfried Riedel, drew landscapes after Dutch models. Appolonia Seydelmann, née de Forgue, copied paintings from the

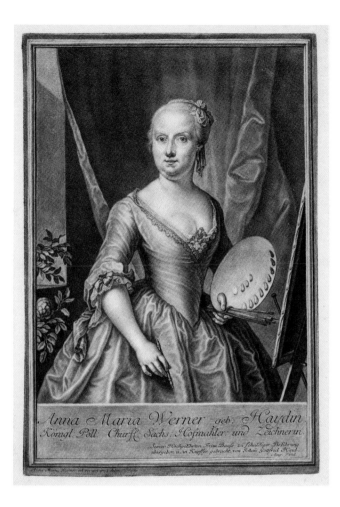

river landscapes with picturesque ruins and cottages in the Dutch manner depicted at various times of day, often as pendants. Not only Dietrich, but also Adrian Zingg and younger painters such as Karl Gottfried Traugott Faber and Johan Christian Clausen Dahl, used engravings after her works as models for their students even after her death. Her son Johann Georg Wagner, influenced by Dietrich, also discovered views in the Italian manner within the landscape of Saxony, in the district near Meissen. In his case, visual models he had encountered in art influenced his perception of real nature.

Thanks to Wille's promotion, Dietrich's and Wagner's work was known in Paris during their lifetimes and long afterwards. Artists such as Schenau, Adrian Zingg, and Johann Christian Klengel in Saxony owed their progress to Wille's efforts to establish the German school in the Paris art market alongside the French, Italian, Dutch, and English schools. Wille made Johann Georg Wagner's method of creating landscapes in gouache and pastel especially popular in Paris. Other artists, including Jakob Philipp Hackert (fig. 16) and François Boucher, imitated them and often heightened the coloring to porcelain-like cool tones. Wagner's works were copied and reproduced in prints by artists such as Jacques Aliamet and Friedrich Christoph Weisbrod in Paris and Johann Friedrich Bause, Johann Christian Klengel, and Johann Gottlob Schumann in Dresden.

Whereas Wagner worked in Meissen, the Upper Lusatians Christoph Nathe and Heinrich Theodor Wehle were influential well outside their region.[16] They developed an Upper Lusatian tradition of landscape painting which, in its concept of space, its desire for topographical accuracy, and the choice of specific natural views and sights considered beautiful, owed much to Adrian Zingg. But, in contrast to Zingg, pictorial denseness and emotional atmosphere played a greater role in their work.

Landscape painting in Saxony as an example of artists' networks in the eighteenth century

Landscape painting as an independent genre in Dresden owes its beginnings to Johann Alexander Thiele. He and his pupils Johann Gottlieb Schön and Christian Benjamin Müller were direct precursors of Adrian Zingg and his workshop, anticipating their interest in topographical and regional attractions as well as their method of collaborating. Thiele's pupil Christian Wilhelm Ernst Dietrich produced an independent body of work whose influence lasted well into the nineteenth century. He was exceptionally varied in style, as a landscape painter but also as a painter of Classical and Biblical histories, wall decorations in the manner of Watteau, and Dutch genre scenes.

The works of Dietrich's sister Maria Dorothea Wagner are closely related to her brother's, but were limited to

FIG. 16
Wilhelm Titel after François-Xavier Fabre,
Jakob Philipp Hackert Drawing Outdoors,
1806. Oil on board, 43 × 33.7 cm.
Hamburger Kunsthalle, inv. no. HK-1953

A poet in the network of artists

The period from the second half of the eighteenth century to about 1832, often called the *Goethe-Zeit* (Age of Goethe), was in Dresden indeed marked by Goethe's influence on cultural and artistic life. His friend and sometime drawing teacher Carl Ludwig Kaaz lived in the city.[18] He promoted other artists by means of commissions, for example the painters and printmakers Johann Adolf Darnstedt and Carl Gottlob Hammer and the painters Luise Seidler and Caroline Bardua. He cultivated personal contact with many artists, among them Gerhard von Kügelgen, Ferdinand Hartmann, Christian Vogel von Vogelstein, Caspar David Friedrich, and Carl Gustav Carus. Gustav Heinrich

Naeke, Moritz Retzsch, and Friedrich Rensch took direct inspiration from his poetry, especially his *Faust*.

A significant new institution for regulating the art market and supporting artists was an organization created by the merchant class, the Saxon Art Association (*Sächsische Kunstverein*).[19] Its founders were the art scholars Johann Gottlob von Quandt and Karl August Böttiger, who had long known Goethe and corresponded with him about the organization. It was founded in 1828, on the 300th anniversary of Albrecht Dürer's death, with the object of acquiring paintings. Which of the members could keep the work acquired was determined by drawing lots, while the others received prints of it. These were later collected in the *Bilderchronik des sächsischen Kunstvereins*.[20] In this way the association also became an important patron of engravers and etchers. The founding date was chosen deliberately, since Dürer represented a brilliant symbol of the flourishing of German art, as opposed to Raphael, who in this way of thinking embodied Italian painting. Promoting German art thus figured significantly in the association's original mission.

At the same time the foundation of the Sächsische Kunstverein heralded the decline in Saxony of the European network that had connected the province with the artistic centers of Paris, Rome, Zürich, Vienna, St. Petersburg, and Warsaw, as well as Stuttgart, Frankfurt, Augsburg, and Berlin. The emphasis was now on the life of one artistic region, Saxony, no longer its integration into the European artistic world as in previous generations.

Notes

1 Schulze Altcappenberg 1987, p. 38.
2 Hagedorn 1755, Hagedorn 1762.
3 For Oeser, see Richard Hüttel, *Das Evangelium des Schönen, Zeichnungen von Adam Friedrich Oeser 1711–1799*, exh. cat. Leipzig, Munich 2008, and Vogel 2017.
4 Sächsisches Hauptstaatsarchiv, 'Acta Die Kunst-Akademie und Zeichen-Schulen', betr. 11126, Geheimes Kabinett, Loc. 22, fol. 13r–15v.
5 See Schulze-Altcappenberg 1987, p. 61.
6 Giovanni Battista Casanova, *Theorie der Malerei*, ed. Roland Kanz with Doris Lehmann, Munich 2008.
7 Hagedorn 1771, fol. 126/24r.
8 See Schniewind Michel 2012.
9 Hagedorn 1771, fol. 126/22v–23v.
10 For Graff, see Ekhart Berckenhagen, *Anton Graff, Leben und Werk*, Berlin 1867; Roland Kanz, *Dichter und Denker im Porträt. Spurengänge zur deutschen Porträtkultur des 18. Jahrhunderts*, Munich 1993; and Marc Fehlman and Birgit Verwiebe, eds., *Anton Graff, Gesichter einer Epoche*, Munich 2013. For Zingg, see Weisheit-Possél 2010 and Petra Kuhlmann-Hodick, Claudia Schnitzer, and Bernhard von Waldkirch, eds., *Adrian Zingg, Wegbereiter der Romantik*, Dresden, 2012.
11 Hagedorn 1771, fol. 126/20v–21r.
12 For Schenau, see Fröhlich-Schauseil 2018.
13 Schulze Altcappenberg 1987, p. 75.
14 See Hermann Jedding, *Johann Heinrich Roos, Werke einer Pfälzer Tiermalerfamilie in den Galerien Europas*, Mainz 1998, pp. 281–303.
15 See Hagedorn 1771, fol. 126/22v–23v.
16 See Bärbel Kovalevski, ed., *Zwischen Ideal und Wirklichkeit, Künstlerinnen der Goethezeit*, exh. cat. Gotha and Constance, Ostfildern-Ruit, 1999.
17 See Anke Fröhlich, *Zwischen Empfindsamkeit und Klassizismus, der Zeichner und Landschaftsmaler Johann Sebastian Bach d. J. 1748–1778*, Leipzig, 2007, and Fröhlich 2008.
18 See Hans Geller, *Carl Ludwig Kaaz, Landschaftsmaler und Freund Goethes 1773–1810*, Berlin, 1961.
19 See Brunnhilde Köhler, *Geschichte des Sächsischen Kunstvereins 1828–1946*, Dresden, 1994.
20 See Bärbel Kovalevski, *Die Bilder-Chronik des Sächsischen Kunstvereins*, Frankfurt am Main, 2010.

Networks of Collectors, Dealers and Artists in Eighteenth- and Early Nineteenth-century Germany: The Evidence of the E. B. Crocker Collection

WILLIAM BREAZEALE

On August 9, 1869, Edwin Bryant Crocker, his wife Margaret (figs. 17 and 18), and their daughters left Sacramento for a trip to Europe. Before their departure, the family had purchased property at 3rd and O Streets in the California capital to accommodate a new house and art gallery. After their arrival in Europe, they journeyed to Dresden, where in 1870 they took rooms at 17 Lüttichaustraße.[1] This address, which they kept for over a year, served as a base for their European travels. The family returned to Sacramento on May 5, 1871, soon followed by the contents of four railroad cars including some 700 paintings and likely the 1344 drawings that form the core of the permanent collection of works by Old Master and nineteenth-century artists.[2]

The circumstances of the Crocker family's drawings acquisitions remain somewhat of a mystery. Newspaper accounts in the *Sacramento Union* and the *Sacramento Bee* mention the paintings but not the drawings, nor do they mention the reproductive prints no longer in the collection.[3] No purchase records from the trip survive at the Museum, though it is possible that bills of sale or other documents may yet be found among the papers remaining with Crocker descendants. The few surviving letters at the Museum deal with other matters besides art, though Glenn Willumson kindly signaled to us payments in foreign currency, likely for art shipping, in June and July 1871, and an 1872 letter from Collis Huntington to E. B. Crocker about pictures shipped from Germany.[4] However, though drawings of other schools may have been purchased from different places during the Crocker family's travels,[5] the evidence provided by the German drawings themselves points to a predominantly German origin for them. In addition, the collection provides a view into the eighteenth- and nineteenth-century art world and the interactions among collectors, dealers, and artists.

Including objects from German-speaking areas of Austria and Switzerland, the German drawings in the E. B. Crocker Collection number 643.[6] Of these, 279 come from the studio of the young Swiss artist Jakob Merz, who studied in Vienna.[7] The collection is especially strong in early German drawings, including the first drawing by Albrecht Dürer to enter the United States, drawings by the Master of the Coburg Roundels and Ludwig Krug, and drawings from the Danube School around Albrecht Altdorfer.[8] The earliest dated drawing is of 1498, the Dürer, and the latest a landscape by Carl Wagner of 1861.[9]

The German eighteenth century is especially strong, the motivation for the present exhibition. Perhaps naturally, given the sources we shall examine, the collection includes many artists working in Dresden, but all of the major German schools of the period are represented. Besides Jakob Merz, the largest number of drawings by a single artist are those by Gottfried Mind (29), then Heinrich Wilhelm Schweickhardt (21), and Joseph Georg Wintter (12), though many of these are minor studies. As seen in the present exhibition, there is a large number of especially fine landscapes in the collection, from Dresden Kunstakademie professors and others.

The Crocker's is the largest of the early collections of eighteenth-century German drawings in the United States. Others include a smallish group now at the Philadelphia Museum of Art, originally gathered by John S. Phillips as part of his collection of prints and drawings that was left to the Pennsylvania Acaemy of Fine Arts in 1876, as well as

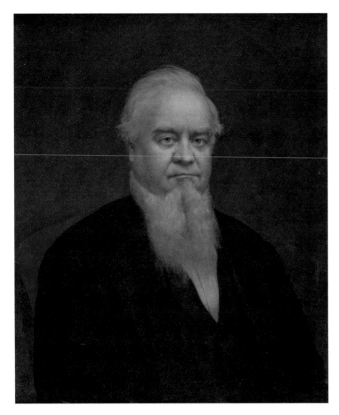

FIG. 17
Stephen William Shaw, *Edwin Bryant
Crocker*, 1873. Oil on canvas, 76.5 × 63.5 cm.
Crocker Art Museum, E. B. Crocker
Collection 1872.384

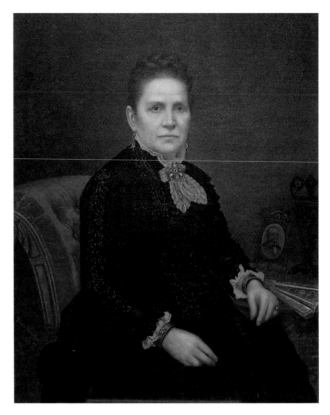

FIG. 18
Francis Marion Pebbles, *Margaret Crocker*,
1877. Oil on canvas, 106.7 × 81.3 cm. Crocker
Art Museum, E. B. Crocker Collection
1885.48

a much larger group collected by John Witt Randall, since 1892 in the collection of the Fogg Art Museum of Harvard University. Both of these have connections to Leipzig, in that Phillips attended some of Rudolph Weigel's auctions in the city during the late 1850s through 1873,[10] and many of the Randall drawings come from the collection of the Leipzig University philosophy professor Friedrich Wilhelm Lindner.[11] Besides the Crocker, largest in number partly because of the Merz drawings, the most extensive modern collection of eighteenth-century German drawings is at the National Gallery of Art in Washington, recently expanded by the 2007 purchase of the Wolfgang Ratjen collection, though Harvard has consistently built on the core of the Randall drawings over the years. Also prominent is the collection of the Metropolitan Museum of Art, built up mainly in the late twentieth century through gift and purchase.

The Crocker eighteenth-century German drawings have benefited from publications by Thomas DaCosta Kaufmann, whose long involvement with American collections of Central European drawings resulted in 1982's *Drawings from the Holy Roman Empire 1540–1680* and 1989's *Central European Drawings 1680–1800*.[12] The latter of these included 21 Crocker drawings, a fifth of the exhibition, bringing wider attention to the collection at a time when the Museum's own resources were sparse. Since the publication of his wide-ranging 2004 collections catalogue *Central European Drawings from the Crocker Art Museum*, research in the field of eighteenth-century German drawings, and research into the Crocker's collection of them, has progressed apace. A second motivation for the present catalogue is to reflect that research, and to provide an in-depth study to supplement the scant literature on the subject in English.

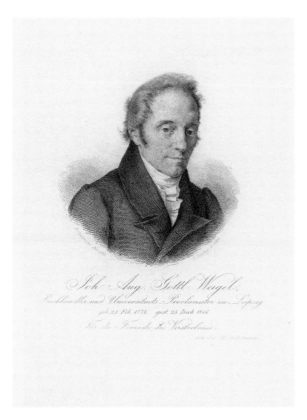

FIG. 19
Lazarus Gottlieb Sichling after Friedrich
Giessmann, *Johann August Gottlob Wiegel*,
after 1846. Engraving, 20.0 × 17.2 cm.
Deutsche Nationalbibliothek, Leipzig

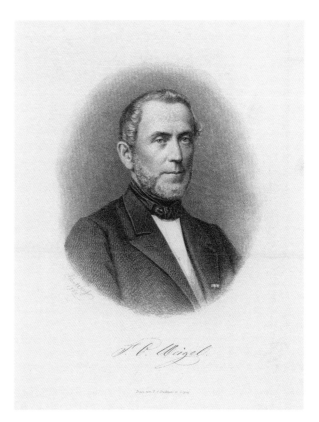

FIG. 20
Albrecht Fürchtegott Schultheiß,
Theodor Oswald Weigel, 1865. Engraving,
18.0 × 15.0 cm. Deutsche Nationalbibliothek,
Leipzig

The sources of the Crocker's collection of German drawings are subject to debate. A long tradition would have it that the entire drawings collection, of all European schools, comes from the stock of the Leipzig dealer and auctioneer Rudolph Weigel, but the question is more nuanced. Comparison with Weigel's *Kunstlager-Katalog* revealed that, of 1344 in the E. B. Crocker Collection, a maximum of 400 drawings, of which 279 are by Jakob Merz, come from the stock listed there.[13] The presence of other dealers in Leipzig and the evidence for wider travel by the Crockers—as well as collection marks from late Parisian collections—make a larger range of sources nearly certain.[14] Among the eighteenth-century German drawings, eighteen entries in the *Kunstlager-Katalog*, among them the Klengel, the Merz, the Hackert, and the Tischbein in this exhibition, can be connected to Crocker objects.[15]

Recent information that has come to light about the networks of dealers, collectors, and artists in Germany during the nineteenth century points to the need for a fresh discussion. The Frits Lugt Foundation's ongoing *Marques de Collections* project has been an invaluable resource, and provides much of the biographical information given here. The Crocker collection, with its narrow span of possible acquisition dates, is especially useful in exploring this network. The prosperous city of Leipzig, with its many publishing houses, its well-attended annual fair, its flourishing art market, and its proximity to the Dresden court, was a nexus of exchange, not only of objects but also of information. Rudolph Weigel's firm, as well connected as any, had its origin with Rudolph's father, Johann August Gottlob (1773–1846; fig. 19). Born in Leipzig, he was a dealer in books as well as an auctioneer for books, prints, and drawings. He also published works of Classical literature.

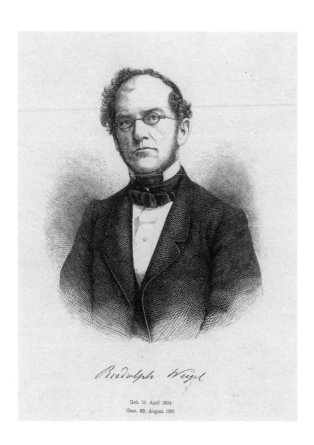

Another dealer who worked in Leipzig during this time was Carl Gustav Boerner (1790–1855; fig. 22). A rather mediocre artist who had studied under Heinrich Friedrich Füger at the Vienna Kunstakademie, he lived in Rome and Munich before settling in Leipzig in 1825. Well connected—he sold drawings to Goethe and enjoyed the patronage of the collector Heinrich Wilhelm Campe, whom we shall meet later—Boerner began dealing in art in 1826. Unlike Weigel, he had no auction arm to the business, freeing him from the demands of volume sales and allowing him to function more as a private middleman. In fact, much of his stock, including drawings and prints sold to Goethe, came from J. A. G. Weigel's early sales, especially the 1826 sale of Prince Schwarzenburg.[21] Paul Erwin Boerner (1836–1880) continued the firm after his father's death, also working for Rudolph Weigel, and absorbed the latter's auction business four years after his death in 1867.[22]

Collectors' marks and inscriptions on Crocker drawings point to conditions in the German art market and relationships among personalities in Leipzig and beyond. Marks of German eighteenth- and nineteenth-century collectors appear most often on drawings of other European schools. The earliest is that of Johann Jakob Faesch of Basel (1732–1796). A merchant, he lived in Amsterdam until 1765, when he returned to his native city and entered the government. Though the mark (Lugt 2464a) appears on a drawing by Pierfrancesco Mola,[23] he collected Dutch paintings as well. Likewise early is Johann Gottlob Schumann (1761–1810) of Dresden, whose mark (Lugt 2344) appears on one of the most important Italian drawings in the collection, by Vittore Carpaccio.[24] Schumann, a painter and printmaker, was a student of Johann Christian Klengel, represented in this exhibition, and lived in Prague and Vienna as well as London, where he settled. Neither of these drawings has further known provenance before their purchase by the Crocker family. Nor does a drawing by

The elder Weigel's catalogues, such as the *Aehrenlese auf dem Felde der Kunst*,[16] were unusually systematic, a characteristic that was passed down in those of his sons. Theodor Oswald (1812–1881; fig. 20), the younger son, focused mostly on the publishing and book part of the business, which he continued under his own name. He published *Die Anfänge der Druckerkunst in Bild und Schrift* in 1866,[17] a catalogue of early printed works in his posession, and brought his father's drawings collection to sale in 1869.[18] Rudolph himself (1804–1867; fig. 21), on the other hand, focused on art almost exclusively. Founding his art dealership and auction house in 1831, he quickly became a desired auctioneer for heirs, directing a constant stream of posthumous sales for a variety of famous collectors throughout his career. A scholar of works on paper, he not only wrote a supplement to Adam Bartsch's *Peintre-Graveur*,[19] but also created *Die Werke der Maler in ihren Handzeichnungen*,[20] a comprehensive directory of reproductive prints and photographs of Old Master drawings. His monumental *Kunstlager-Katalog*, begun in 1838, was a systematic list of his offerings, updated almost yearly until his death.

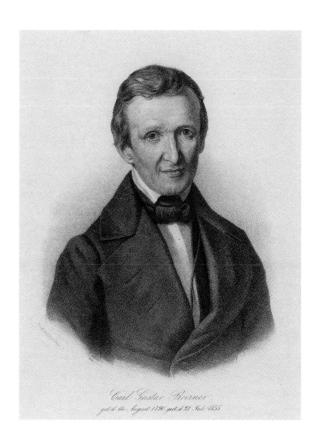

Dughet[25] bearing the mark (Lugt 1008) of the Basel dealers Theodor Falkeisen (1768–1814) and Johann Friedrich Huber (1766–1832), who were also printmakers. Because of the lapse of time before the Crockers' European trip (Falkeisen had left the business as early as 1812), it is impossible to know if the drawings returned to the art market in Saxony or were purchased elsewhere. Another mark of this sort is that of the Viennese collector Franz Gawet, a printmaker (1765–1847), which appears on a series of natural history drawings by unknown artists, one reattributed to Otto Marseus van Schrieck,[26] and all bearing the collector's date of 1828.[27]

However, as we move closer in time, we also seem to move closer to Leipzig geographically. The collection of a wool merchant in the city, Heinrich Wilhelm Campe (1770–1862), who also served as Bavarian consul general, included around 1300 drawings. It was sold as a result of financial stresses in 1827 in an auction directed by his erstwhile protégé, Carl Gustav Boerner.[28] Two marks are associated with his collection. The first (Lugt 2731) is the one used by the city of Leipzig to mark the drawings

seized in 1826, and appears on two Dutch drawings, one by an unknown hand, and two by the eighteenth-century German Joseph Georg Wintter.[29] The second, a blind stamp with the artist's initials (Lugt 1391), appears with the other on a drawing by Moeyaert,[30] as well as alone on one attributed to the Italian artist Giovanni Battista Lenardi[31] and one by Georg Wagner.[32] Since Campe went on to form a second collection, the latter mark does not indicate, as the first one does, presence in the 1826 sale.

Another such collection is that of Stiglmeier. It seems likely the collector is the Johann Stiglmeier of Straubing, now a suburb of Munich, whose sale took place beginning October 6, 1856 at Rudolph Weigel's rooms. The collection mark (Lugt 2314) appears on some of the most important drawings in the Crocker collection, including the Albrecht Dürer,[33] a large and important François Boucher,[34] a Goltzius and other Dutch drawings.[35] Later German drawings are instructive, since a drawing by Johann Theophil Bauer after Albrecht Altdorfer carries the additional inscription "Straubing 51," connecting the mark definitively to the collector living in that town,[36] and one by Maximilian Albert Hauschild is signed and dated 1836 by the artist, providing a *terminus post quem* for the collector's death. The drawing by Johann Elias Ridinger in this exhibition appears in the 1856 sale catalogue[37] but does not bear the Stiglmeier mark, and perhaps originated in the collection of Friedrich Niesar, sold with the Stiglmeier collection.

A last important German collection for the Crocker is that of Carl Freiherr Rolas du Rosey (d. 1862) of Dresden, whose posthumous sale took place at Weigel in 1864.[38] His family was of Swiss origin and had served the Brandenburg princes and Prussian kings in the eighteenth century; he himself was a Prussian general. His collection was predominantly Dutch and his mark appears on twenty Dutch drawings, among them the famous Hans Savery *Dodo Birds*, and two Italian ones, both from Giovanni Benedetto

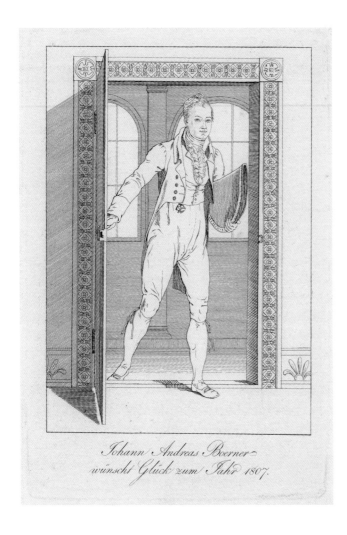

Johann Andreas Boerner
wünscht Glück zum Jahr 1807.

Castiglione's circle.[39] A magnificent Daniel Lindtmeyer[40] and a Johann Heintz drawing[41] represent early German schools, while the only later German drawing is a minor work likely by Johann Adam Fassauer.[42]

The common thread in the discussion of these later collection marks is sale in Leipzig. However, since some of the drawings in question bear a collection mark but do not appear in the sale catalogue, exchange or gift must be considered as another way of objects changing hands. The inscriptions surviving on Crocker drawings are a richer resource for studying the network of artists, collectors, and dealers active in the nineteenth century in German-speaking lands. Though many have been recorded in previous publications, systematic comparative study has been lacking until now.

An inscription on an *Allegory of the Reformation* records the artist's work with Goethe: "After the original drawing in the possession of the Goethe family in Weimar, copied by Chr. Schuchardt" (*Nach der originalen Zeichnung im Besitz der Goethe'schen Familie in Weimar / copirt von Chr. Schuchardt*).[43]

The copyist, Christian Schuchardt, was the cataloguer of the author's art collection,[44] sold to him in large part by Carl Gustav Boerner, as noted above. Among his other works was a study of Lucas Cranach.[45] The original of the *Allegory*, by the sixteenth-century Nuremberg artist Peter Vischer the Younger, is now in the collection of the Goethemuseum.[46] An inscription by the Swiss watercolorist Johann Friedrich Füchslin records his high opinion of his contemporary Salomon Gessner and his study of the Old Master landscapists, concluding "*Er gab auch grosse in Wasserfarben*" (He also did good work in watercolor).[47] Such inscriptions serve as a reminder of the many polymaths among nineteenth-century artists, who served as curators, critics, and art historians as well.

One object in the collection is mysterious, and not only for its attribution. By a late follower of Rembrandt, it shows more enthusiasm than skill in recalling the master's style. However, it not only bears the mark of Stiglmeier mentioned above, but also an inscription in an unknown hand "Winckler ... Speck-Sternburg."[48] These are likely two other famous collectors active in the nineteenth century, Joachim Gustav Heinrich Winckler and Maximilian Freiherr Speck von Sternburg. The former (b. 1822) was a merchant in Hamburg and London, while the latter (1776–1856), also a merchant, was famous as a patron of the arts in Leipzig. He was ennobled by the Russian and Bavarian rulers and his large collection of Old Master and nineteenth-century artists is now a core of the Museum der bildenden Künste in Leipzig. If these inscriptions indicate ownership, the drawing's weakness provides a reminder of very differing standards of quality in the early nineteenth century.

FIG. 24
Johann Adam Klein, *Two Riders before Nuremberg*, 1810. Pen and black ink, brush and watercolor, 15.4 × 19.9 cm. Crocker Art Museum, E. B. Crocker Collection 1871.93 verso

FIG. 25
Jakob Gauermann, *Scene from Goethe's 'Hermann und Dorothea'*, circa 1808. Brush and watercolor and opaque watercolor, pastel on blue laid paper, 38.6 × 53.1 cm. Crocker Art Museum, E. B. Crocker Collection 1871.1055 verso

FIG. 26
Philippe Leclerc, *Veste Hohen Salzburg*, after 1799. Black chalk and graphite, 31.1 × 45.2 cm. Crocker Art Museum, E. B. Crocker Collection 1871.1037 verso

The Nuremberg collector Johann Andreas Börner (1785–1862; fig. 23) left his signature (Lugt 270) on a variety of German drawings now at the Crocker. A merchant and later, with Johann Friedrich Frauenholz (1758–1822) an art dealer, he also functioned as an auctioneer. Leaving the trade in 1830, he devoted himself to scholarship. He was not related to Carl Gustav Boerner, the Leipzig dealer. His mark appears alone on an 1810 drawing by Johann Adam Klein depicting two horsemen (fig. 24).[49] More often, however, other inscriptions appear either in his own distinctive brown ink script or in another, more gestural hand in black chalk.

In the case of an equine study by Johann Georg von Bemmel, the inscription in Börner's hand provides the attribution,[50] and likewise for a view of Salzburg by Philippe Leclerc, in which he also identifies the place.[51] However, an elaborate watercolor scene by Jakob Gauermann bears an inscription identifying the subject, taken from a poem by Goethe—'Hermann und Dorothea'—and the information that it served as the model for a print (fig. 25).[52]

The drawing by Philippe Leclerc provides a clue to the more gestural black chalk inscriptions. At lower right it bears the words *Geschenk von frd.* [*Freund*] *Börner / in Nürnberg / Weihnachten 1860* (Gift from my friend Börner / in Nuremberg / Christmas 1860). Below this, in sharper chalk but, the present writer believes, in the same hand, is "*R. Weigel*" (fig. 26). If this is the case, the black chalk hand, present on many drawings, is Rudolph Weigel's.

Johann Jakob Wolfensberger, *A View of Mount Vesuvius*, n. d. Brush and blue, green, brown, yellow-green, pinkish watercolor over black chalk, 24.3 × 33.0 cm. Crocker Art Museum, E. B. Crocker Collection 1871.531 verso

FIG. 28
Gotthard Ringgli, *The Sacrifice of Isaac*, n. d. Pen and black ink, brush and gray wash, 21.5 × 22.3 cm. Crocker Art Museum, E. B. Crocker Collection 1871.509 verso

The Leclerc, then, would have been a Christmas gift to Weigel from his fellow dealer in Nuremberg, seven years before his own death and two years before Börner's. A drawing by the seventeenth-century artist Georg Strauch[53] bears both Johann Andreas Börner's mark and the black chalk notation "*Geschenk von ... Börner in Nürnberg*," in the familiar hand, making it nearly certain that the Nuremberg collector, not Carl Gustav Boerner, was meant.

If we can accept that this hand, which for simplicity I shall refer to as the RW? hand, is indeed Rudolph Weigel's, it explains other inscriptions that accompany J. A. Börner's mark or text. The Gauermann mentioned above would also have been an 1860 Christmas gift—*Geschenk von Freund J A Börner / Nürnberg zu Weihnachten / 1860* and a drawing by Johann Christoph Erhard would indicate that Börner had begun his gifts at least thirteen years earlier.[54] Only German drawings in the Crocker collection have inscriptions indicating that they were received as gifts.

Before accepting the RW? hand as definitively Rudolph Weigel's, inscriptions present on a watercolor of Vesuvius by Johann Wolfensberger should be examined (fig. 27).[55] The first reads: *Geschenk meines Freundes Leichtmans, nach seiner Rückkehr aus / Italien, um 23 Junij 1828., starb im Oktober desselben Jahres zu Leyden / RW* (Gift of my friend Leichtman, after his return from Italy about 23 June 1818, [he] died in October of the same year in Leiden) and in the lower right corner: *Ansicht des Vesuvs / Von dem Schweizer Mahler / Wolfensberg / Rom ... in Rom* (View of Vesuvius by the Swiss painter Wolfensberg, Rome ... in Rome).

The words "Wolfensberg" and "in Rom" are in a larger script, similar to the RW? hand. The rest of the inscription is in a rather smaller and neater script. Perhaps, given the seemingly early date of the inscription, this is a youthful version of the looser hand that signed with the full surname on the Leclerc drawing. I have been unable to locate a likely person for the name of Leichtman mentioned here.

The RW? hand often attributes drawings from the eighteenth and nineteenth centuries in the Crocker collection, among them the Georg Melchior Kraus in this exhibition,[56] as well as a scene of Tivoli's waterfalls by Johann Philipp Veith[57] and a Johann Friedrich Ludwig Oeser drawing after Rubens.[58] Heinrich Leutemann and Albert Emil Kirchner, two much younger artists, show the collector's attention to his contemporaries.[59]

FIG. 29
Johann Caspar Schinz, Cleric and traveller in hills above Florence, n. d. Graphite on beige wove paper, 15.2 × 16.4 cm. Crocker Art Museum, E. B. Crocker Collection 1871.1188 verso

Besides J. A. Börner, RW? received three gifts from Bernhard Keller (1789–1870), all early Swiss designs for stained glass, by Hieronymus Lang, Werner Kübler, and Gotthard Ringgli (fig. 28).[60] This is appropriate, given that Keller was based mostly in Schaffhausen. From a family of businessmen and collectors, he devoted himself exclusively to his collection, which was largely focused on prints, late in his life. A final notable gift, a drawing of a Tuscan scene by Johann Kaspar Schinz, is from Wolf Heinrich Graf von Baudissin (1789–1878; fig. 29).[61] From a Danish family, he studied law in Kiel and served as a diplomat for the Danish court before settling in Dresden in 1827. In addition to collecting, he was a prolific author and translator, especially of theatrical works.

The foregoing information allows a series of tentative conclusions. In relation to collectors' marks, the absence of any but German-speaking collectors for later German drawings is telling. The eighteenth- and early nineteenth-century collectors are widespread geographically, including sources in Basel and Vienna as well as Dresden. Artists' and collectors' inscriptions add Weimar and Hamburg (and possibly even London) to the mix. A large proportion of marked drawings were sold in Leipzig, whether by Boerner or by Weigel, even when the collector resided elsewhere, though these collectors may of course have exchanged or sold drawings before their deaths while living in Bavaria or closer to Leipzig. Inscriptions prove that German collectors interacted closely, even exchanging drawings as presents.

The proposal of the RW? hand as Rudolph Weigel would show direct friendships between Leipzig and Nuremberg, Schaffhausen, and Dresden collectors. This points to an extremely lively personal exchange of information and objects across German-speaking lands, paralleling the more official exchanges in publications and the market.

The identification of the RW? hand as Rudolph Weigel has implications specifically for the Crocker collection as well. The number of German drawings at the Museum bearing this hand extends the already significant number of Rudolph Weigel provenances in the collection known from his *Kunstlager-Katalog*. Sources from other dealers active in Germany during the period 1869–71 are difficult to prove. None of the drawings appears in the 1869 death sale of J. A. G. Weigel by his son Theodor Oswald. None appears in the death sales of Rudolph Weigel himself in 1868 and continuing until 1871.[62] And none has a proven connection to the firm of Carl Gustav Boerner after the Campe sale in 1827 or before its absorption of the Weigel firm in 1871, but as it functioned mainly as a dealership not an auction house records would not have been published. Though such a proposal must be taken with caution, the nature of the RW? inscriptions points to the possibility that at least the German eighteenth- and nineteenth-century drawings, or a large number of them, belonged to Rudolph Weigel personally, and that drawings sometimes moved from the business stock to his personal collection.

Notes

1 Letter from Rat der Stadt Dresden to Richard Vincent West, 1980; Crocker curatorial files.

2 Mrs. Crocker is known to have traveled to Europe in 1881, after E. B.'s death in 1876, and other trips may have taken place before her definitive departure from Sacramento in 1891.

3 These appear in the 1924 collection inventory, Crocker curatorial files, but not afterwards.

4 In Stanford University Special Collections, M 1010, RG4, Flat Box 56, and the Huntington correspondence at Syracuse University, microfilmed as Collis Huntington Papers 1856–1901, respectively; see this author, "E. B. Crocker, His Family, and the Museum's Early Years," in Scott Shields et al., *The Crocker Art Museum Unveiled*, Sacramento, 2010, p. XXIII and note 10.

5 See Breazeale 2008, pp. 207–08, and Breazeale 2010, p. 11, for my reasoning on this point.

6 Though previous scholars have limited their inquiries to present-day Germany and Austria for practical reasons, this essay—and the exhibition—seeks to preserve eighteenth- and early nineteenth-century definitions of the German cultural area, best defined by language use.

7 Weigel 1838–66, no. 5776b, the most likely source, lists 471 in his estate.

8 1871.3, 1871.7, 1871.1, 1871.11 and 1871.9 respectively.

9 1871.95.

10 Annotated copies of auction catalogues in the Philadelphia Museum of Art Library; see John Ittmann, *The Enchanted World of German Romantic Prints 1770–1850*, exh. cat. Philadelphia, 2017, pp. 14–16, and Ann Percy and Mimi Cazort, *Italian Master Drawings at the Philadelphia Museum of Art*, Philadelphia, 2004, p. 35.

11 Inscriptions; see Kaufmann 1989, nos. 9, 38, 49, 97.

12 Exhibition catalogues Washington, 1982, and Princeton, 1989, respectively.

13 Breazeale 2008, p. 208.

14 Ibid., p. 210; Breazeale 2010, p. 11, discusses other traditions once held regarding Weigel and the collection.

15 These include the large series by Merz and Schweickhardt; see Breazeale 2008, p. 223.

16 Leipzig, 1836.

17 Leipzig.

18 *Catalog einer Sammlung von Original-Handzeichnungen ... gegründet und hinterlassen von J. A. G. Weigel in Leipzig*, Leipzig, 1869.

19 *Suppléments au Peintre-Graveur de A. Bartsch*, Leipzig, 1843.

20 Leipzig, 1865.

21 Dieter Gleisberg, "'im Zusammenhang wird jedes Blatt instruktiv', Goethe als Kunstsammler in seinem Verhältnis zu Carl Gustav Boerner," in *Goethe, Boerner und Künstler ihrer Zeit*, exh. cat. Düsseldorf and tour, 1999, p. 20. This rich resource provided many of the biographical notes on Boerner as well.

22 In May 1871. In the meantime the house had been directed by Andreas Andresen and Gustav Hermann Vogel; see *Verzeichnis der Sammlungen des Börsenvereins der deutschen Buchhändler*, vol. II, Leipzig, 1897, pp. 601–02, quoted in Ittmann 2017, as in note 10 above, p. 30 n. 24.

23 1871.245.

24 1871.220.

25 1871.353.

26 Breazeale 2007.

27 1871.461–66.

28 Leipzig, September 24, 1827.

29 1871.130 (Moeyaert), 1871.150 (traditionally Pieter van Laer), 1871.1045, and 1871.127 and 1871.1058 respectively.

30 1871.130.

31 1871.330, by Catherine Loisel, visit of April 4, 2007.

32 1871.533.

33 1871.3.

34 1871.401.

35 1871.142, 1871.136, 1871.54.

36 1871.1288.

37 Lot 1946.

38 5 September and following days.

39 1871.100-02, 1871.125, 1871.129, 1871.132, 1871.140-41, 1871.154, 1871.168, 1871.184, 1871.191, 1871.194, 1871.197, 1871.530, 1871.547-48, 1871.572, 1871.575, 1871.578 (all Dutch), 1871.386-87 (Italian).

40 1871.13.

41 1871.29.

42 1871.952.

43 1871.1042.

44 *Goethe's Kunstsammlungen*, 3 vols., Jena, 1848–49.

45 *Lukas Cranach der Aelteren Leben und Werke*, 2 vols., Leipzig, 1851.

46 As pointed out by Derek Dreher in 1996; see Kaufmann 2004, p. 295.

47 1871.76.

48 1871.136.

49 1871.93.

50 1871.199; *Zeichnung / von J. Gg. v: Bemmel.*

51 1871.1037; *Veste Hohen Salzburg. / Zeichnung von Philippe Le Clerc / bayr: Hofmaler.*

52 1871.1055; *Hermann und Dorothea am Brunnen. / Erfindung und Zeichnung von Jacob Gauermann, / Maler u: Kupferätzer / D. gegnung[?] Zchng: diente als Vorlage zu dem Stiche / des Professors C. Rahl.*

53 1871.36.

54 1871.1020, Lugt 270; *J C Erhard / Geschenk fr. Börners / 1847.*

55 1871.531.

56 1871.1068.

57 1871.1284.

58 1871.1061.

59 1871.1043, 1871.1047.

60 1871.508, 1871.509, 1871.12 respectively.

61 1871.1188.

62 March 2 and June 29, 1868; April 4 and July 14, 1870; and March 27, 1871; all Leipzig, Weigel (at the time directed by Andresen).

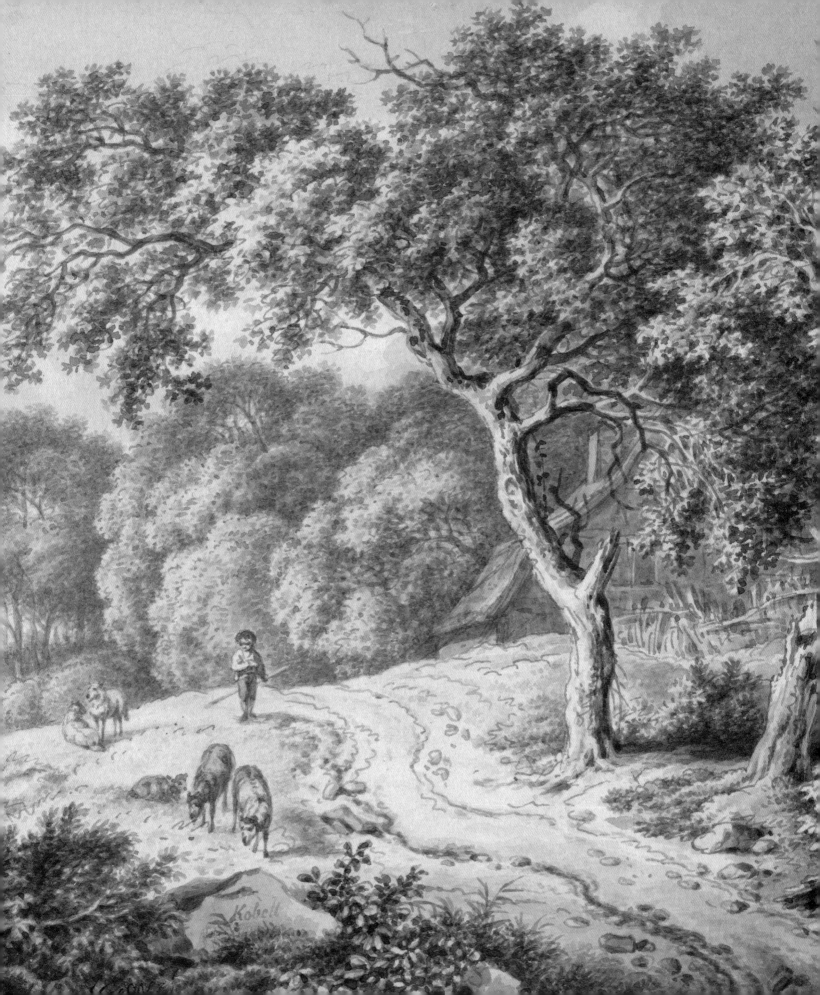

CATALOGUE

German Visions

I *Saint Martin Appealing to the Virgin*, 1715

Pen and dark brown ink, brush and brown and grayish-brown washes and blue, pink, brownish-red,
magenta watercolor, white pinkish, red opaque watercolor, over black chalk, 34.2 × 30.2 cm
Crocker Art Museum, E. B. Crocker Collection 1871.60

Inscriptions: brown ink, lower left corner, signed: *Joh. Georg Berckhmiller fecit Año* 1715; brown ink,
center right, on shield: *QUIS UT DEUS*

Marks: center bottom margin: Lugt 2237 (Rolas du Rosey)

Johann Georg Bergmüller's surviving drawings are nearly
all compositional, whether through accident or because
his confident skill allowed him to skip later studies. This
example is preparatory to the altarpiece of the parish church
of Tannheim, located in southern Württemberg between
Ulm and Lake Constance. Signed and dated 1715, it represents
the artist's early maturity at the moment he frees himself
from the style of his master, the Munich court artist Johann
Andreas Wolff.

Frescoist, printmaker, publisher, art academy director,
and art theorist as well as painter of altarpieces, Bergmüller
dominated the art world in eighteenth-century Augsburg
until his death in 1762. Born in 1688 in Türkheim, the seat of
a cadet branch of the house of Wittelsbach, he attracted the
attention of Duke Maximilian Philipp, who between 1702
and 1707 sponsored his apprenticeship to Wolff. The young
artist then spent time in Düsseldorf, at the time also ruled
by the Wittelsbachs, and in 1711 went to the Netherlands
for study, again sponsored by the Duke. Upon his return to
southern Germany he left behind Wittelsbach patronage
and artists, preferring to settle in the Free Imperial City
of Augsburg, perhaps because of reduced competition as
compared to elsewhere. In any case, his quick acceptance

into the artists' guild in 1713 is unusual.[1] He married that
same year. By 1722 Bergmüller was the guild's leader, and
by 1730 the Catholic director of the Augsburg art Academy,
in a city where public offices were often duplicated for the
Catholic and Protestant communities. In 1739 he was made
court painter to the Prince-Bishop of Augsburg, whose
territory surrounded the city proper, and continued in his
role as a leading artist until his death from a stroke in 1762.
Of Bergmüller's many pupils, he had the closest relationship
with Johann Evangelist Holzer, also represented in this
exhibition.

Though Bergmüller's art shows the influence of Italy,
there is no evidence for a trip there mentioned by his early
biographer Felix Anton Oefele.[2] Rather, as Alois Epple
and Josef Strasser have convincingly argued, the artist's
experience of Italian painters in Munich collections and
churches, his knowledge of Wolff's print collection, and
especially his knowledge of the Roman Baroque through
prints, supplied him with Italian prototypes and ideas—
his drawing of the Death of the Virgin reverses a figure
from a print after Maratta.[3] Where he learned the technique
of fresco, a medium in which none of his early contacts was
proficient, must remain a mystery, however.

PROVENANCE

Carl Fürst zu Schwarzenberg, by 1820; his
sale, Leipzig, Weigel, November 8 (catalogue
date October 25), 1826, no. 3018. Carl Freiherr
von Rolas du Rosey, by 1862; his sale, Leipzig,
Weigel, September 5, 1864, no. 5072. Edwin
Bryant Crocker, by 1871; gift of his widow
Margaret to the Museum, 1885

LITERATURE

Alois Epple and Josef Strasser, *Johann Georg
Bergmüller, die Gemälde*, Lindenberg im Allgäu,
2012, under no. G33; Breazeale 2010, no. 46;
Breazeale 2008a, p. 211; Josef Strasser, *Johann
Georg Bergmüller 1688–1762, die Zeichnungen*,
exh. cat. Salzburg and Munich, 2004, no. Z9;
Kaufmann 2004, p. 96; Günter Hütter and
Alois Epple, *300 Jahre Pfarrkirche St. Martin
Tannheim, Festschrift zum Jubiläum im Jahre
2002*, Tannheim, 2002, p. 73; *Meister der
Zeichnung*, exh. cat. Nuremberg, 1992, under
no. 85; Alois Epple, "Das Hochaltarbild in der

Pfarrkirche in Tannheim," *Der Spiegelschwab*,
no. 3, 1990; Kaufmann 1989, no. 8; Howard et
al. 1983, no. 35; Steadman and Osborne 1976, no.
7; Kent Sobotik, *Central Europe 1600–1800*, exh.
cat. Sarasota, 1972, no. 61; Crocker 1971, p. 161;
Crocker 1959, no. 2; *Age of Elegance: The Rococo
and its Effects*, exh. cat. Baltimore, 1959, no.
260; Lawrence 1956, no. 6; Crocker 1939, no.
46; Rosey sale, Leipzig, Weigel, September 5,
1864, no. 5072; Schwarzenberg sale, Leipzig,
Weigel, November 8 (catalogue date October
25), 1826, no. 3018

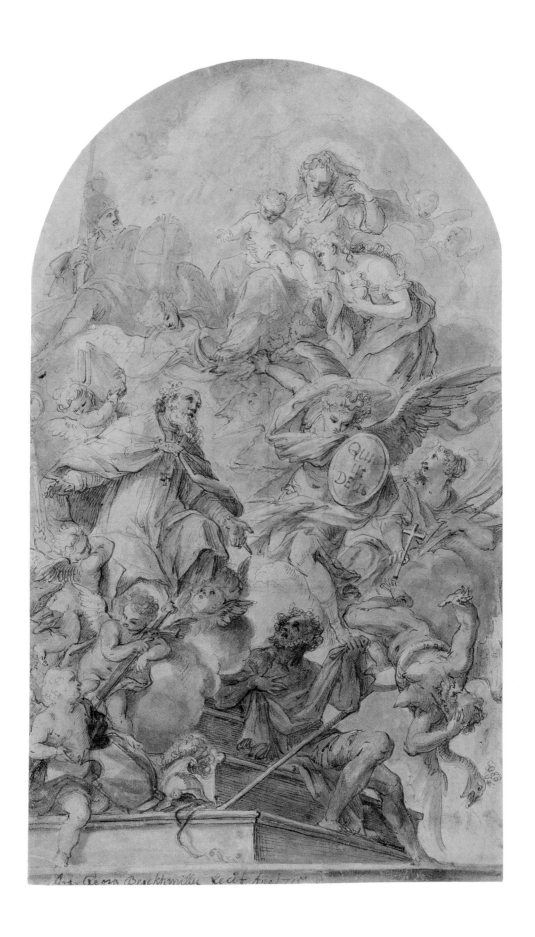

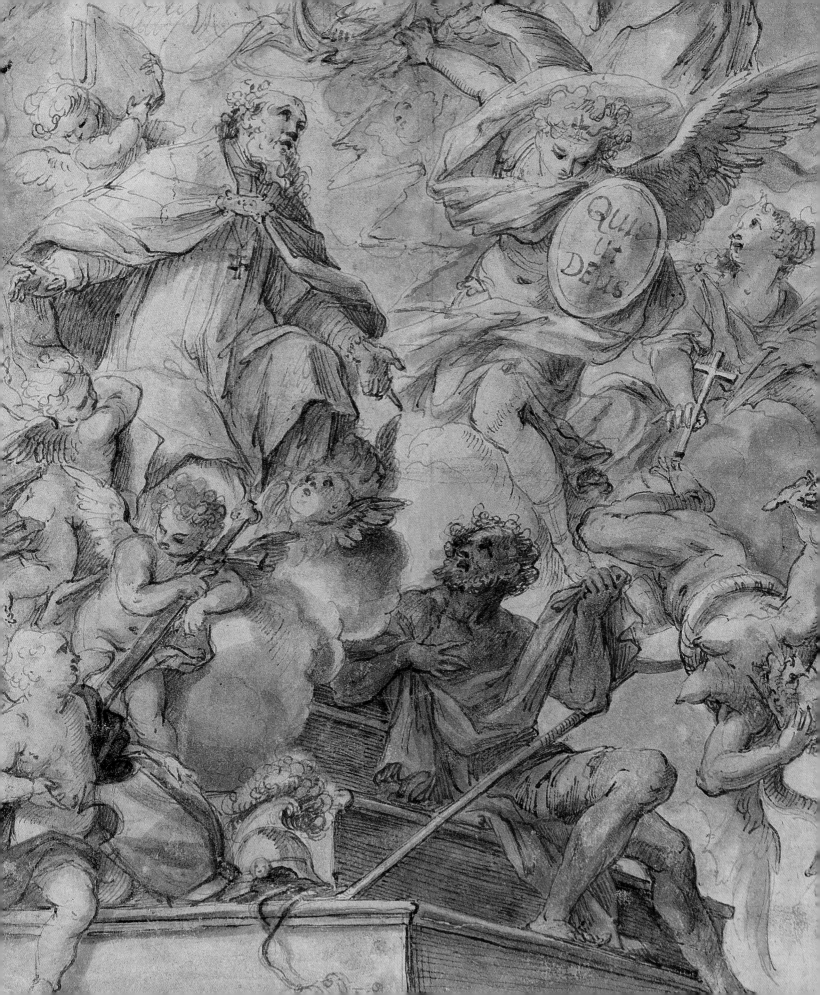

In his compositions one finds nothing bold or turbulent, except when called for by the subject, but rather everything is depicted pleasingly and agreeably, according to its nature (*In seinen Inventionen wird man nichts verwegenes oder furioses (ausser es brachte die Materie mit sich) finden, sondern alles angenehm und leutseelig vorgestellt, seinem Naturel gemäß*).[4]

In the Crocker drawing, Bergmüller has achieved the essence of his early biographer Georg Christoph Kilian's words, creating a gracefully legible composition. When he began the *Saint Martin Appealing to the Virgin*, Bergmüller was engaged on a major commission, the altarpiece of *The Assumption of the Virgin* for the church in Kirchhaslach.[5] In the 1714 watercolor for this altarpiece, preserved in Frankfurt,[6] the artist created a harmonious composition similarly based on strong diagonals. There, however, the composition is less successful because of the repetition of the witnessing figures' heads lining the v-shaped span of empty air required by the subject.

The Crocker drawing, created a year later and likely during the production of the Assumption altarpiece, is more ambitious. Here Bergmüller integrates the main story, the intercession with the Virgin by Saint Martin, the Tannheim church's patron, with symbols related to his life (the sword and the beggar with his cloak) and many saints. Michael casts out a demon at right, Mary Magdalen kisses the foot of the Christ Child, and Saints George and Catherine (?) adore the Mother and Child. The presence of Saint George is likely due to his patronage of the abbey of Ochsenhausen, which owned the parish church of Tannheim.[7]

It seems that at this transitional moment Bergmüller was developing motifs which would inform his visual language throughout his career. The figure type of the beggar holding Saint Martin's cloak compares well with the figures surrounding the tomb in the Frankfurt drawing of a year before, especially the elder at left leaning on the tomb. Likewise, he nearly repeats the head of Mary in his *Saint Luke Painting the Virgin and Child* of 1717 for the church in Tannhausen. The dramatic lightning bolt, in the Crocker drawing a useful compositional device, reappears with different effect a decade later in *The Glorification of the Catholic Church* in Donauwörth and *The Vision of Saint Benedict* in Obersulmetingen.[8]

In any case, the Crocker drawing represents not only a stylistic turning point, but also a turning point in Bergmüller's renown as an artist. Bruno Bushart's analysis of his commissions finds that the Tannheim altarpiece was exceptional both for its large size and for its cost of 500 florins, so that by 1715, only two years after settling in Augsburg, Bergmüller commanded top prices for his work.[9] In the event, the painting was executed with some changes, as with the *Assumption of the Virgin* based on the Frankfurt drawing of a year before. The putto at left now holds a goose, since in the life of Saint Martin a goose revealed his hiding-place when the people of Tours sought to make him their bishop. Other putti change poses slightly, as do the beggar and Saint Martin. The flames of Hell now burn behind an anvil-like stone and, rather incredibly, Saint Michael's lightning-bolt now spells out his motto *Quis ut Deus* in mid-air. Later restoration in addition to the patron's wishes may have led to some other changes, the sum of which notably detract from the quality of the painting in relation to the drawing.[10] WB

2 *The Adoration of the Shepherds*, circa 1732

Pen and brown ink, brush and gray washes over black chalk, incised, verso rubbed with charcoal, 15.3 × 10.8 cm
Crocker Art Museum, E. B. Crocker Collection 1871.65

Unusual in draughtsmanship among Holzer's surviving works, this *Adoration* focuses on the interplay of extremes of light and dark in a night scene, a type sporadically popular from the late fifteenth century onwards. Holzer's print made after this drawing belongs to a small group, including the pendant *Adoration of the Magi*, that likewise contrasts with the more fluid, decorative style found in most of his prints.

"Young, poor, and obscure, but of good cheer in spite of his ragged clothes" (*Jung und arm, unbeachtet, doch frohen Sinnes trotz seiner zerschlissenen Kleider*). Thus his early biographer Andreas-Felix Oefele described Holzer, later known as one of Augsburg's greatest artists, upon his arrival in the city in 1730. Originally from the village of Burgeis (now Burgusio) in the Tyrol, he was born in 1709 to a miller. Educated at the nearby abbey of Marienberg, he learned Latin and French and,[1] soon after, began to make drawings that copied engravings after Rubens.[2] His first master, Nicolas Auer, who worked in Passau, had studied with Johann Georg Bergmüller. After five years with him, Holzer moved to the workshop of Joseph Anton Merz in Straubing, near Munich, in 1729. The following year saw his arrival in Augsburg to work with Bergmüller himself. Having just become the Catholic director of the city's painting Academy, Bergmüller was at the height of his powers, with a large workshop that soon included artists such as the frescoist and engraver Gottfried Bernhard Göz, later famous for his color prints. Holzer lodged with Johann Georg Rothbletz until, interrupting his study of art, he returned to Marienberg seeking to join the monastery. Rejected by them, he was back in Augsburg in 1732 working as a painter and printmaker,

living in Bergmüller's house "not so much as a pupil, but rather more as a companion" (*nicht sowohl als Scholar, sondern vielmehr als Compagnon*) as his biographer Georg Christoph Kilian said, the word *Compagnon* implying as much a professional relationship as a personal one.[3] These were certainly intertwined as, in addition to collaborating with Holzer on projects, Bergmüller wanted him to marry his daughter. The objections of Bergmüller's wife led to the two artists parting ways in 1738.[4] In January 1740 Holzer became an Augsburg citizen, allowing him to own property and exercise his art without restriction. Called soon after to decorate the chapel for the hunting lodge at the estate of the Archbishop-Elector of Cologne, Clemens August von Wittelsbach, Holzer fell ill shortly after his arrival, dying of typhus on July 21. Mourning a life cut short, Bergmüller completed his friend's last altarpiece, begun for the abbey of Münsterschwarzach.

In contrast to the night scene under discussion, a second drawing by Holzer, an *Adoration of the Shepherds* also in the Crocker collection (1871.64), typifies his handling, in full Augsburg Rococo, of drawings for his many series of religious prints. There his line is bolder and more confident, the sure contours of the folded drapery matched by those of the whorled and arching framing elements. The figure of the Christ Child, however, is a firm stylistic connection between the drawings. With lighter strokes of the pen, the artist provides the essential forms. Here, as in the night scene, the Child is one of the sources of light, which explains the flickering touch.

PROVENANCE

Carl Freiherr von Rolas du Rosey, by 1862; his sale, Leipzig, Weigel, September 5, 1864, no. 5277. Edwin Bryant Crocker, by 1871; gift of his widow Margaret to the Museum, 1885

LITERATURE

Emanuel Braun et al., *Johann Evangelist Holzer, Maler des Lichts*, exh. cat. Augsburg, 2010, pp. 103–04, 153, p. 298 under cat. no. 52; Ruda 1992, no. 77; Kaufmann 1989, no. 33; Ernst Wolfgang Mick, *Johann Evangelist Holzer 1709–1740, ein frühvollendetes Malergenie*, Munich, 1984, pp. 26, 99, under no. 20; Reno 1978, no. 6; Crocker 1971, no. 83, p. 33 and 153; Ernst Wolfgang

Mick, "Johannes Holzer 1709–1740, Beiträge zur Monografie unter besonderer Rücksicht auf iconographische Fragen," in *Cultura Atesina, Kultur des Etschlandes*, vol. XII, nos. 1-4, 1958, pp. 92-93 [31–118; vol. XIII, 1959, pp. 16-54]; Crocker 1939, no. 51; Rosey sale, Leipzig, Weigel, September 5, 1864, no. 5277

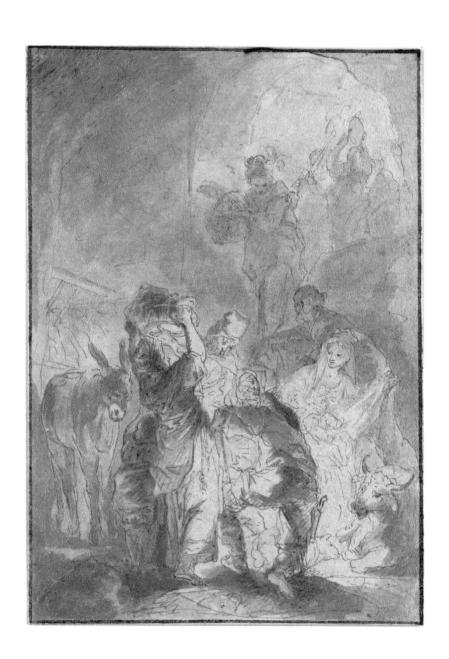

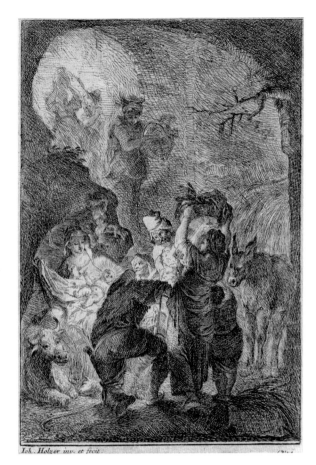

The night *Adoration* at the Crocker is created almost
exclusively with the same wiry, almost nervous line. The
verso rubbed with charcoal and the lines of the recto incised
with a stylus, it is certainly the drawing used to transfer the
design to the plate for Holzer's etching (fig. 30),[5] since the
dimensions of drawing and print are exactly the same. In the
print, the presence of three female figures bearing baskets
and vases, as well as a further two women and a child,[6]
adds a pleasing variety to the composition, for example
motivating the light source at upper left and providing
a strong diagonal, but diverges from both Scripture
and artistic tradition. The areas of gray wash, present in
five different dilutions, are rendered in the print with a
technique that recalls the etchings of Giovanni Benedetto
Castiglione, especially his night scenes such as the *Raising of
Lazarus* and *Tobit Burying the Dead*.[7]

Many discussions of the drawing and print, however,
point to Rembrandt instead, largely on the basis of a mention
in Kilian's biography.[8] Ernst Wolfgang Mick in 1958
considered Rembrandt the source for Holzer's technique,
and Rubens for his composition,[9] while Ernst Neustätter
discussed the print in relation to Rembrandt's use of light in
1933. Although Neustätter's thesis was challenged by Lorenz
Dittmann in the catalogue to the Augsburg exhibition in
2010,[10] Josef Strasser, in the same catalogue as Dittmann,
follows Kilian, finding Holzer's night *Adoration* one of the
earliest examples of the Rembrandt revival in eighteenth-
century German printmaking.[11] Strasser also finds a painted
version[12] to be evidence of the composition's popularity, in
addition to the fact that Goethe is known to have owned
both this *Adoration* print and its companion, an *Adoration
of the Magi*.[13] By seeking parallels for Holzer's use of light
in Rembrandt's oeuvre, notably his night *Nativity* painting
now in Munich, most authors lead themselves into the error
of supposing the Christ Child to be Holzer's only source of
light[14]—true for Rembrandt's painting but not for Holzer,
as the arched passageway above is lit and the kneeling
foreground figure holds a candle quite clearly in both
drawing and etching.

Rembrandt's printed oeuvre has few direct parallels to
Holzer's own print. Night subjects tend to become *tours de
force* of etching and drypoint to represent a rich darkness
from which shadowy, incomplete forms emerge. Likewise,
the figures, even in religious works, tend to be represented
as naturalistically as possible. Both characteristics are present
in Rembrandt's 1652 night *Adoration of the Shepherds*, for
example. In Holzer's *Adoration*, the more open technique,
the multiple light sources that provide a different effect,
and the rather Italian dress of the figures, especially the
mysterious attendants, reflect a wider range of sources than
Kilian perceived. Dittmann pointed to Italian painting,[15] but
the work of Italian printmakers was more readily available
to Holzer in Augsburg, a center of print publishing with
strong connections to northern Italy.

Though a date of 1733 has been generally accepted for
the drawing, Strasser is more careful in dating it "around
1732," soon after Holzer's return to Bergmüller.[16] A drawing
related to the *Adoration of the Shepherds*' pendant print, the
Adoration of the Magi, was in the Anton Schmid collection
in 1984.[17] WB

3 *Lazarus and the Rich Man*, n. d.

Pen and dark-brown and gray ink, brush and point of brush and grayish washes and white opaque
watercolor on blue laid paper, incised, verso rubbed with red chalk, 18.1 × 29.4 cm
Crocker Art Museum, E. B. Crocker Collection 1871.77
Inscriptions: verso, graphite, lower left: [graphite circle and stroke]

Like his contemporary Johann Evangelist Holzer, Johann Wolfgang Baumgartner worked as a designer of prints during the full flowering of the Augsburg Rococo. In this design for *Lazarus and the Rich Man*, Baumgartner turns the architecture itself into a mass of decorative curves and ornaments.

The son of a blacksmith, Baumgartner was born in 1702 in the village of Ebbs, near Kufstein in the Tyrol.[1] First trained to follow his father's trade, he was then apprenticed to a Salzburg musician who also worked as a *Hinterglasmaler*, a painter of scenes on the reverse of glass panels. Completion of his apprenticeship was marked by a journey through many of the lands ruled by the Hapsburgs, including Styria, Bohemia, and Hungary. It is generally accepted that he traveled to Italy as well, but documentary evidence is scant. By 1730, the date of his father's death, Baumgartner had returned to Ebbs. His inheritance must have allowed him a certain freedom, as the next year he moved to Augsburg and married. During the 1730s he developed a relationship with the Augsburg Kunstakademie, whose Catholic director from 1730 had been Johann Georg Bergmüller. Only in 1733 did he receive permission to work in the city, and his situation remained somewhat irregular. He could only work as a *Hinterglasmaler*—of which he was likely the only one in the city—and as a designer for prints, of which there were many. In 1746 Baumgartner received his Bürgerrecht, or citizenship, and soon after was admitted into the painter's guild. By this time he had absorbed much of the Rococo style, which became more and more evident in his works. His more than 300 print designs for 1754's *Tägliche Erbauung eines wahren Christen* (Daily devotions of a true Christian) represents his most involved print project, though he also created large series of independent religious prints, as well as *Thesenblätter*, allegorical prints celebrating the conferral of an academic degree. His first independent oil paintings date from about the same time as the *Tägliche Erbauung*.

Though not confirmed by documents, Baumgartner likely learned the art of fresco painting from Bergmüller. In the later part of his career he was continuously occupied by major fresco commissions, beginning with those of 1754 for the church of St. Jakob in Gersthofen, now destroyed. Two years later, he frescoed the church of the Heilige Kreuz at Bergen bei Neuberg an der Donau, then in 1758 the Loretokirche in Augsburg. In 1760, he copied a fresco by his friend Johann Evangelist Holzer for Cardinal Franz Konrad von Rodt's Schloß Meersburg, and frescoed the Wallfahrtskirche in Baitenhausen, considered his best work. He received the prestigious commission for the church of the Vierzehnheiligen near Bamberg in 1759, but the nave was vaulted only in 1764, three years after Baumgartner's death.

Baumgartner's drawing recounts the parable of Lazarus and the Rich Man (Luke 16:19-31), in which the beggar Lazarus witnessed a banquet and hungered for the crumbs off the table. Upon his death he was carried by angels to Abraham, while the rich man, who died also, was taken to Hell's torments. The rich man asked Abraham to send Lazarus to bring him drink to relieve his suffering, and was refused with the words "the chasm between Heaven and Hell cannot be crossed."

Lazarus is shown outside the rich man's banqueting hall, which takes the form of an open loggia with statues and columns. Behind Lazarus is a display of plate of the type well known in Southern Germany in the eighteenth

PROVENANCE

Edwin Bryant Crocker, by 1871; gift of his widow Margaret to the Museum, 1885

LITERATURE

Breazeale 2010, no. 47; Kaufmann 2004, pp. 91-92; Steadman and Osbourne 1976, no. 67; Crocker 1971, no. 87; Schulz 1968, no. 26; Scheyer 1949, no. 144; Crocker 1939, no. 64

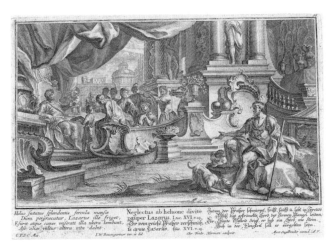

FIG. 31
Christian Hörmann after Johann Wolfgang
Baumgartner, published by Martin Engelbrecht,
Lazarus and the Rich Man, circa 1743. Engraving,
approximately 19.8 × 31.0 cm. Staatsgalerie
Stuttgart, inv. no. B 154,I,100

century, with a shelf of silver jugs before an array of salvers
stretching up the wall. In a touch of exoticism, the rich man
and some of his guests sport turbans. Servants approach
the table with trays and jugs so that the company may
begin its meal. Lazarus, seated on a rough boulder outside,
is accompanied by dogs who lick his sores, in accordance
with the Scripture passage. The architecture of the rich
man's palace is elaborately Rococo. The shell-like, irregular
forms and swooping curves recall those of Baumgartner's
illusionistic frescoes as well as his *Thesenblätter* and large
religious sheets.[2]

First known as a work by Januarius Zick, the drawing,
rouged for transfer and incised, is preparatory to an undated
print in the opposite sense designed by Baumgartner,
etched by Christian Hörman, and published by Martin
Engelbrecht, as noted by Heinrich Geissler in 1976 (fig. 31).[3]
Bruno Bushart and Thomas Le Claire later independently
confirmed the attribution to Baumgartner.[4] The dimensions
of the scene in the print coincide with those of the drawing,
and only a very few minor changes are evident: the drape
below the silver jugs falls straight rather than being caught
on a pedestal as in the drawing; the windows in the distant
square palazzo are staggered, not above each other; and
the number of cypresses next to the distant rotunda has
changed from four to five. The inscription emphasizes the
rich man's hard-heartedness, saying that even the dog has
mercy on Lazarus, and foreshadows the reversal of fortune.
Among Engelbrecht's series, the format of this inscription is
identical to that of his *Engelbrechtsche Bibelfolge* of circa 1743,
as is the size, indicating that the Crocker drawing may be
one of Baumgartner's more than fifty designs for the series.
Unlike other artists who contributed designs to the *Bibelfolge,*
Baumgartner never learned to etch or engrave, hence
Christian Hörman's involvement; in fact, many of
his print designs were, unusually, in oils.

Until it is confirmed that Hörman's print after
Baumgartner is part of the *Engelbrechtsche Bibelfolge*, the
proposed date of circa 1741-43 must remain conjectural.
The style, however, is consistent with Baumgartner's other
work of the early 1740s, the period in which he developed
the Rococo style that he later used to such great effect in his
frescoes. WB

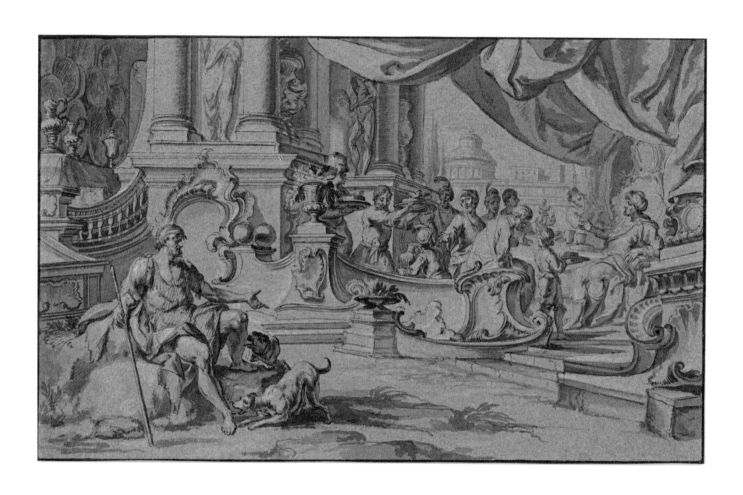

ANTON RAPHAEL MENGS

4 *The Death of Dido*, n. d.

Pen and brown and dark brown inks, brush and brown washes over black chalk on cream laid paper, 47.0 × 39.0 cm
Crocker Art Museum, E. B. Crocker Collection 1871.75
Inscriptions: brown ink, lower right on sheath: -*RM ft*; brown ink, lower right corner: *Raphael Mengs fecit*; verso, graphite,
center of mount: *No 65-*; verso, graphite, below center of mount: *E da*; verso, black ink, below center of mount: -*ca*

"There has never been a painter in all the world more sought after by rulers than Mengs; it seemed that they could not talk to him without losing their hearts to him, and conferring commissions" (*Non v'è mai stato al mondo un Pittore più del Mengs ricercato dai Sovrani, e parea che non potessero parlargli senza innamorarsene, e senza dargli commissioni*).[1] Though the author of this drawing, Anton Raphael Mengs, was later one of Europe's most important Neoclassicists, the favored artist of cardinals and kings, at the time it was made he had barely begun his career.

Born in 1728 in Aussig, now Ústí nad Labem, in Bohemia, Mengs was first trained by his father Ismael, painter to the Saxon court, who trained his sisters Theresia Concordia and Juliane Charlotte to be miniature painters as well. In 1740, Ismael took Anton Raphael with him to Rome, where they remained four years, absorbing the lessons of ancient sculptors and Renaissance and Baroque painters. While there, the young artist attended life drawing sessions in the studio of Marco Benefial, a somewhat rebellious champion of the nature-based Classical tradition originating in the work of the Carracci family in Bologna. On his return to Dresden, the sixteen-year-old created a pastel portrait of Prince-Elector Friedrich August II and one in oils of Prince Friedrich Christian. The elector then sponsored a three-year trip for further work in Italy, where Mengs studied the art of Titian in Venice, Correggio in Parma, and the Carracci in Bologna, as well as spending more time in Rome. 1750 found him at work on three major altarpieces for the Hofkirche

in Dresden. This commission brought him the title of court painter and support for a third trip to Rome; though he drew his stipend until 1756, he never returned to the Saxon capital. In the Eternal City he found a welcoming artistic community, which made him a member of the Accademia di San Luca in 1752 and a founding professor, the only foreigner, at the Accademia del Nudo set up by Benedict XIV in 1754. The following year he met Johann Joachim Winckelmann, the archaeologist and art theorist of the Classical world. This proved decisive to his later career, in which he devoted himself to a Neoclassical painting style based in the ancients. With the cessation of payments from Dresden, Mengs had to support himself through the rest of the 1750s with portraiture and art dealing, though relieved by major commissions for the church of Sant'Eusebio and the Villa Albani al Gianicolo, and a trip to Naples to depict the royal family and visit ancient sites. In 1761 he was brought to Madrid, along with Giambattista Tiepolo, to fresco the Palacio Real. He remained there most of the decade, involving himself in the reform of the Academia de San Fernando and becoming *Primer pintor* to the Spanish court. Poor health sent him back to Italy in 1769, where he remained, except for a last effort on the Madrid frescoes in 1774–75, until his death in 1779. His lasting influence was assured not only by his paintings but also by his art-theoretical writings, such as his *Gedanken über die Schönheit und den Geschmak in der Malerey* of 1762, and his collections of exacting plaster casts of ancient sculptures, one of which

PROVENANCE

Edwin Bryant Crocker, by 1871; gift of his widow Margaret to the Museum, 1885

LITERATURE

Shields et al. 2010, p. 145; Breazeale et al. 2008, no. 50; Kaufmann 2004, pp. xxi, 131–33; Steffi Röttgen, *Anton Raphael Mengs, 1728–1779, das malerische und zeichnerische Werk*, Munich, 1999, vol. I, p. 461, no. Z109; Seymour Howard, *A Classical Frieze by Jacques-Louis David*, Sacramento, 1975, pp. 25–26; Andor Pigler,

Barockthemen, eine Auswahl von Verzeichnissen zur Ikonographie des 17. und 18. Jahrhunderts, 2nd ed., 3 vols., Budapest, 1974, vol. II, p. 317; Howard et al., 1972, no. 34; Crocker 1971, p. 156; Crocker 1959, no. 15; Scheyer 1949, no. 91; Crocker 1939, no. 62

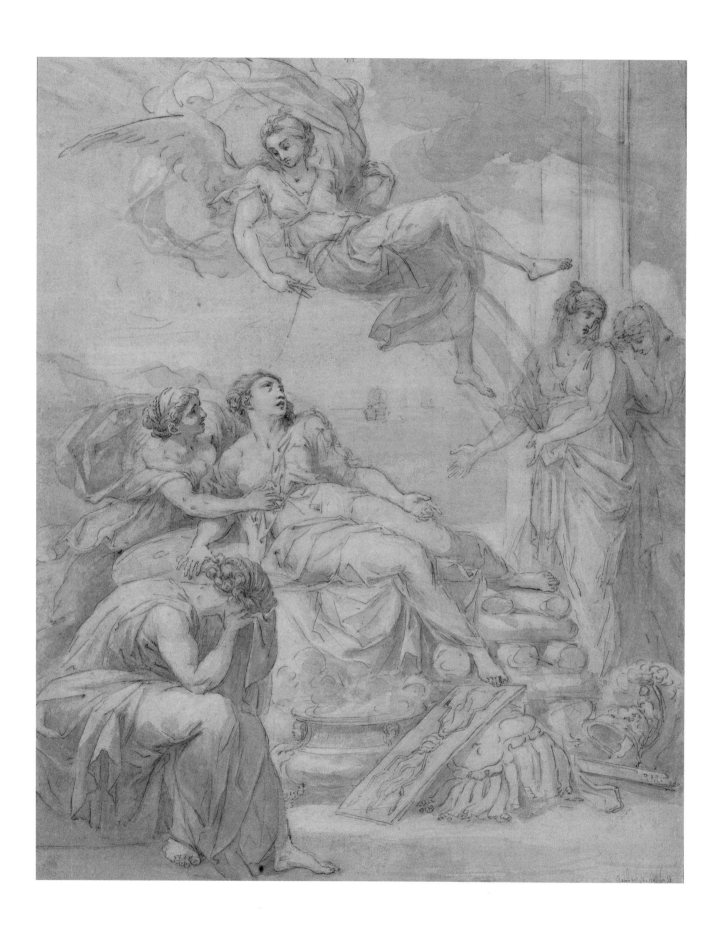

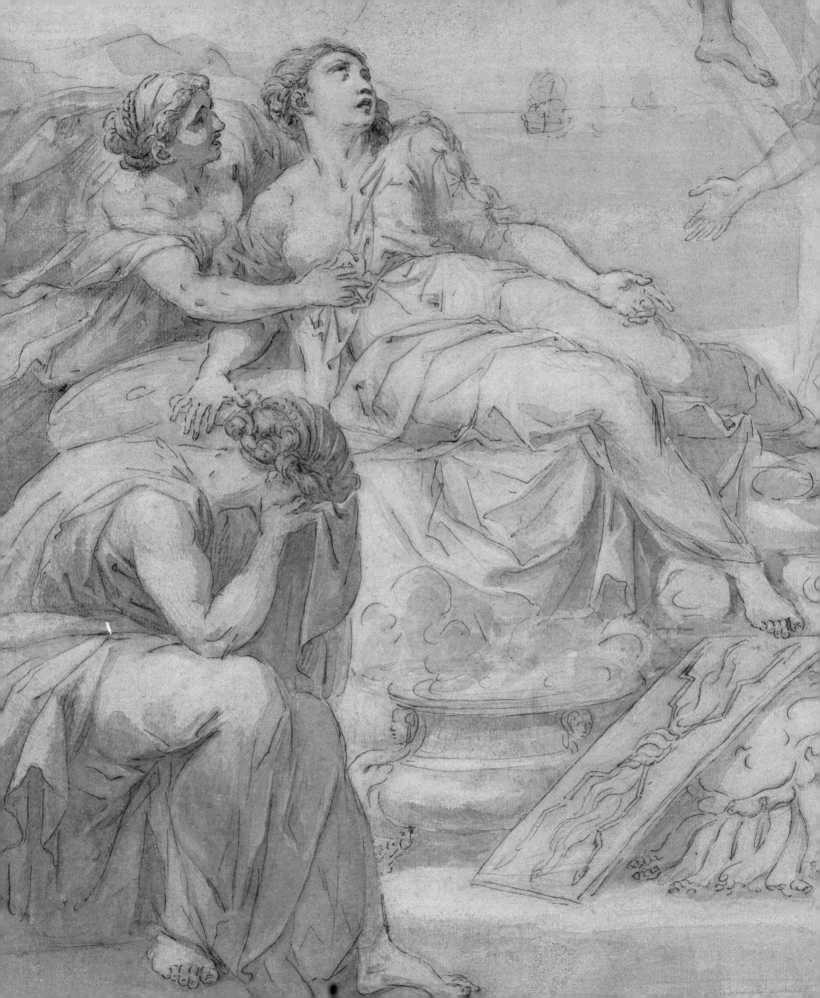

he gave to the Academia de San Fernando in 1776 and one of which was acquired for the Kunstakademie in Dresden after his death.

The Crocker drawing relates the episode of Dido's death from the *Aeneid*. Having fallen in love with the Trojan hero Aeneas who had come to Carthage, the city-state's queen, Dido, wanted to rule jointly with him. After a pleasant interlude, however, Aeneas was reminded of his duty and made secret plans to leave. Upon discovering this, Dido told her sister Anna to prepare a sacrifice so that she might burn all the effects Aeneas had left behind, by way of a cure for her heavy heart. But once the pyre was prepared, she cast herself upon it with a curse to Troy, and stabbed herself with the absent warrior's sword. Anna rushed in, stanching Dido's blood with her dress, but too late. Juno had sent her servant Iris to sever a lock of the Carthaginian queen's hair, at which her life ended.

Mengs includes the main elements and characters from Virgil's text, with the addition of mourning figures flanking the scene. Aeneas's departure is indicated by the stern of a ship on the horizon at center. Rather than the dramatic act of suicide, however, Mengs has chosen, unusually, to depict the aftermath. Dido has laid down the sword—her proper right hand rests on its hilt—and gazes upward in agony as Anna tries to stop the wound. The artist may depart from the text here, as it is not clear if Anna's cloth is her own dress.

He certainly innovates with the figure in the air, who wields a scissor. Though she has been identified as Atropos, the Fate who cuts each thread of life after it has been spun and measured by her sisters,[2] she rides gracefully on a rainbow, Iris's attribute. Rather than an entire lock, Iris severs a single long hair pulled up from Dido's head.

Mengs's drawing is created with light, active lines of black chalk underneath, as well as somewhat bolder hatching added later for shading in the two figures at left. The pen strokes refine several forms, such as the changed rim of the brazier at front and the foot of Iris. However, the artist relies most on the brush and wash for many contours, especially in the drapery, as if the short, nervous pen lines were added last. Using at least three shades of wash, Mengs occasionally works wet into wet as in the clouds at upper right.

Steffi Röttgen relates the artist's use of wash to a drawing in St. Petersburg of a subject with Athena and Apollo[3] and the elongated figures and nervous pen work to his 1740 copy of Carlo Maratta and Pietro Aquila's *Memorial to Raphael* now in the British Museum,[4] placing the Dido scene within the teenage artist's first Roman trip with his father, 1740–44. The work of a precociously talented artist, the monogrammed and signed drawing, unrelated to known surviving paintings or prints, may be a preparation for a subject from the *Aeneid* mentioned by early biographers, as Röttgen proposed in a letter of 1972.[5] WB

5 *A False Friend is Worse than an Open Enemy*, n. d.

Pen and brown and gray ink, brush and brown and gray washes and greenish, reddish,
bluish watercolor on cream laid paper, 30.7 × 23.8 cm
Crocker Art Museum, E. B. Crocker Collection 1871.2009

Inscriptions: dark brown ink, across lower margin: *Ein verstellter Freund is schädlicher
als ein offenbahren Feind.*; verso, graphite, lower right corner: *-w*

One of the most famous German artists who dealt with
animals, Johann Elias Ridinger created a series of prints in
1744, in which to illustrate his own fables similar to those
of La Fontaine or Aesop. This watercolor on the theme of
betrayal is related to the series.

Born in Ulm, southeast of Stuttgart, in 1698, Ridinger
first studied Latin, but felt the call to become a painter. At
the age of fourteen he was apprenticed to a minor painter
of altarpieces, Christoph Resch. Though resentful of the
restrictions in his practical training, he was well taught in art
theory, especially after discovering Joachim von Sandrart's
Teutsche Academie.[1] In 1716 he went to nearby Augsburg to
study under a more congenial master, the plant and animal
specialist Johann Flach, and showed a growing talent for
depicting animals. Three years later, he entered the service of
Wolf, Freiherr von Metternich, the Elector of Brandenburg's
representative at the Perpetual Diet in Regensburg. Ridinger
remained in Regensburg three years, incidentally profiting
from study of the horses at the city's riding-school.[2]

Returning to Augsburg in 1722, Ridinger learned etching
and engraving from Georg Philipp Rugendas the Elder,
professor at the Augsburg Academy. He married in 1723,
and soon founded what was to become a productive and
successful publishing house in the 1730s and 40s. In 1759 he
succeeded Gottfried Eichler the Elder as Protestant director
of the Augsburg Kunstakademie and held the post until his
death in 1767. His publishing firm was continued by his sons
Johann Jakob and Martin Elias. Three-quarters of all the
prints Ridinger made were of animals.[3]

The Crocker drawing is remarkably fresh and unfaded. In
addition to the brilliant shades of watercolor there are touches
of white opaque watercolor on the owl's wings, the back
of the partridge, and the muzzle of the lower fox. In their
biography of the elder Ridinger, the artist's sons praise his
great ability to convey expression in animals while depicting
their anatomy accurately, an ability certainly in evidence
here.[4] The story comes from Fable III of Ridinger's *Lehrreiche
Fabeln aus dem Reiche der Thiere.*[5] A partridge, wounded in
its wing, was pursued by foxes and a cat. Since the owl had
made friendly overtures in the past, the partridge placed itself
under its protection, only to be trapped in its powerful claws.
Soon to be devoured, the bird laments its fate at the hands of
such an untrustworthy friend.

Given the relationship to Ridinger's print of 1744, the
Crocker drawing should be dated just before or soon after.
The differences between the two are minor, having to do with
the foreground foliage—spikier in the print—and the shape
of the rock at the lower left corner, and point to Ridinger's
authorship. If a design for the print, it is very close to the
moment of etching and engraving, and colored designs were
sometimes used for prints. The high finish has led to the
suggestion that it might have been intended for sale.[6] In favor
of this are the use of color and the fact that the composition
is in the same sense as the print. The absence of a signature
would be unusual for a drawing intended for sale, however,
though perhaps Ridinger created the watercolor as a fully
worked-up *ricordo* of a favored composition.

A watercolor of identical facture and with a similar
inscription, illustrating Ridinger's Fable VII ("*Die Rache einer
niedrigen an einem mächtigern is schädlich*": the revenge of an
underling on an overlord is harmful) was offered for sale at
Sotheby's in London, November 2, 2017, lot 186. WB

PROVENANCE

Johann Stiglmeier or Friedrich Niesar, by 1856;
their sale, Leipzig, Weigel, October 6, 1856, no.
1946. Edwin Bryant Crocker, by 1871; gift of his
widow Margaret to the Museum, 1885

LITERATURE

Kaufmann 2004, p. 149; sale, Leipzig,
Weigel, October 6, 1856, no. 1946 (as Nach
J. E. Ridinger)

Ein verstellter Freund ist schädlicher als ein offenbahrer Feind.

JOHANN PETER MOLITOR

6 *Portrait of a Girl*, n. d.

Black and white chalks, stumped, on blue laid paper, 18.6 × 29.5 cm
Crocker Art Museum, E. B. Crocker Collection 1871.999
Inscriptions: brown ink, lower left center: *J: Peter Molitor*; verso, graphite, lower left corner:
[graphite circle and stroke]

Johann Peter Molitor was born in Schadeck am Lahn near Koblenz in 1702. Little is known of his early training, though it included travel to Bonn, Berlin, and Dresden. He settled in Plauen, southwest of Leipzig near the Bohemian border. He prepared for a move to Prague as early as 1727, however, and arrived there in 1730. At the same time, he converted to Catholicism. Originally named Müller, he Latinized his surname, perhaps to distinguish himself from another artist working in the city.[1] By 1734 he was a member of

the city's painters' guild, and began working both in oils and fresco. He developed a close relationship with Wenzel Lorenz Reiner, a pupil of Petr Brandl, and both became renowned for portraits as well as religious works. Molitor's fame became such that in 1750 he was given the commission to decorate Schloß Werneck, the summer residence of the Prince-Bishop of Würzburg, Karl Philipp von Greiffenclau. A prestigious commission for Molitor—at the time he arrived, Giovanni Battista Tiepolo was painting the Prince-

Bishop's winter home, the Residenz—little is known of the decoration, though the artist's surviving religious frescoes in Osek's Cistercian monastery give an idea of his abilities. After his return to Prague, Molitor precipitously moved to Poland in 1756,[2] and died in Cracow the next year. It was said of him: "He almost never put hand to his work without consulting Nature or plaster [casts]" (*Sonst legte er fast keine Hand ans Werk ohne Natur oder Gips zu Rathe zu ziehen*).[3]

The drawing in the Crocker Art Museum is a charming subject, a young girl who looks up from her book. In this intimate domestic moment, she addresses the viewer with a frank, unguarded gaze. Molitor's work with the black chalk is very sensitive, especially around the eyes and mouth. The contrasting stumping in the background and drapery serve to shift the focus to the girl's finely drawn features, hair, and hands. The fading of the paper has weakened the effect of the white chalk highlights, present especially in the face and hands, which would have provided greater definition to the volumes.

The drawing's informality and intimacy raise the question of its intended purpose. Though Jeffrey Ruda finds that such informality is alien to eighteenth-century portraiture,[4] the present author finds that to be the case with finished paintings more than with drawings, exemplified by the Johann Gottlieb Prestel in this exhibition (cat. no. 15). The overtone of genre he sees in the drawing, on the other hand, is apt—the young lady would fit well in the intimate environment of Johann Christian Klengel's domestic scene (cat. no. 16). However, it seems to this writer that the artist simply records a casual moment in a quick, observant manner, creating an image that was not necessarily intended for further development. Furthermore, the intimacy and directness of the scene make it appear that the sitter was known to the artist, perhaps a family member. In this context, the sketchy image in the book, generally read as a portrait of a man in a peruke, would be best described as an incidental motif, rather than something like a lover's portrait or an image from a *Stammbuch*.[5]

Without disputing the current view of authorship of the drawing, accepted for many decades now, a comparison may be made between the inscription on the Crocker drawing and that on a drawing in Prague by Molitor's friend Wenzel Lorenz Reiner (fig. 32).[6] The graphism and its obtrusive placement on the drawing in each case are similar enough that it is worth asking if, rather than being signatures, both inscriptions might be from the same hand, certainly close in time to the artists, though not either of theirs—perhaps a collector's, or even that of a shop assistant. WB

PROVENANCE

Edwin Bryant Crocker, by 1871; gift of his widow Margaret to the Museum, 1885

LITERATURE

Pavel Preiss, *Česká barokní kresba*, exh. cat. Prague, 2006, no. 126; Kaufmann 2004, pp. 135–36; Pavel Preiss, *Jan Petr Molitor*

1702–1757, podobizny a portrétní motivy, exh. cat. Prague, 2000, no. 7; Ruda 1992, no. 63; Kaufmann 1989, no. 62; Crocker 1971, p. 158

7 *Hermes Stalking Argus*, n. d.

Graphite, brush and point of brush and gray wash on oatmeal laid paper, 27.8 × 26.7 cm
Crocker Art Museum, E. B. Crocker Collection 1871.66

This magnificent depiction of Mercury and Argus shows Dietrich's great facility in drawing with the brush, its contours and volumes defined by short but fluid strokes, the figures surrounded by gestural hatched shade. The artist's many changes to the composition give us an unusual view into his working method, as most of his other surviving drawings are either studies of single figures or finished scenes.

Born in Weimar in 1712, Dietrich came from an artistic family, both his father and maternal grandfather being court painters to the Wettin Duke Wilhelm Ernst of Saxe-Weimar. A drawing of a peasant made when he was twelve years old shows his talent emerging under the tutelage of his father.[1] Soon after, he was sent to Dresden to work with the landscape painter Johann Alexander Thiele, and to study at the academy directed by Louis de Silvestre. In 1728, he went to the Schwarzenburg court at Arnstadt with Thiele and learned to etch. Three years later in Dresden he was made court painter on the basis of two canvases made in Prince-Elector Friedrich August I's presence and, from this time forward, the elector's finance minister, Count von Brühl, was his main patron. A trip to the Netherlands was sponsored by the elector in these years, but Dietrich may have used the money to return to Weimar and visit other German cities.[2] About travel, he said he found all he really needed in Dresden.[3] In 1740 demand for his work was such that von Keyserlingk, the Russian ambassador, ordered eleven paintings.[4] Made court painter to the new Prince-Elector, Friedrich August II, the next year, he enjoyed great popularity. Another unwilling trip, this time to Italy, allowed him to meet Anton Raphael Mengs, and he spent more time absorbing the landscape than the art of the past.

Inspector of the Gemäldegalerie from 1748 onwards, he remained in Saxony during the Seven Years' War (1756–63). Made professor of landscape at the newly re-founded Dresden Academy in 1764, he was rather independent and chafed under the pressure of his duties. He died in 1774.

Like Giuseppe Cades, an Italian artist active later in the eighteenth century, Dietrich had a dazzling ability to work in the styles of other artists. Unlike Cades, whose reputation suffered, Dietrich made this ability the basis of an entire career. Though he delighted in Dutch and Flemish art, his wide choice of models led to his being called an 'eclectic' painter, though this must be understood as something distinct from the tradition of idealizing selective imitation practiced in Italy and France.[5]

The Crocker drawing relates the story of the messenger god Mercury and Argus, the hundred-eyed guardian. Jupiter, chief of the gods, had seduced the nymph Io and, when discovered by his wife Juno, had turned her into a heifer. The suspicious Juno asked for the heifer as a gift, and set the hundred-eyed Argus to guard her. Jupiter then sent Mercury to free her, which he managed to do by lulling Argus to sleep with the music of a flute and decapitating him. In the drawing, Argus has just nodded off and Mercury approaches him, still holding his flute and with his sword at the ready.

The figure of Io has evidently given Dietrich some trouble, as four separate poses appear. Perhaps the first version, since it is in the same medium as the underdrawing, is the ghostly black chalk heifer at lower right, who balances the composition horizontally and draws the viewer's attention to the central action with her glance. Another heifer appears in ink at upper right, cancelled with a few dry

PROVENANCE
Rudolph Weigel, by 1867. Edwin Bryant Crocker, by 1871; gift of his widow Margaret to the Museum, 1885

LITERATURE
Breazeale 2008, no. 51; Kaufmann 2004, pp. 103–04; Howard et al. 1972, no. 32, pp. 34–35, 56; Crocker 1971, p. 150; Crocker 1959, no. 3; Scheyer 1949, no. 13; Crocker 1939, no. 52; Weigel 1838–66, no. 7630

brushstrokes, perhaps because of her distance from the main scene. At left, behind Argus, are two overlapping animals, one gazing out at the viewer and the second looking back to see her coming liberation. As the second head is more finished, perhaps this last pose was the one preferred.

A painting of the same subject once in the Dresden Gemäldegalerie shows the transformed Io similarly attentive to her fate, her white body outlined against dark foliage behind.[6] However, though associated with the Crocker drawing by previous authors,[7] the painting, presumably destroyed in the Second World War, differs in the pose of Io, the choice of narrative moment, and in the setting of a wide, craggy hillside more distant than the drawing's rocks and bushes. There, Mercury has his sword raised to decapitate Argus, sleeping with his head in his lap.

Christiane Andersson points out that in the Crocker drawing Mercury holds his sword in his left hand not the right, which would be logical if the drawing were related to a print.[8] This author has not located such a composition, which perhaps remained unexecuted. On the verso of the drawing, however, a separate study of the figure of Mercury holds his sword in his right hand.

Though a dating of circa 1754, when Dietrich explored the same subject in the lost painting, would be hasty, the Crocker drawing is certainly a mature work, graceful and sure with its bold brushstrokes. WB

8 *Peasant Woman Eating*, n. d.

Red chalk, brush and brownish wash and bluish-gray watercolor on cream laid paper, 40.1 × 27.4 cm
Crocker Art Museum, E. B. Crocker Collection 1871.1068
Inscriptions: black chalk, lower right corner, signed: *G. M. Kraus*; verso, black chalk,
lower right corner: *E- / Kraus : Weimar*

Known to many as a close friend of Goethe, Georg Melchior Kraus was remembered by the poet as a lively, sociable personality.[1] Moving easily within German artistic circles in France, Italy, and Weimar, Kraus enjoyed a productive career as a painter and printmaker in the third quarter of the eighteenth century, until changing tastes in the 1780s dictated his turning to fashion illustration. Here, even in the period of his early training, he shows his eye for human nature, capturing a young girl as she finishes a meal.

The artist was born in 1733[2] to a family of innkeepers in Frankfurt am Main. Related to painters at the Saxon court,[3] he took up the profession himself, studying under Johann Heinrich Tischbein the Elder, uncle of the more famous Johann Wilhelm, in Kassel. He arrived in Paris in 1761, settling in among the German artistic colony around Johann Georg Wille. Like his German colleagues, he interacted with French artists, attending life drawing classes at the Académie royale, where, unlike most of them, he paid especial attention to François Boucher and Jean-Baptiste Greuze. These two artists were to prove essential to his later work.

He returned to Frankfurt in 1766 and, in 1770-71 and 1774, spent time in Switzerland as well, where he met Goethe and Caspar David Lavater. A member of the Vienna Academy from 1768, Kraus worked mainly as a portraitist and designer for prints until, in 1776, he became director of the Herzogliche Freie Zeichenakademie (Free Ducal Drawing Academy) in Weimar. This came about through his association with the baronial vom Stein family—when a daughter, whom Kraus instructed in drawing, married

the count of Werthern, he moved with them to Thuringia, where he made portraits of the ducal family in Weimar.[4] In Weimar he also made a portrait of Goethe, who had arrived in the city the year before, and, under the poet's influence, took up landscape painting as well. In 1786, in collaboration with the ducal Drawing Academy's founder, Friedrich Justin Bertuch, Kraus began the *Journal der Luxus und der Moden*, providing its illustrations, mostly fashion plates, until his death in 1806 under the French occupation.

Though the verso inscription mentions Weimar, the Crocker drawing dates from well before Kraus's residence in the city. Depicting a young woman interrupted at her meal, the drawing unusually combines red chalk and bluish-grey wash. The subject and the vigorous use of red chalk reflect the influence of Greuze, whose domestic, often sentimental subjects were prized by Parisian artists and public at the time of Kraus's training in the city. Two other drawings of single figures now in Frankfurt date to the Paris period and are similar in handling, though in black and white chalk on blue paper.[5]

The young woman in the Crocker drawing is closely related to a watercolor kitchen scene now in Lübeck (fig. 33).[6] In the watercolor, dated 1766 in the artist's hand, a young mother is shown with her three children. Her elbow on the table, she gazes at the youngest, who grasps his spoon and gestures with it in the air. Aside from the difference in the angle of the head, the figure is remarkably similar in costume and pose to the figure in the Crocker drawing. However, the glass has disappeared, while the hand that held

PROVENANCE

Edwin Bryant Crocker, by 1871; gift of his widow Margaret to the Museum, 1885

LITERATURE

Birgit Knorr, Georg Melchior Kraus (1737–1806), Maler, Pädagoge, Unternehmer, unpubl. Ph.D. diss., Universität Jena, 2003, no. Z183; Breazeale et al. 2010, no. 48; Kaufmann 2004, p. 127; Kaufmann 1989, no. 80; Crocker 1971, p. 154; Scheyer 1949, no. 87

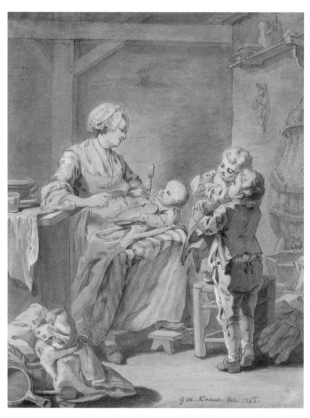

FIG. 33
Georg Melchior Kraus, *Mother with Three Children*, 1766. Watercolor, 20.4 × 16.6 cm. Die Lübecker Museen, Museum Behnhaus Drägerhaus, Sammlung Dräger/Stubbe, inv. no. 2007/67

it now points to the young child, and the charcoal-fueled pierced footwarmer has been replaced by a small footstool. The two elder children stand by with hands clasped in supplication—for food, presumably—and the scene is completed with a pile of clothes, firewood, and the other accoutrements of a simple kitchen. Kraus experimented with another scene of a mother and child during his Paris period, in a third drawing in Frankfurt.[7] There, however, the scene differs in pose and is focused on the drapery.

The verso of the Crocker drawing, which bears a transmitted-light outline of the recto composition, bears the inscription *Kraus : Weimar*, as noted above. Since Kraus arrived in the ducal city in 1773–74, well after the drawing's creation, which must be around 1766, the date of the Lübeck watercolor, it seems possible that the Crocker drawing remained with the artist, the verso tracing and inscription being added by him at a later moment of experimentation with the reversal of the figure. This would be consistent with the history of the three Frankfurt drawings from the same period mentioned above, which remained with the artist until his death. WB

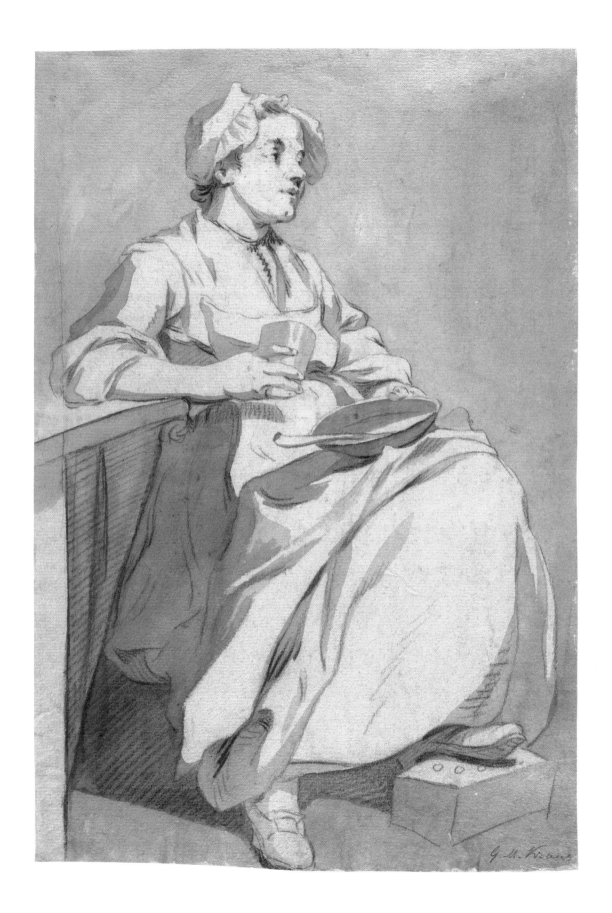

G. M. Kraus

KARL GOTTLIEB LENZ

9 *The Adoration of the Golden Calf*, 1772

Pen and brown and dark brown ink, brush and brown washes over black chalk on cream laid paper,
25.0 × 36.1 cm
Crocker Art Museum, E. B. Crocker Collection 1871.83
Marks: verso, black ink, lower margin left of center: unidentified collector's mark, monogram *EY* (not in Lugt)
Inscriptions: black ink, lower left, signed: *C. G. Lenz inv: / 1772*; verso, black chalk, upper center: *Po. b / ig.r*; verso, black chalk, lower left corner: *Lenz bez.*; verso, black chalk, lower left corner: *Poj* (?); verso, printed in black ink, lower margin left of center: *EY* monogram

A talented product of the Dresden Academy, Karl Gottlieb Lenz died early, cutting short a promising career. This brush drawing made by the still teenaged artist is one of the most dynamic of his surviving multi-figured compositions.

Born in Dresden in 1753, Lenz studied under the Kunstakademie's French director, Charles-François Hutin. After the latter's death in 1776, the professor Johann Eleazer Zeißig, called Schenau, continued the young artist's training. According to Ernst Scheyer, he moved to Leipzig in the early 1780s to Adam Friedrich Oeser's studio.[1] Writing late in that decade, his first biographer tells us that Lenz was interested above all in history painting but was unable to pursue it as he liked since he was forced to support himself with portraiture and drawing instruction.[2] In 1788, however, he went to Italy to improve his knowledge of history painting at his own expense, later receiving a stipend from the Elector Friedrich August III. This came just months before his death in Rome in 1790, when he was only 37 years old.

Writing at the turn of the nineteenth century, Hans Heinrich Füssli passed on personal information and anecdotes about Lenz's life, saying that he was prized as an artist but also for his knowledge of languages, history, and mathematics, as well as for his amiable temperament. Under Hutin he supposedly learnt to copy the elder artist's drawings so closely that they could be distinguished from the originals only with difficulty. He must have had great powers of invention, as he would do ten or twenty variations on the same subject. And his talent was such that often he and Hutin would create competing compositions on the same subject.[3]

Signed and dated, this drawing of *The Adoration of the Golden Calf* is a virtuoso exercise in brush drawing. After lightly sketching the scene in black chalk, Lenz created the forms and shading with the brush, only then, it seems, finishing the details of the central figures with the pen. The story is from Exodus: the Israelites, impatient from waiting for Moses to return from Mount Sinai, turned to Aaron seeking a god to worship. He told them to gather their gold and fashioned a calf from it. When they sacrificed to it, God sent Moses down to them, intending to destroy them for their idolatry. Asking God for mercy on the Israelites, Moses returned to them, breaking the tablets of the Law in his rage. In the aftermath, God did not completely destroy the Israelites but sent a plague upon them.

In the drawing, Lenz chooses the moment when Moses returns, finding the Israelites at their worship. An inner circle of adorers, all seated or kneeling round the garlanded pedestal, gaze up at the calf. Beyond, the semicircle of fellow idolaters is more varied in pose and gesture, including small children at either end. On a distant mountain, Moses, his hands already raised to hurl the tablets, approaches with his companion Joshua. The draped male figure at extreme right is likely Aaron, turning away from the corrupt scene for which he is responsible.

The artist's talent in capturing the essence of Old Testament narrative is amply attested here, and in *Joseph Interpreting Pharoah's Dream* in the Dresden Kupferstichkabinett[4] and *Cain Hearing God's Voice* in the Albertina.[5] The latter, like the Crocker scene, shows his talent

PROVENANCE

Edwin Bryant Crocker, by 1871; gift of his widow Margaret to the Museum, 1885

LITERATURE

Kaufmann 2004, pp. 127–28; Howard et al. 1973, no. 24; Crocker 1971, p. 155; Scheyer 1949, no. 88; Crocker 1939, no. 70

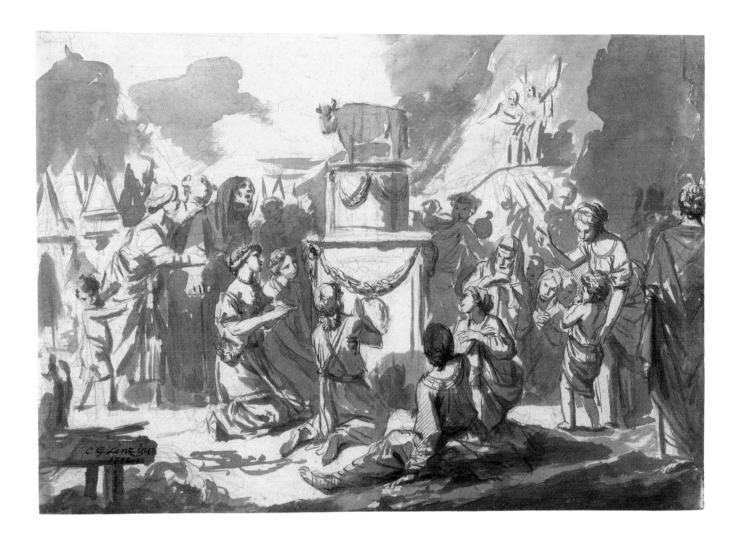

in brush drawing. If the anecdotes in Füssli's biography are true, the Crocker drawing is the result of long and copious practice in composition and, possibly, given its early date of 1772, an entry for friendly competition with his master.

It is difficult to concur with the view that Lenz's composition is dependent upon Nicolas Poussin's painting of the same subject now in the National Gallery, London,[6] especially given Lenz's likely focus on compositional variety.[7] The main similarities between painting and drawing, the golden calf on its pedestal and the background vignette of Moses, take a form that is conventional from the sixteenth century onwards. In contrast to the Poussin painting, Lenz's calf is placed at center of the drawing. There are no dancers and no crowd to the right, the kneeling and standing idolaters being spaced more evenly across the composition. The background and the pose of Aaron also differ. The painting itself was in the collection of the Viscount Folkestone, later the Earl of Radnor, from 1741, so that Lenz could only have known it from a secondary source.

A collector's mark, the conjoined letters EY in black, was recently uncovered on the verso after conservation. WB

10 *Children Playing with a Cat*, circa 1765

Black and white chalks on cream laid paper, 20.7 × 16.4 cm.
Crocker Art Museum, E. B. Crocker Collection 1871.1084

Inscriptions: verso, black chalk, lower left corner: *Schoenau del.*;
verso, black chalk, lower left: *Z*; verso, black chalk, lower right corner: *-co/1*

A girl stands in a partially seen window while a second child sits on the sill with his back to the viewer. They have put a cat into a doll's bed. Subject and style are related to those in Schenau's 1765 etching series 'Accheter mes pettites Eau forttes!', especially the third, *Children with a Dog and Cat*, in which a windowsill also frames a composition portraying animals as children's playthings. The artist depicted such a window frame in other drawings and paintings, directing the eye to the figures as if there were a picture within the picture. By employing this device, Schenau (1737–1806) quoted a type of composition used by Dutch seventeenth-century masters, and often by his elder Dresden colleague Christian Wilhelm Ernst Dietrich.

The girl's slightly tilted head with its little bonnet, round cheeks, and faint smile, is in accordance with a type of charm and sweetness that Schenau knew from the work of Jean-Baptiste Greuze. This rather stereotypical prettiness appears in his Dresden works even after 1770, earning him the nickname of "the Greuze of Saxony."

The forms and drapery are outlined with long strokes, though the locks of hair, the collars, the bodice, and the tassels on the pillow are reproduced with lively, brisk but exact chalk lines. They appear to dissolve into cheerful disorder at the center of the picture, while the borders of the window opening are connected to the calmer background with taut parallel hatching.

Many such scenes of children show them imitating grown-up activities and offering them up to the amused gaze of adults. Schenau understands especially well their reverie, their naïve cruelty and insouciance, even their childlike poses and motions. Schenau passed on this interest and empathy, as well as the curly-headed, chubby-cheeked facial type, to his pupils Carl Leberecht Vogel and Traugott Georgi. AF-S

PROVENANCE

Edwin Bryant Crocker, by 1871; gift of his widow Margaret to the Museum, 1885

LITERATURE

Fröhlich 2018, no. Z52a; Kaufmann 2004, p. 164; Crocker 1971, p. 163

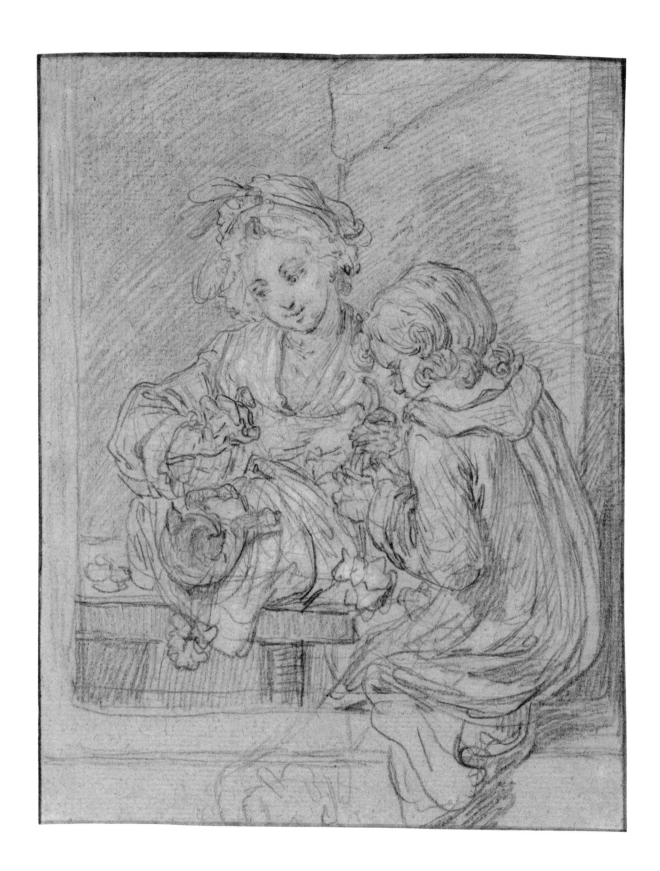

JOHANN ELEAZAR ZEISSIG, CALLED SCHENAU

II *Self-portrait*, 1773

Black, white and red chalks on brown laid paper, 20.3 × 16.5 cm
Crocker Art Museum, E. B. Crocker Collection 1871.1067
Inscriptions: black chalk, lower right, signed: *Schenau se ipse del. 1773*

FIG. 34
Detail of fig. 12, Schenau, *Das Kunstgespräch*,
1773. Oil on canvas, 80 × 63.5 cm. Dresden,
Gemäldegalerie Alte Meister, inv. no. 3161

The scene of children playing with a cat (cat. no. 10) was drawn in Paris when the young Schenau (1737–1806) was making a name for himself as a painter of genre scenes. He created this self-portrait in Dresden later in life, in 1773. In that year he became chief painter, chairman, and director of the Meissen porcelain manufactory's drawing school. Three years later he accepted the co-directorship of the Dresden Kunstakademie, the other director being Giovanni Battista Casanova.

Though this is a self-portrait, the artist does not address the viewer directly as, for example, in his Berlin self-portrait, nor does he depict himself with the upturned, inspired gaze he has in the one he made for his younger Dresden friend Carl Gustav Carus's friendship album.[1] Here, he wears a cravat and black hair ribbon and inclines his head to the right, his lips slightly parted. In this respect, the sheet appears to be preparatory to the painting *Das Kunstgespräch* (fig. 12, p. 20) specifically for the middle figure in the group standing to the left (fig. 34). In this painting Schenau depicted himself and his younger Kunstakademie colleagues Anton Graff and Adrian Zingg listening to a conversation between the Academy's general artistic director, Christian Ludwig von Hagedorn, and the Prime Minister of Saxony, Thomas von Fritzsch. However, the painting is dated 1772, and the drawing is from a year later. A sheet by Schenau's friend Heinrich Friedrich Füger portraying Schenau with mouth closed and his head resting on his chin therefore has to be considered the direct model for the painting.[2]

Schenau's self-image in this portrait is evidently how he was seen by others; Daniel Chodowiecki described the 38-year-old artist as "very gentle and modest" (*sehr sanft und bescheiden*) after his visit.[3]

However, the drawing speaks for itself. Outlined with sure strokes, the face and cravat are subtly heightened with white chalk. This combination, along with the use of red chalk, lends the gently contoured planes of the face and its features a sculptural effect that recalls pastel. By employing this *trois crayons* technique, the artist was referring to the highly developed French mode of drawing seen in the works of Jean-Baptiste Greuze and Pierre-Alexandre Wille. AF-S

PROVENANCE

Edwin Bryant Crocker, by 1871; gift of his widow Margaret to the Museum, 1885

LITERATURE

Fröhlich 2018, no. Z224; Breazeale et al. 2010, no. 49; Angela Carus Böhm, *Carus-Album, die Wiederentdeckung einer Porträtsammlung*, exh. cat. Dresden, 2009, p. 459; Breazeale 2008a, p. 211; Kaufmann 2004, pp. 161–62; Kaufmann 1989, no. 66; Crocker 1973, p. 163; Scheyer 1949, no. 121

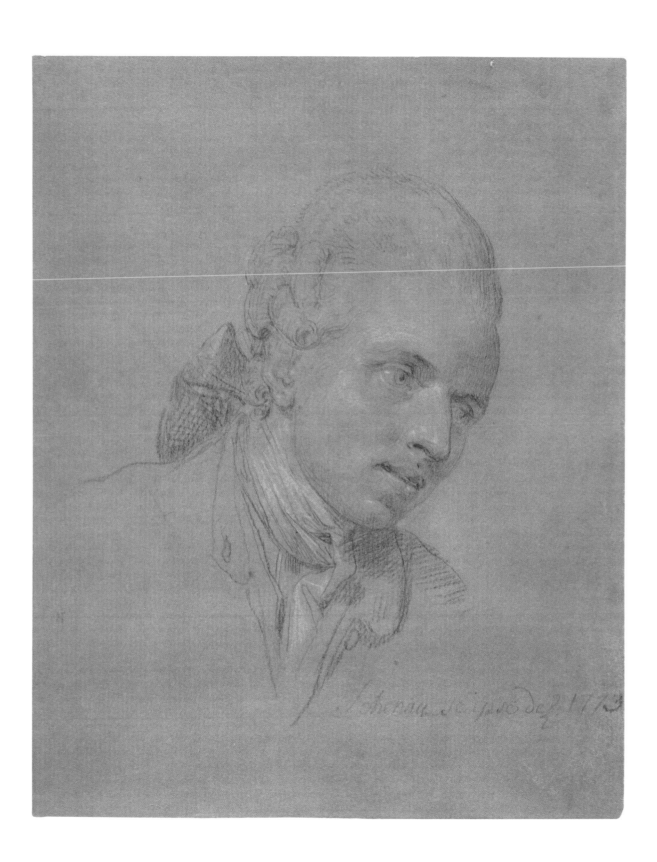

12 *Traveling Performers at an Inn*, n. d.

Pen and dark brown ink, brush and dark brown ink and brown and gray washes
and gum arabic over black chalk, incised, on cream laid paper, 22.8 × 16.5 cm
Crocker Art Museum, E. B. Crocker Collection 1871.79
Inscriptions: black chalk, upper right corner: *No 2.*; verso, red chalk, lower right corner: *A*[cut off]
Marks: bottom margin at right: Lugt 2237 (Rolas du Rosey)

Friedrich Müller's scene of traveling musicians, a design
for a genre print, is related to a tradition of monkey scenes
popular in Europe in the seventeenth and eighteenth
centuries.

A poet as well as a painter, Müller was born to a baker's
family in the Palatinate town of Bad Kreuznach in 1749.
Through his mother he was related to the poet Johann
Nicolaus Götz and probably to the landscape painter
Johann Heinrich Roos. The early death of his father limited
his possibilities for schooling but, his talent in drawing
becoming noticed, he was sent to Zweibrücken for training
by the court painter to Duke Christian IV, Daniel Hien.
Hien's training especially emphasized the seventeenth-
century artists of the Low Countries. After four years in
Zweibrücken, in 1769 Müller was sponsored by the duke
to attend the Kunstakademie in nearby Mannheim, then
ruled by the Wittelsbach family. There he met the painters
Franz and Ferdinand Kobell and, thanks to his experience
with the collection of the Electoral Prince Karl Theodor
and the Kunstakademie's casts after ancient sculpture,
began a lifelong interest in Classicizing art. At this time he
also began to write, making the acquaintance of many in
Goethe's circle and, eventually, of the man himself. In the
1770s Müller was better known as a poet, publishing the
first part of his own *Faust* and a series of 'Idylls'. To the poets
Lessing, Klopstock, Wieland and others he was known as
"Maler-Müller" (Painter-Müller). In 1777 he became court
painter to Karl Theodor, whose court was soon to move to
Munich, and who sponsored a trip to Rome for the artist to
study, in 1778. Müller was to remain there the rest of his life.

FIG. 35
Friedrich Müller, *Affenkomödie* (Monkey
scene), circa 1775. Etching, 22.5 × 17.5 cm.
Staatliche Museen zu Berlin, Preußischer
Kulturbesitz, Kupferstichkabinett, inv. no.
537-121

PROVENANCE

Carl Freiherr von Rolas du Rosey, by 1862; his
sale, Leipzig, Weigel, September 5, 1864, no.
5435. Edwin Bryant Crocker, by 1871; gift of his
widow Margaret to the Museum, 1885

LITERATURE

Heribert Rissel, 'Erkundungen zu den Genre-
Darstellungen im radierten Werk des Friedrich
"Maler" Müller,' in *Kunst in Hess und am
Mittelrhein*, N. S. vol. II, 2006, p. 29; Kaufmann
2004, p. 138; Kaufmann 1989, no. 81; Crocker

1971, p. 158; Scheyer 1949, no. 93; Crocker 1939,
no. 66; Rosey sale, Leipzig, Weigel, September
5, 1864, no. 5435

In Rome Müller soon met Mengs, Batoni, and Winckelmann, as well as Heinrich Friedrich Füger, who praised his paintings, of which few survive. His small stipend from the Wittelsbach court becoming intermittent, he turned to guiding Grand Tour visitors, writing on art, and art dealing to support himself. A 1781 letter from Goethe thanks him for supplying Old Master drawings, while at the same time strongly criticizing his painting skills.[1] Not discouraged, Müller continued his devotion to classicizing art, painting many mythological and epic subjects. In 1805, he met the eighteen-year-old Crown Prince Ludwig of Bavaria in Rome, soon becoming his court painter and art agent. Among his achievements was the first purchase of ancient sculpture for the Glyptothek founded by the prince, but court intrigue resulted in a bitter parting of ways in 1810. In the next decade, partial blindness limited his painting but not his writing. The project to publish the second part of his *Faust* in 1823 came to naught, however. Müller died two years later, a stroke ending a life filled with wit and good company, but also poverty and disappointment brought on by his habit of carelessly alienating possible supporters in the literary and artistic worlds.

The drawing in the Crocker dates from Müller's early period in Mannheim, when he was still enchanted by Dutch art. Outside an inn with potted plants in the window, a couple with their baby witnesses a performance while others lean out the windows and the inkeeper stands in the doorway. A drummer and bagpiper stand at right, and facing them is a third figure whose strap and stick identify him as another drummer. Four monkeys perform, one looking at the couple, one pulling a wheelbarrow, another pacing with his hat held behind him, and the last riding a turbaned dog. All wear tunics with ruffs of the Pierrot type, and their hats are tricornes of eighteenth-century form. The technique is a combination of brown ink and brown and gray washes, with great contrasts of light and dark, the latter deepened with gum arabic.

A print in the opposite sense and of nearly the same dimensions (fig. 35) was cut by Müller, almost certainly from the drawing, which is incised. According to Heribert Rissel, no direct model from the Dutch seventeenth century is known, though monkey subjects do appear, mostly as animal-training scenes.[2] In Müller's own time, though, monkeys, especially those engaging in human activities, were familiar not only from the earlier work of Teniers the Younger and van der Borcht but also from the early eighteenth-century French vogue for *singeries* in the palaces at Chantilly and Marly, in the work of Watteau and Chardin, and in Christophe Huet's 1740 series of prints. In Germany the Meissen *singeries* such as the *Affenkappelle* figures were of course well known. And Müller's own likely relative Johann Heinrich Roos had designed a natural-history scene of monkeys engraved by John Philip Aubry for Hiob Ludolf's *Historia Aethiopica* of 1681.[3] The difference in Müller's drawing and print is that his group of monkeys is presented not as a commentary on human nature or as natural history, but rather as performers in a simple village entertainment, a counterpart to the *Bänkelsänger* in his print of the same period.

The *Bänkelsänger* and the *Traveling Performers at an Inn* are the only genre scenes Müller did and his last independent prints, according to Rissel.[4] Though dated by Nagler 1768 and 1775, seven years apart, Rissel proposes on the basis of the publisher's licensing date that they are both from 1775.[5] If his dating is correct—the licensing date provides only a *terminus post quem*—then the Crocker drawing is of a similar date. WB

13 *Peter Healing the Lame Man*, n. d.

Red chalk on cream laid paper, incised, verso rubbed with red chalk, 21.8 × 18.4 cm
Crocker Art Museum, E. B. Crocker Collection 1871.70

Inscriptions: verso, graphite, lower left corner: [graphite circle and stroke]

As a lame man at right is carried into view and set down, the apostle Peter points to him and simultaneously turns to his companions. This dynamic drawing of *Peter Healing the Lame Man* is instructive not only for Rode's mastery in handling red chalk, but also for insight into his working method for narrative scenes.

Christian Bernhard Rode's entire career was centered on Berlin. Born in the city in 1725 to a family of goldsmiths and sculptors, he trained with the court painter to Friedrich II, Antoine Pesne. In 1750-52 he studied in Paris with Carle van Loo, at the time governor of the École des Élèves Protégés and later rector of the Académie royale. Jean Restout, famous for his religious subjects, also contributed to his education. Two years later Rode went to Rome, where he lodged in the via Sistina near Anton Raphael Mengs.[1] At his return in 1756, two events in quick succession changed the course of his career: his acceptance into the Berlin Academy, which though he was no friend of the director brought him into the city's highest artistic circles, and the death of his father, which gained him financial independence.

In 1766–68 he received a royal commission from Friedrich II for the decoration of the Neues Palais in Potsdam, but most of Rode's major projects until the 1780s were for the country houses of the nobility, or for altarpieces in churches. His quickness with the brush earned him the epithet "Fix-Maler" (Speed-painter) from the sculptor Johann Gottlieb von Schadow. In his intellectual life and his art Rode was a proponent of the Enlightenment ideals that were current in Berlin at the time, especially in his

friendship with the philosopher and art theorist Johann Georg Sulzer. He was Director of the Berlin Academy from 1783 until his death in 1797.

Rode was a powerful figure in Berlin during his lifetime, dominating the city's art world with Daniel Chodowiecki. Rode and Chodowiecki were given one of the most important ecclesiastical commissions in 1780, decorations for the Huguenot and German Reformed churches, respectively, on the Gendarmenmarkt.[2] Though this commission shows their equal appeal during their lifetimes, Rode was forgotten after his death much more quickly than Chodowiecki was.[3] The two were both colleagues and rivals and, especially after Rode became director of the struggling Academy, the rivalry became more intense. Rode was a pragmatic, somewhat conservative leader but Chodowiecki favored a return to the grand ideals of 1699, the Academy's original founding date, and did not hesitate to undermine Rode's authority in order to achieve it.[4] In the event, he became Rode's vice-director and ultimately succeeded him.[5]

The drawing under discussion depicts the scene of healing described in Acts of the Apostles, Chapter 3, as identified by Deborah Born in 1976.[6] Peter and John were going to pray at the temple and were importuned by a beggar, a lame man who was being carried to the temple gate. Peter tells him he has no money ("Silver and gold have I none") but he can give him something else, commanding him in the name of Jesus Christ to walk.

Rode picks his narrative moment carefully, focusing not on the miracle and the crowd's astonishment but rather the

PROVENANCE

Edwin Bryant Crocker, by 1871; gift of his widow Margaret to the Museum, 1885

LITERATURE

Mitchell B. Frank and Erika Dolphin, *Central European Drawings from the National Gallery of Canada*, Ottawa, 2007, p. 84, under no. 28; Kaufmann 2004, no. 153; Howard et al. 1976, no. 35; Crocker 1971, p. 161; Scheyer 1949, no. 117; Crocker 1939, no. 56

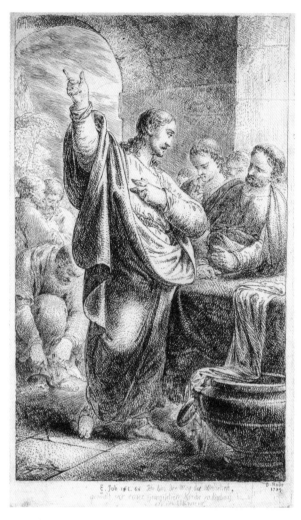

moment before. At right, the lame man, his crutches already on the ground, is being set down by his companions. Peter, placed on the center axis, points to the lame man and gazes into the crowd at left, either to draw attention to his coming action or to find John, who may be the hooded figure. Rode's graceful red chalk lines, in addition to creating the beautiful sweep of Peter's cloak, pick out the main figures with firm intensity. The architecture and the surrounding crowd are less defined, though a figure in the right background pushes back the people and an altar, perhaps for libations given the jug at its foot, appears at left. The subject is comparatively rare, though it was used by Carle van Loo for a 1742 painting that might have been known to Rode during his study with the French artist. No etching of this subject is yet known, though the drawing is incised, the verso is rouged for transfer, and the thin, strong paper is similar to that used for Rode's other red chalk print designs, such as the *Lazarus and the Rich Man* of 1776 now in the British Museum.[7]

The pose of Saint Peter reverses that of Jesus in a 1784 print Rode made after his painting *Christ Preaching to the Disciples* for the church in Babai, Ukraine, near Kharkiv (fig. 36). The difference is that the cloak is gathered around the raised arm not the bent one. An anecdote recorded by Rode's friend Karl Wilhelm Ramler points to the artist's reuse of motifs: he would not sell a painting of the Resurrection to the Duchess of Courland, but insisted on making a copy since he wanted to use the especially beautiful head of Christ as the model for all his others.[8] Renate Jacobs's analysis of Rode's prints accents his reuse of pose and gesture in subjects with similar emotional content, and proposes that not only does it aid in maintaining the artist's habitual narrative clarity, but also that his impulse for narrative clarity is based on his Enlightenment ideals.[9] Here, the preaching of Christ and Peter's preparation for the miracle are indeed similar in their focus on gaining the attention of a crowd, and the gestures aid Rode's fidelity to the text. However, emotional impact and faithfulness to Scripture were already part of his training in the French academic tradition.

Though reuse of motifs does not help in determining which is the original, a date in the early 1780s, near the time of the *Christ Preaching* print, and to a red chalk scene of *Christ Healing the Lame Man*, a subject parallel to that of the present drawing, should be considered.[10] WB

14 *The Improvement of Morals*, circa 1787

Pen and red and black ink, black chalk, partly stumped, on cream laid paper, partly incised, 20.2 × 33.7 cm.
Crocker Art Museum, E. B. Crocker Collection 1871.72

Inscriptions: red ink, on chart at center: *Weihnacht*; *Neu Jahr*; *Ball*; *Schlitten Fahrt* / Hochzeit; *Zwietracht*;
Ehescheidung; *Concert* / *Komödie*; *Diebstahl*; *Mordbrenner* / *Picknick*; *Krankheit*

"I wanted to be a painter; the public wanted me to be a printmaker" (*Je voulait* [sic!] *être peindre, le public voulait que je sois graveur).*[1] Despite this complaint to his mother in a letter of 1770, Daniel Chodowiecki was one of the most successful artists in eighteenth-century Berlin. His portraits, illustrations, and independent prints brought him great popularity with the public and his fellow artists. This preparatory drawing to an etching shows his talent both for depiction of human nature and for satire, with the ironic title *The Improvement of Morals.*

Chodowiecki was born in Danzig, now Gdansk in Poland, in 1726, to a Huguenot family of merchants and shopkeepers. His father provided early training, which he supplemented by copying prints. During this time, he worked in a grocery run by his aunt and recorded his surroundings and fellow workers in drawings. In his autobiography, he says he practiced his art into the middle of the night, "until sleep came and bid me stop, or the light burnt out" (*bis der Schlaf wieder ein stellte und aufzuhören geboth, oder das Licht ausbrannte).*[2] In 1743 he arrived in Berlin to work in his uncle's shop that, like many run by the Huguenot colony, specialized in luxury goods, which the young artist decorated.[3] 1756-57 saw him working in oils, but he was not successful and turned to etching instead. Chodowiecki considered himself an autodidact but gave credit to Johann Lorenz Haid and Antoine Pesne for some instruction, and participated in private life-drawing classes held by Christian Bernhard Rode.[4] Once his commissioned etching series began in 1759, Chodowiecki made a career of illustration, with many calendar prints with moralizing or literary scenes,[5]

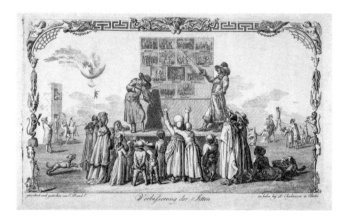

FIG. 37
Daniel Chodowiecki, *Verbesserung der Sitten* (The Improvement of Morals), 1786.
Etching, 21.0 × 33.4 cm. British Museum, inv. no. 1863,0613.1299

and books from Goethe, Schiller, and Lessing to Shakespeare and Cervantes. Seldom leaving Berlin, he produced over 2000 etchings, and over 4000 drawings survive.

The artist became a member of the Berlin Kunstakademie in 1764 but, after Christian Bernhard Rode's directorship began, suffered from disappointed hopes in its reform. Though he advocated a return to its original goals from 1699, he preferred 'nature' to much academic training, denigrating drawing after casts and the idealizing improvement inherent in academic life drawing: "when they drew in the academy, they translated, so to speak, natural flesh into

PROVENANCE

Edwin Bryant Crocker, by 1871; gift of his widow Margaret to the Museum, 1885

LITERATURE

Kaufmann 2004, p. 97; Antony Griffiths and Frances Carey, *German Printmaking in the Age of Goethe,* exh. cat. London, 1994, under no. 25; Ruda 1992, no. 80; Kaufmann 1989, no. 84;

Steadman and Osborne 1976, no. 15; Crocker 1971, no. 85, pp. 34 and 149; Schulz 1968, no. 23; Scheyer 1949, no. 11; Crocker 1939, no. 58

plaster" (*wenn sie in der Academie zeichneten, so übersetzten sie (mocht ich sagen) das Natürliche Fleisch in Gibs*).[6] This brought him into conflict with Rode, who was both a more academic artist and a more pragmatic leader. Serving Rode as vice director nonetheless, Chodowiecki was appointed Kunstakademie director in 1797, unusually for an illustrator and enemy of the academic method. After his 1801 death, an article in the *Neuen Miscellaneen* said: "[Chodowiecki] became the bestower of a new genre of art in Germany: the depiction of modern figures with realistic physiognomy, lively expression, and inimitable feeling, combined with strictest attention to moral improvement" ([Chodowiecki] *ward der Stifter einer neuen Kunstgattung in Teutschland: der Darstellung moderner Figuren, mit einer Wahrheit in der Physiognomie, einer Lebhaftigkeit des Ausdrucks und einer unnachahmlichen Laune, verbunden mit der strengsten Hinsicht auf sittliche Besserung*).[7] *Die Verbesserung der Sitten* (The Improvement of Morals), the print for which this drawing is preparatory, is a satirical one (fig. 37). The occasion was the publication by one of Chodowiecki's competitors of a series of weekly prints chronicling notable events in Berlin. The printmaker, one Merino, was not successful and the enterprise ceased after thirteen weeks. In a letter to his friend the Countess von Solms-Laubach, Chodowieki says he has made his own print for fun and adds rather disingenuously that it was created as an introduction to the series.[8] In the print *Bänkelsänger*, a kind of traveling ballad-singer, intones the stories he points to, accompanied by a fiddler. The thirteen panels depict the kind of banal events Merino recorded and possibly the exact ones:[9] Christmas, New Year, a ball, a sleigh ride, a wedding, discord, divorce, a concert, a play, a theft, arson, a picnic, and illness. In the background, beyond the attentive crowd, are much more dramatic happenings, recorded by a draughtsman on either side. They seem to reflect some of the obsessions of late eighteenth-century German society: at left, one man has hanged himself while another shoots himself while gazing at a picture of his beloved, Werther-like; a man falls from a flaming balloon; and two men fight a duel. At right, acrobats turn cartwheels and stilt-walk, while an ill-matched couple promenades and a woman rides her husband around like a pony, ready to beat him with her slipper. The combination of well-known

types—the pony-riding woman comes from the Aristotle and Phyllis story—and more specific events is interesting; the inclusion of the draughtsmen suggests that these are events Merino could have recorded but did not. Animals reinforce the fun, with monkeys gesturing within the frame and a dog eating a young girl's basket of pretzels.

The drawing differs from the print in details. Two of the *Bänkelsänger*'s scenes, discord and the play, are called differently (*Zwietracht* and *Komödie* in the drawing, *Uneinigkeit* and *Schauspiel* in the print). The fiddler's boot in the drawing turns into a peg-leg for the print. The figure leaning out of the window at left drops something in the drawing but not in the print, and a second window in the building disappears. Clouds are added along the horizon. The design in black ink must have come first, as it is corrected at least twice: the young girl at right was originally a boy, and the angle of the *Bänkelsänger*'s hat has changed. Finally, the number and position of the children at left of the stage change from drawing to print.

There has been some disagreement as to the relationship between drawing and print. The Crocker drawing corresponds exactly to the dimensions and, with the above exceptions, to the design of the print, including the shadows in black chalk. The verso is not rouged and there are no traces of pouncing. Like many other surviving print designs by the artist, it is in the same direction, indicating that there must have been a secondary transfer sheet for it to have been used for the print. It is partly incised at upper left, but it is possible, and to this writer likely, that Chodowiecki used the youthful method described in his autobiography: "... I saw French engravings after Watteau and Lancret and copied only a few with India ink, but when I made such copies, I drew the outlines at the window" (*sah ich französische Kupferstiche nach Watteau und Lancret und kopierte nur ein paar mit Tusche, wenn ich aber dergleichen Kopien machte, wurde der Umriß am Fenster durchgezeichnet*).[10]

The medium of pen and black and red ink, black chalk and red chalk is unusual for eighteenth-century Germany but not for Chodowiecki's print designs. A date of 1787, the year of the corresponding print, is most likely. WB

15 *Self-portrait*, n. d.

Black chalk, brush and black ink and gray wash, white chalk on blue laid paper, 31.0 × 21.8 cm
Crocker Art Museum, E. B. Crocker Collection 1871.581
Inscriptions: black chalk, lower right corner, signed: *J. G. Prestel fec.*

"In drawing he sought neither flawless handling nor a handsome linear manner, but rather a drive to capture and depict the nature of every individual thing" ([*E*]*r verlangte im Zeichnen nicht eine geleckte Behandlung, oder schöne Strichmanier, sondern Drang auf Ergreifung und Darstellung des Charakters eines jeden Dinges*).[1] This is how Johann Gottlieb Prestel's pupil Georg Christian Braun described his master's method of drawing instruction, in which the ability to depict inner character was more important than technical polish. Prestel's self-portrait embodies his precepts, while also demonstrating his great proficiency, capturing his pensive likeness with casual strokes of brush and chalk.

Born in 1739 to a carpenter's family in Bad Grönenbach in Swabia, the young Johann Gottlieb Prestel trained in his father's trade. During his *Wanderjahr* in 1757 he traveled to Prague. Becoming disenchanted with carpentry, he planned to become a clockmaker or painter, apprenticing with Jacob and Anton Zeiler in Ottobeuren. From 1759 he lived in Venice, where in 1762 a German engraver, Josef Wagner, noticed his abilities, as did the painter Giuseppe Nogari. Their connections enabled him to go to Rome for four years. This was a decisive period in which he studied ancient art and the Italian masters, supported by ecclesiastical commissions. However, overwhelmed by the greatness of past artists, he had a crisis of confidence so severe that he gave up painting in favor of grinding colors and preparing materials for other artists.[2] He later found his way back to his profession, even being offered a position at the Florentine court in 1766, which he refused.

In 1769 he settled in Nuremberg as a painter in oil and pastels and as a drawing instructor. Three years later he married one of his pupils, Maria Katharine Höll. By

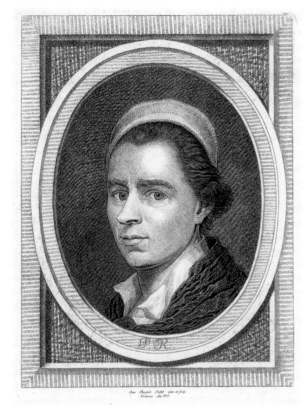

FIG. 38
Johann Gottlieb Prestel, *Self-Portrait as a Young Man* (oval), 1777. Etching, 26.0 × 19.6 cm. Galerie Bassenge, Auction 76, lot 5629

PROVENANCE
Edwin Bryant Crocker, by 1871; gift of his widow Margaret to the Museum, 1885

LITERATURE
Shields et al. 2010, p. 150; Kaufmann 2004, p. 148; Kaufmann 1989, no. 67; Crocker 1971, p. 160; Scheyer 1949, no. 102

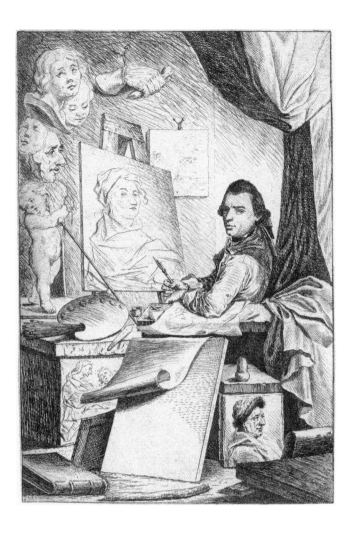

In fact, he was never able to bring his wife back from London, where she died in 1794. Prestel himself died in 1808.

Prestel's self-portrait appears surprisingly modern, partly because of the excellent state of preservation but also because of technique. The handling of black chalk for the main drawing is direct, if light. The treatment of the shaven cheeks is especially subtle, and there is little blending except around the eyes. More subtle still is the presence of white chalk, both at the temple and in the peruke, where only a few strokes are visible. The drama of the portrait lies in the use of brush and ink, undiluted at the profile, eyebrows, and lips. To create the shadows at left and around the nose, Prestel diluted the ink once, then diluted it again for the shadow under the chin, which is extremely important for the illusion of depth.

The artist's more pensive expression and deeper flesh folds can be compared with Prestel's etched *Self-Portrait at an Easel*, published by Johann Georg Hertel and dated around 1770 (fig. 39).[5] The print shares the same strong features and three-quarters view, but addresses the viewer where the drawing does not. There, the artist shows himself with the tools of his art—palette, chalk-holder, mahlstick—working on a portrait. If the dating is correct, this depiction likely served as a sort of professional calling-card, since it would have been made soon after his setting up shop in Nuremberg as a painter. A second etched *Self-Portrait*, this time bust-length, shows the artist as a young man, his head in a three-quarters view (fig. 38).[6] Accounting for the reversal of the printing process the Crocker drawing is in a similar pose to the *Self-Portrait at an Easel* as well. Taken together, the three serve as a remarkable record of the artist's changing visage: the young artist at the beginning of his career, the mature artist in full flower, and, in the Crocker drawing, the pensive printmaker at the moment his cares begin to weigh on him.
WB

1775, he had become renowned as a printmaker with skill in reproducing drawings, developing further the crayon manner of stipple engraving popularized by Gilles Demarteau and the aquatint used by Jean-Baptiste Le Prince to reproduce wash drawings.[3] His most famous reproductions are of the Praun drawings collection in Nuremberg, the Schmidt collection in Hamburg, and various smaller private collections.[4] Repeated financial problems forced him to move to Frankfurt to restart his career in 1782 and in 1785 to live apart from his wife. In 1786 Maria Katharina moved to London to pursue her own career as a printmaker and found a great friend and supporter in John Boydell. During the late 1780s and early 1790s Johann Gottlieb began to regain the recognition he sought but was pursued by financial worries.

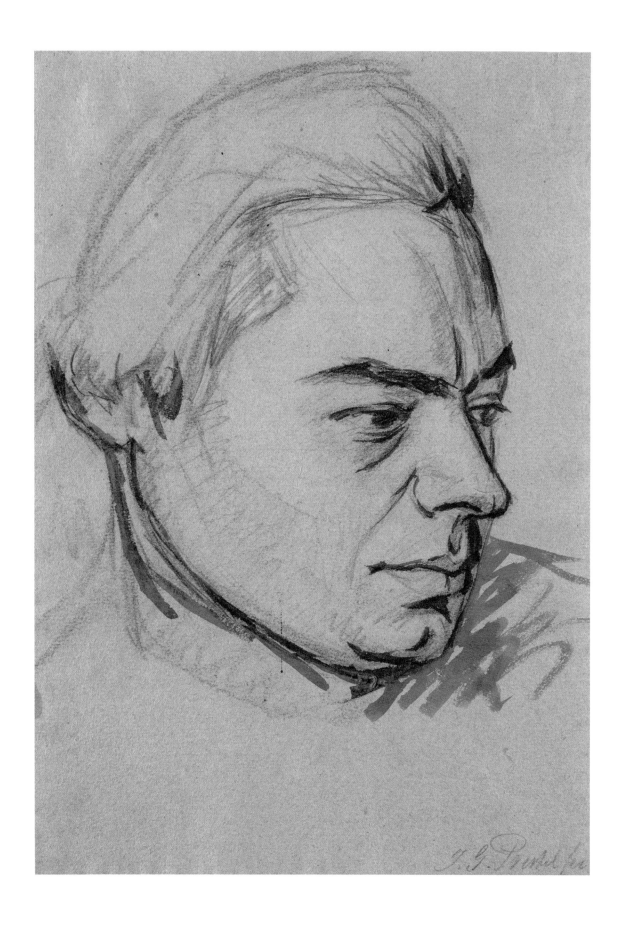

JOHANN CHRISTIAN KLENGEL

16 *A Family at a Table*, n. d.

Pen and gray ink, brush and gray washes and white opaque watercolor on blue laid paper, 19.2 × 16.3 cm
Crocker Art Museum, E. B. Crocker Collection 1871.81

Known for being the teacher of the Romantic painter Caspar David Friedrich, Johann Christian Klengel came of age with the Dresden Kunstakademie, where he studied as a child and where he was later a professor. A talented landscape painter, he made drawings of domestic scenes which, however, he never made into paintings.[1]

The artist was born in Kesselsdorf, a village just west of Dresden, in 1751. The son of a brewer, he was first apprenticed to a bookbinder in the city. The following year, 1764, the thirteen-year-old's talent in drawing was brought to the attention of Christian Hagedorn, general director of the newly re-founded Dresden Kunstakademie, who allowed him to take lessons there several hours a week. Christian Gottlob Mietzsch taught him drawing, Bernardo Bellotto perspective, and the artistic director Charles-François Hutin became his protector. Considered something of a prodigy, in 1768 Klengel made a copy of a Rembrandt in the Elector's collection that caught the eye of Christian Wilhelm Ernst Dietrich. The elder artist soon became Klengel's teacher and moved the teenager into his household, relieving him of the need for outside support. Klengel remained with him until Dietrich's death in 1774, during which time he began to make etchings. Like Adrian Zingg, he often combined etching and hand-applied brown wash for landscape, according to early biographers.[2]

After Dietrich's death Klengel, by now recipient of a stipend from the court, requested funds for a trip to Italy but was refused. Three years later he was made a member of the Kunstakademie and given apartments in the building, the first Academy member to have been trained there. The Berlin Kunstakademie made him an honorary member in 1786. In 1790 he finally made his long-awaited Italian trip but, while his etchings of scenes in and near Rome were well received, his style and interests were little changed by the experience. Ten years later he became professor of landscape drawing at the Kunstakademie and, in 1802, published his treatise *Principes de dessein pour les paysages*. Besides Caspar David Friedrich, he had many other students such as Johann Heinrich Menken, represented in this exhibition, and took one of them, Traugott Faber, into his household as Dietrich had done for him so many years before. Poor health plagued Klengel during the 1810s, marring his production, and in 1824, he died at the age of 73. As Anke Fröhlich points out, Goethe prized Klengel's work so much that he purchased 75 of his etchings at the sale of his estate.[3]

The Crocker drawing depicts a peaceful domestic scene. Members of a family gather round a table, the scene lit by a single light source, either a candle or a lamp. A woman is silhouetted against it, gazing towards a baby held by its seated nurse or mother. An older child, likely female, sits opposite. Furnishings typical of a middle- or upper-class interior surround the group: the nurse sits on a Louis XV canapé drawn up to the gracefully bow-legged table, while the elder child sits on a high-backed chair with a wide central splat. Further to the right, a cradle, half covered by a blanket or mattress, is set next to a high curtained bed. Beyond, an arched mirror and what is likely a framed work of art flank a tall, lavishly curtained window, the valance pulled up and the tasseled cord picked out by the light. The end of one curtain is draped over the high-backed chair.

PROVENANCE

Rudolph Weigel? Edwin Bryant Crocker, by 1871; gift of his widow Margaret to the Museum, 1885

LITERATURE

Breazeale 2008, p. 223; Fröhlich 2005, no. Z53; Kaufmann 2004, p. 114; Kaufmann 1989, no. 83; Crocker 1971, p. 154; Scheyer 1949, no. 66; Crocker 1939, no. 68; likely Weigel 1838-66, no. 16174

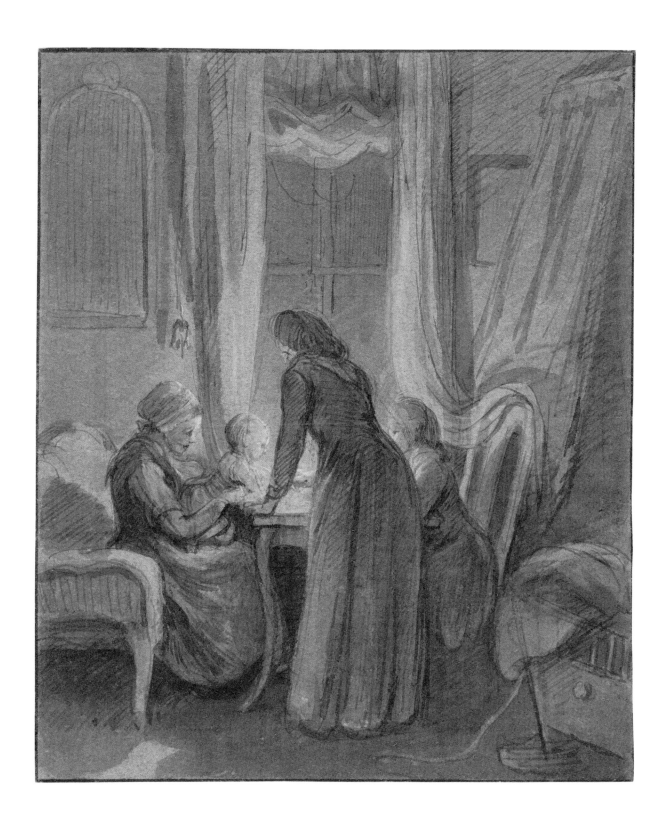

In 1942 Bernhard Dörries compared Klengel's candle-lit interiors to Chodowiecki's.[4] The Berliner artist's *Occupations des Dames* (*Beschäftigungen der Damen*), a series of twelve prints depicting women's activities published for a 1781 calendar, would have been easily accessible to Klengel and includes many such scenes, nighttime sewing, gaming and visiting, for example. The figure silhouetted in front of a candle, however, is a motif less common in Chodowiecki's work than in that of Gottfried Schalcken and Gerard Dou, whom Klengel would have known from his time with Dietrich, who was enchanted by Dutch and Flemish artists. Though rarely combined with domestic interiors, candlelit and silhouette effects occur often in Dietrich's own work, for example the Leipzig *Flight into Egypt* and the Karlsruhe *Adoration*.[5]

A second version of the Crocker scene is in Berlin (fig. 40). Of similar medium and slightly larger dimensions, it shows an identical placement of figures but the surroundings are simpler: the chair, table, and couch are not ornate, the bed, crib, mirror and frame have disappeared, and the window dominates the scene more completely, with the valance drawn up to reveal the window's arch and the curtains spread as if to embrace the figures gathered around the candle or lamp. Thomas DaCosta Kaufmann proposes that the detail in the Sacramento drawing dates it after the Berlin one, but the present writer believes the greater compositional unity of the Berlin drawing might mean a simplification of the Sacramento version, or, given the difference in curtains and furnishings, the two drawings might represent a summer and winter version of the same scene.

The dating of both the Berlin and Sacramento drawings has traditionally been circa 1785. Anke Fröhlich has proposed that the sitters may be the artist's own family, his wife Maria Rebecca, née Wolrab, his daughter Emilie Charlotte Clementine, and his son August Alexander. If so, with the latter two born in 1785 and 1783 respectively, she proposes the date of the Crocker drawing to be circa 1790 based on the ages of the children.[6] WB

FIG. 40
Johann Christian Klengel, *A Family at a Table*, n. d. Pen and black ink, brush and gray washes and white opaque watercolor, 20.3 × 17.0 cm. Staatliche Museen zu Berlin, Preußischer Kulturbesitz, Kupferstichkabinett, inv. no. F347

17 *Portrait of an Artist*, n. d.

Black chalk and black crayon on cream laid paper, 35.8 × 26.2 cm
Crocker Art Museum, E. B. Crocker Collection 1871.1075
Inscriptions: black crayon, lower left: *N. Ritter*; verso, black chalk, lower left corner: *B*; verso, black chalk, lower right corner: *-9*

Nikolaus Ritter the Younger was an accomplished draughtsman, to judge from this drawing and his surviving portraits. Born in Amsterdam in 1777, he was a member of the Felix Meritis association. Though biographical information about him is scant, he is known to have worked in Russia and died sometime after 1797. Georg Nikolaus Ritter, his father, was German and worked in Amsterdam as a miniaturist.

The Crocker drawing is quite fresh, the skilled work in hatched black chalk sharpened by touches of black ink at the face and clothing, as well as some gray wash in the shadows. It represents a mature man, certainly an artist, before the pedestal of an enormous cast of the Apollo Belvedere. The artist's hand grasping a chalk-holder rests on an unfastened large, untidy portfolio with crumpled drawings projecting around its edges. At his left, his companion or assistant gazes up at the ancient sculpture while holding a portfolio and chalk-holder himself. Both of their costumes include decorative, personal touches—a signet ring and bowed shoes for the artist and an earring for his companion. Given the many elements pointing to the artistic profession, it is not surprising that the cover of the artist's portfolio bears a medallion depicting a large flower, bees, and a beehive. This most likely refers to the common trope in art and poetic theory, that the artist must be like the bee gathering nectar: by studying the best parts of earlier masters, he can then incorporate them into his own works and style, the "honey" of the metaphor.

The sitter's profession and the prominent signature raise the question of whether the drawing is a self-portrait. In fact, a self-portrait in the Universiteitsbibliotheek Amsterdam of around 1795 bears a thematic resemblance and, accounting for a difference in age, a physical one as well

(fig. 41).[1] There a young man with a chalk-holder in hand stands before an ancient nude sculpture, his gaze addressing the viewer. These elements, along with the similar hairstyle to the Crocker sitter, leads to the conclusion that the latter depicts Ritter a few years later, his features hardened with maturity. The artist's inclusion of the art of the ancient world and, through the bee metaphor, the principle of selective imitation, would then show his allegiance to a certain type of artistic training still important in the early years of the nineteenth century, the likely date of the drawing. WB

FIG. 41
Nikolaus Ritter, *Self-Portrait*, circa 1795. Black chalk, graphite, brush and gray wash, 18.2 × 19.0 cm. Universiteitsbibliotheek Amsterdam, Special Collections, Handschriften XXI C 19

PROVENANCE
Edwin Bryant Crocker, by 1871; gift of his widow Margaret to the Museum, 1885

LITERATURE
Kaufmann 2004, p. 243; Crocker 1971, p. 161

18 *Lais and Socrates*, 1800

Pen and gray ink, brush and gray and brownish washes and white opaque watercolor, touches of black chalk
on blue laid paper, 46.0 × 34.3 cm
Crocker Art Museum, E. B. Crocker Collection 1871.82
Inscriptions: black chalk, lower left corner: *H*[? cut off] *Füger 180...* [cut off at bottom]

A dedicated Neoclassicist, Heinrich Friedrich Füger shaped the artistic life of Vienna through his long service at the city's Kunstakademie and Imperial paintings gallery. Though its subject has long been under debate, this drawing shows well the artist's exacting style based on his experience of ancient Roman art in the Eternal City and the rediscovered Herculaneum and Pompeii.

Füger was born in the southern German city of Heilbronn in 1751. At first a student of the law, he gave it up in favor of art, moving to nearby Stuttgart to study under the court painter Nicolas Guibal. In 1769 he pursued further study with Adam Friedrich Oeser in Leipzig. Five years later he was admitted to the Kunstakademie in Vienna on Guibal's recommendation.[1] The main patron of the newly re-founded (1772) Academy, Fürst Anton Wenzel von Kaunitz, sponsored Füger's study trip to Italy, which began in 1776 and lasted nearly seven years. While there he became very close to Mengs and his circle, absorbing their views on ancient and modern art. In 1781, he visited the court of Naples, where Maria Theresa's daughter Maria Carolina was queen, receiving from the royal family a commission for frescoes at the palace at Caserta. He also visited the excavations at Herculaneum and Pompeii. Bettina Hagen discerns Pompeii as a source for Füger's distinct classicizing facial type.[2] Offered service to the Neapolitan and Russian courts in 1782, he refused.

A year later, he accepted the vice-directorship of the Vienna Kunstakademie and left Italy. His paintings effectively introduced the new classicizing style to the Viennese public.[3] A friend of many in the city's wider artistic world, he married the actress Josefa Hortensia Müller in 1791, and in 1795 Füger became both court painter and director of the Kunstakademie. In addition to a long series of paintings in the Neoclassical style, he created an altarpiece for the Hofburg chapel in 1802, with a pendant by his fellow academician Hubert Maurer. He was also a prized miniaturist. In 1806, just over a year after the proclamation of the Austrian Empire, he became director of the Imperial paintings gallery and, finding his energies stretched, gave up the Kunstakademie directorship. The war with France taxed his capacities as well, forcing him to remove and rehang the entire collection three times and to endure French troops carting away 400 paintings.[4] He died in 1818.

According to Robert Keil, the present drawing illustrates Christoph Wieland's epistolary classicizing novel *Aristipp und einige seiner Zeitgenossen* (Aristippus and Some of his Contemporaries).[5] This is in accord with Füger's close relationship to German authors and his concentration on modern not ancient literary sources for ancient historical and mythological subjects.[6] The conversation depicted here takes place between Socrates and the educated *hetaera*, or prostitute, Lais. This identification settles a controversy, as she was proposed to be one or other of the *hetaerae* Aspasia or Theodota, both known to Socrates as described in ancient sources.[7] The scene is in letter XXV of the first volume of the novel. Lais makes a kind of intellectual pilgrimage to Athens, where, to gain access to various members of society, she assumes an alternate identity as Anaximandra,

PROVENANCE

Edwin Bryant Crocker, by 1871; gift of his widow Margaret to the Museum, 1885

LITERATURE

Robert Keil, *Old Master Drawings, Recent Acquisitions, Autumn 2010, n.p.; Kaufmann 2004, p. 195; Stefan Füssel, Georg J. Göschen, ein Verleger der Spätaufklärung und der deutschen Klassik*, Berlin, 1996, no. 2405, p. 324; Richard J. Campbell in Richard J. Campbell, Victor

Carlson et al., *Visions of Antiquity: Neoclassical Figure Drawings*, exh. cat. LACMA, 1993, no. 102; Kaufmann 1989, no. 48; Howard et al. 1972, no. 38; Crocker 1971, p. 152; Scheyer 1949, no. 19; Crocker 1939, no. 69

Aristippus's relative from their native Cyrene. Her meeting with Socrates is ostensibly to bring him news of Aristippus, though her real objective is philosophical discussion. She soon gathers a sort of intellectual *salon* around her that is always enlivened by the elder philosopher's presence. The poses of the two figures, with the newly modest *hetaera* gazing meaningfully at her intellectual hero, capture the moment when Socrates assures her of his goodwill towards the entire family of Aristippus.

The drawing is one of a group of four identified by Robert Keil as illustrations for Wieland's novel.[8] The second, *Lais Taking Aristippus by Surprise*, is now in the Metropolitan Museum[9] and illustrates vol. II, letter XXXIX. The other two, *Cure for Nympholepsy*, illustrating vol. III, letter IX, and *Cleone with her Children,* illustrating vol. IV, letter XIII, were with Keil in 2010. The drawings had been unknown to him when he published his monograph on Füger the year before. Friedrich John's mezzotints after the drawings were published in the 1802 edition of Wieland's book. WB

19 *Ajax Abducting Cassandra*, n. d.

Brush and reddish-brown washes in various shades and flesh-colored and white opaque
watercolor over graphite, 26.5 × 21.6 cm
Crocker Art Museum, E. B. Crocker Collection 1871.1007

"Then I went to Cavaliere Pompeo Battoni, who was very
well disposed towards me. I showed him a head of Paris he
liked so much that he said, 'One day you will be a leading
painter'" (*Hierauf ging ich zum Cavaliere Pompeo Battoni, der
mir sehr geneigt war. Ich zeigte ihm einmal einen Pariskopf,
der gefiel ihm so, daß er sagte: 'Voi farete una volta spicco tra
i pittori.'*)

Johann Wilhelm Tischbein fulfilled the Roman painter's
prophecy. Born in 1751 in Haina in the west-central German
region of Hesse, Tischbein became the most famous member
of a prolific family of painters. Trained by his uncles Johann
Heinrich and Jacob, he first learned portraiture but then
studied history painting in Hamburg. After travel across
northern Germany and the Netherlands, he served as court
portraitist in Berlin for two years. In 1779 he moved to Rome
and encountered the new Neoclassical style. He returned to
Italy in 1783, after time in Switzerland and his homeland,
and did not leave again until 1799. He met Goethe, whom he
instructed in drawing, and made his most famous portrait,
Goethe in the Roman Campagna (now Frankfurt, Städel).

1787 found him in Naples, where he introduced his
distinctive Neoclassical style. His directorship of the
Neapolitan Accademia Borbonica di Belle Arti, beginning
in 1789, brought him in closer contact with the city's
flourishing artistic élite, which included many foreign
artists and patrons. Among these were Jacob Philipp Hackert
and Angelica Kaufmann, as well as the English prime
minister of Naples, Sir John Acton, 6th Baronet, and the
English envoy, Sir William Hamilton. For Hamilton, whose
bewitching wife Emma was a close friend of Queen Maria
Cristina (and later mistress of Lord Nelson), Tischbein

illustrated a four-volume edition of line engravings which
recorded his collection of ancient vases.[1] His classicizing
history paintings and portraits of his contemporaries
similarly reflected his keen interest in the continuing
discoveries of ancient objects in the ruins of Herculaneum
and Pompeii.

Twelve years after his arrival, and at the height of his
career, Tischbein was forced to leave Naples because of the
French occupation. His wanderings in northern Germany,
where he nonetheless continued to pursue his interest in
the ancient world, ended in 1808, when he settled at the
Oldenburg ducal court. His duties there, in addition to
serving as court painter, included the directorship of the
paintings gallery. The gallery consisted largely of Tischbein's
own purchases in Italy, which he had sold to the family as
early as 1804.[2] He remained there for over two decades until
his death in 1829.

The subject of the Crocker drawing is the episode of Ajax
and Cassandra [*Aeneid* II, 400-404], in which, during the
sack of Troy, the warrior Ajax brutally rapes the prophetess
Cassandra, dragging her away from the temple of Minerva,
where she had taken refuge. The prophetess, whose
predictions were accurate but never believed, clung to the
statue of Minerva in her struggle. This violation of Minerva's
sanctuary earned Ajax the wrath of Odysseus, who called for
his fellow warrior's death. Clinging to the statue of Minerva
himself, he loudly proclaimed his innocence.

Created in reddish washes and two shades of opaque
watercolor, Tischbein's drawing presents the participants
in a shallow stage-like space. Ajax, sword in hand, grasps
Cassandra by the hair to carry her away. She, her body

PROVENANCE

Rudolph Weigel, by 1867; Edwin Bryant
Crocker, by 1871; gift of his widow Margaret to
the Museum, 1885

LITERATURE

Breazeale 2008, p. 222; Peter Prange, *Deutsche
Zeichnungen 1450–1800, Sammlungen der
Hamburger Kunsthalle Kupferstichkabinett*,

2 vols., Cologne, 2007, p. 350; Howard et al.
1972, no. 36; Kaufmann 2004, pp. 252–53;
Crocker 1971, p. 164; Weigel 1838-66, no. 17334

twisted dramatically, embraces the statue of Minerva. Her pose is reversed from a famous ancient relief once owned by Lorenzo Ghiberti known as the "Letto di Policleto," which depicts a female figure from behind as she balances on the edge of a *kline* to unveil a sleeping male figure.[3] The relief would have been known to Tischbein from his time in Rome, since modern replicas were at Palazzo Corsetti and in the loggia of the Palazzo Mattei di Giove.[4]

A series of drawings of similar technique and conception exists in the Cotta-Archiv in Stuttgart,[5] some depicting more figures, for example in battle scenes. They were created in preparation for the artist's *Homer nach Antiken gezeichnet* (Homer drawn from the Antique), a folio-sized series of prints with commentary on the ancient epics by Christian Gottlob Heyne (Göttingen, 1801). The shallow space and dark background with figures standing out as if in relief, common to both the Crocker and Stuttgart drawings, may have a source not only in vase painting but also in Tischbein's period in Naples. During his visits to Naples Goethe recorded not only Emma Hart's—as she was then, later Lady Hamilton—emotive classicizing performances in Greek costume, but also an apparatus before, or rather within which, she performed. This was a monumental, shallow rectangular box with a frame in gold and a black background, so that the young woman's poses and gestures appeared against it like paintings from Pompeii, or modern ones. Hermann Mildenberger has identified paintings in which Emma posed in her distinctive manner for both male and female figures.[6]

In 1806, Tischbein created a painting of *Ajax and Cassandra* in a quite different pose, for which a drawing for the body of Cassandra survives.[7] In his discussion of the drawing, Peter Prange identifies an engraving in Tischbein's reproductions of Hamilton's vases with the Crocker drawing, but it does not show the same Cassandra episode.[8] Likewise, the idea that a red-figure vase by the Kleophrades painter now in Naples is the source for Tischbein's composition for the Crocker drawing[9] is based on a misreading of Lois Perkins's entry of 1972.[10] The vase in question, inv. no. 81699 in the Museo Archeologico in Naples, shows the rape of Cassandra by Ajax as part of the sack of Troy, but the position of the figures and the statue is unlike the scene in the Crocker drawing. Anke Fröhlich, however, has identified a possible model for Tischbein's drawing among the small plaster reliefs in Philipp Daniel Lippert's *Dactylothek*, created in 1767 in Leipzig.[11] The pose of Ajax is identical to that in the Crocker drawing, but Cassandra and the statue are in a different position.

The Crocker drawing likely dates from the late 1790s, near the time of the technically similar Stuttgart works, rather than from 1806, the date of his painting of the same subject. WB

20 *Portrait of Jakob Egger*, circa 1806

Black crayon, white and red chalks, black chalk on brown laid paper, 50.5 × 41.5 cm
Crocker Art Museum, E. B. Crocker Collection 1871.813
Inscriptions: mount, black chalk, below center: *Kupferstecher Eggert* (two different hands)

"Those who wish to become great in this field, must not only know simply how to engrave with the burin, but also how to treat the subject in a painterly manner" ([*W*]*er in diesem Fach groß werden will, muß nicht blos verstehen mit dem Grabstichel zu gravieren, sonder die Sache mit mahlerosen Geschmack tractieren können*).[1] Though Merz's words were written about printmaking, they apply equally to his draughtsmanship. Created with black, red, and white chalks, this depiction of his friend Jacob Egger shows the same skill as his surviving oil portraits.

Born in Buch am Irchel near Zürich in 1783, Jacob Merz showed early talent in drawing, so much so that his father complained that no paper in the house was safe from his sketches.[2] After a period of strife with his father, who wanted the young Merz to follow him in his trade as a weaver, he was received into the household of a preacher, Wilhelm Veith, in Andelfingen. There he was able to pursue his interests, copying drawings by sixteenth-century Swiss artists, for example, and meeting a Swiss professor at the Dresden Kunstakademie, Anton Graff. After two years, in 1797, Veith and his friends sponsored Merz's study with the printmaker Heinrich Lips, who illustrated Kaspar Lavater's *Physiognomische Fragmente*.[3] By 1800 Merz was sufficiently advanced to create a print after Domenichino and the search began for an appropriate academy for the seventeen-year-old. Partially because of Veith's friendship with its patron Count von Delmotte, the young artist enrolled at the Vienna Kunstakademie, his acceptance piece being a portrait of Lavater.

Arriving in the Hapsburg capital in 1802, he was welcomed by the director Friedrich Heinrich Füger and found a supportive community of Swiss artists, including Johann Rudolf Füßli, librarian at the Academy. Soon he met Delmotte, who introduced him to Archduke Karl, the powerful Hapsburg protector of the Academy, and gained the latter's sponsorship. In this period Merz produced many miniature portraits, following the example of Füger, but decided that oil painting, rather than printmaking or miniatures, was his goal. In 1803-04 he made a series of portrait prints of the Kunstakademie faculty. He traveled east, to Schönau in 1804, and in 1805 to Hungary as drawing instructor to a noblewoman. The year was eventful. He began to share quarters with his fellow Swiss printmaker Jacob Egger. Later he met the sculptor Antonio Canova, in Vienna to complete the masterful monument to Maria Christina of Austria, and received the commission for the published print of it. Another commission was six prints of écorchés for Johann Martin Fischer's anatomy treatise *Darstellung des Knochenbaues und der Muskeln des menschlichen Körpers* (Depiction of the Bone Structure and the Muscles of the Human Body)[4] In fall 1805, however, he was denounced as a political agitator and impressed into the Imperial army, released only after the intervention of Egger, Füger, and the Princess Schwarzenberg.

The most important commission of Merz's career came in 1806, when he was given a stipend and the span of a year to complete prints of the bronze equestrian monument to Emperor Josef II by Franz Anton von Zauner, by then

PROVENANCE

Rudolf Weigel, by 1866; Edwin Bryant Crocker, by 1871; gift of his widow Margaret to the Museum, 1885

LITERATURE

Seymour Howard, 'Jacob Merz's Portraits of the Vienna Academy Faculty,' in *Master Drawings*, vol. XXII, no. 1, Spring, 1984, p. 54 n. 15; Seymour Howard, *Jacob Merz (1783–1807)*, exh. cat. Zürich, 1981, no. 33; Crocker 1971, p. 156; Weigel 1838-66, in lot 5776b

FIG. 42
Jakob Merz, *Portrait of Jakob Egger*, 1802 or
after. Black, red, and white chalk, blue pastel,
26.3 × 20.6 cm. Crocker Art Museum, E. B.
Crocker Collection 1871.805

Swiss and, before studying printmaking in Zürich, had
served as a mercenary in the army in the Palatinate. He came
to Vienna much earlier than Merz, in 1797. Later, he became
the librarian and print curator at the Kunstakademie,
replacing Johann Rudolf Füßli.[3]

Merz's chalks have captured his friend's piercing gaze,
tousled hair, and strong chin. Egger wears the cravat, double-
breasted vest, and high collar fashionable at the turn of the
nineteenth century. The subtle interaction of white and
red chalk in the flesh tones and the use of stumping in the
hair and coat impart liveliness and credibility, and intensify
the sense of personality that emanates from the likeness.
Seymour Howard pointed out the similarity to oil portraits
Merz made of other friends, though the same intense
presence is also found in a pastel self-portrait of 1802.[4]

A second, smaller portrait of Egger, also in the Crocker
collection, shows a more studious, younger man (fig. 42).
Here the sitter is more reserved, with a closed jacket and
closely-knotted cravat unlike the pleated butterfly-like
bow in the first. The difference is striking, especially since
a maximum of five years separates the two: Merz arrived
in Vienna in 1802 when Egger was 36. The difference in
psychology is striking as well. Though likely done late in his
short life, there is no necessity to date the present drawing
after Merz's political episode.[5]

As talented as these drawings show him to be, Jakob Merz
remains little known because of a life cut short. The Crocker
is the main repository of his graphic work, consisting of
279 drawings of the 471 that appeared in the stock of the
Leipzig dealer Rudolf Weigel (1804–1867).[6] Taken as a whole,
they are a fascinating document of a single artist's training,
from copies after Sadeler's prints he made as an apprentice
under Lips, to studies after the Kunstakademie's casts of
ancient sculpture, to drawings for the Fischer écorchés and
Academy faculty prints, to his final drawings of the Josef II
monument. WB

director of the Kunstakademie. Merz regarded this as the
springboard for his entire future, making very specific
plans for his later life as an oil painter.[5] However, it was not
to be. On the very day, it seems, of presenting his work and
receiving Zauner's praise, he fell ill of a fever, dying in 1807
at the age of 24.

"You should see the two artists Egger and Merz—how
simple, contented, and really artist-like is their life. The
apartment [is] as tidy and handsome as if it were a princely
dwelling" (*Da sollten Sie nun die beiden Künstler Egger
und Merz sehen—wie einfach, wie vergnügt, und wahrhaft
Künstlermäßig—sie leben. Die Wohnung so schön und reinlich,
als ob sie eine fürstliche Residenz wäre*).[1] Artist and sitter
for the Crocker drawing had a close relationship: Egger
had witnessed the political accusations against Merz,
engineered his release, and was present for his last illness.
Perhaps because he was well known to Merz's circle, little
about Egger can be gleaned from the younger artist's early
biographies.[2] Jacob Egger, born in 1766 near St. Gallen, was

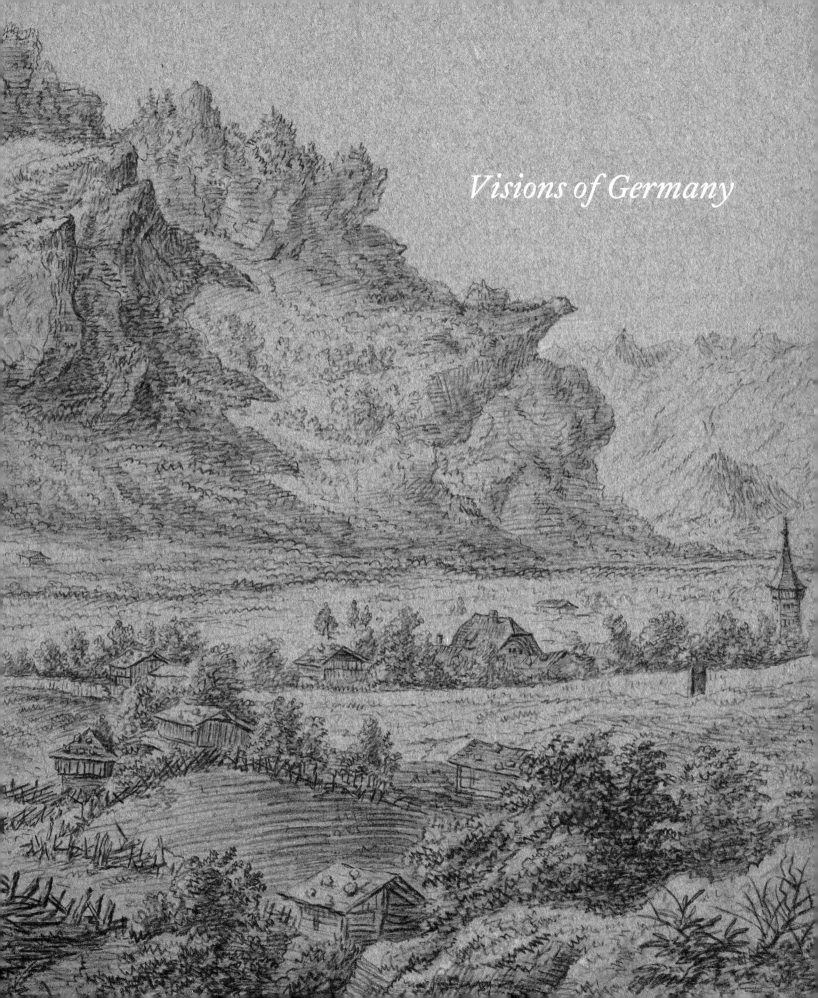
Visions of Germany

JOHANN ALEXANDER THIELE

21 *A Marble Crag*, 1746

Pen and brown ink, brush and brown wash, over black chalk, 46.0 × 33.0 cm
Crocker Art Museum, E. B. Crocker Collection 1871.603 verso

Inscriptions: graphite, upper margin at right: *Geschenk von Hrn. Müller*; signed, dark brown ink, lower right corner:
ein weißer Marmorfels / bey Frauenstein, / ad viv. del. per JA Thiele / 1746.; verso, dark brown ink, lower right corner:
Ein andrer weißer Marmor / fels bey Frauenstein / ad viv. del. per J […] / 1746; verso, red ink, center of lower margin: *346.*

Painter to the Electoral Saxon court, the landscapist Johann Alexander Thiele (1685–1752) took sketching trips through Thuringia,[1] Saxony, Upper Lusatia and Bohemia, as well as northern Germany, where he recorded the region around Schwerin, the seat of the Margrave of Mecklenburg-Schwerin.[2] The drawings he created along the way in graphite, black chalk, or pen and brown ink with brown wash, served as preparatory works for his so-called *Prospekte*. These were large-format canvases with characteristic views of castles, fortresses, cliffs, and villages ensconced in landscapes, conveying an image of the princely domains and power. The attractions he sketched on site appear mostly in the middle ground of the relevant painting, while the foreground was reserved for an imagined landscape scene. The artist placed figures, paths, bushes, and treetops around and over the attractions in the middle ground, with a result that recalls the stage sets in Baroque peepboxes.

Landscape was not at the top of the hierarchy of painting genres during Thiele's lifetime, and his own paintings were considered of secondary value since they reproduced the monuments and nature before him rather than being invented compositions. His importance as founder of the school of landscape painting in Saxony has nonetheless been recognized since his own time. At the beginning of the twentieth century Moritz Stübel brought Thiele's status as 'Pre-Romantic' and 'Father of Saxon landscape painting' to the public's attention once more by producing high-quality photographic reproductions of his *Prospekte*. His book is even now a rich resource, since not all the artist's works have survived over time.

The present double-sided drawing, with one motif vertical and the other horizontal, was created in 1746 in Frauenstein, south of the Saxon capital, Dresden. Perhaps it belongs to the preparatory works Thiele created there for his painting *The Castle and Town of Frauenstein Towards Morning* (*Schloß und Stadt Frauenstein wie solches gegen Morgen presentiret*).[3]

Near the little town of Frauenstein in the Erzgebirge, the so-called Buttertöpfchen (Little Butter Dish), a weathered gneiss quartzite rock formation, stands in an open field. It is part of the quartzite vein stretching from Oberschöna to Frauenstein, and is now a natural monument.[4] The entire Erzgebirge in southern Saxony, on the border with Bohemia, was rich in veins of silver and tin. From medieval times forward, Saxony's wealth came from the mines in the district, which is the reason geological anomalies such as the Buttertöpfchen have always been noticed. The mines in Johanngeorgental, Annaberg, Schneeberg, and Freiberg were important places. The word *Taler*, which became the English word "dollar", originated in the Erzgebirge mining town of Joachimsthal, where a coin called the *Joachimsthaler* was struck. This drawing is not the only testimony of the region's geological and cultural history. Five *Prospekte* by Thiele of the district around Freiberg that include shaft mines, pit mines, stamp mills, flumes, and slag heaps show the economic importance of the region.[5]

PROVENANCE

E. B. Crocker, by 1871; gift of his widow Margaret to the Museum, 1885

[not lot 1242 in Crusius sale, Leipzig, Weigel, March 2, 1863 as mentioned in Kaufmann 2004 as in Literature below]

LITERATURE

Kaufmann 2004, pp. 171–72; Kaufmann 1989, no. 89; Crocker 1971, p. 164

In his painting of the castle and town of Frauenstein mentioned above Thiele represented several gradations of the space stretching into the distance. Here, on the other hand, he focused on the motif of the bizarrely eroded rock formation jutting out from its surroundings. On the verso only a few slender fir trees surround it to support its form and give it scale. On the recto the trunk of a dead tree, along with the horizon line, anchors the depiction of the rock formation in space. Thiele used long strokes of the pen to outline the forms he shaded with brush and wash, giving them volume and mass.

A few other studies like this one survive from Thiele's hand, emphasizing his careful preparation for his paintings. The Romantic artists at the beginning of the nineteenth century were not the first to study nature with a thoroughly reverent attitude towards individual forms; they were anticipated by Thiele and his pupils fifty years earlier. AS-F

22 *Mother and Child before a Thatched Cottage in Vernon, Normandy*, 1761

Burnt red chalk on cream laid paper, 23.5 × 34.3 cm
Crocker Art Museum Purchase with funds provided by Anne and Malcolm McHenry, Peter Flagg, Zarou and Hanns
Haesslein, Paulette and Rodney Hennum, Gary Johns and John Schneider, Muriel and Ernie Johnson, Lisa Paxiao,
Jean Reynolds, Charles Roberts, David and Patricia Roberts, and Sachi Wagner, 2013.31
Inscriptions: burnt red chalk, lower right at bottom margin: *dessiné par Wille a Vernon 1761*

Johann Georg Wille (1715–1808) was a versatile and influential artistic personality. Artist, collector, art dealer, teacher, friend, and correspondent, he was a networker, as we would call him today, a character typical of the eighteenth century before the French Revolution.

First trained as an engraver in a gunsmith's workshop, Wille left his home in Hesse and journeyed on foot to Strasbourg. From there, he went to Paris in the company of the engraver Georg Friedrich Schmidt. He was able to make a name for himself among the most famous Parisian printmakers of his time. Besides engraving from his own designs, he created portraits after popular Dutch masters, but especially after paintings by Germans such as Christian Wilhelm Ernst Dietrich and his former pupil Johann Eleazar Zeißig, called Schenau. As the Parisian dealer for many of his well-known colleagues, he promoted their talents and reputation through sales on the city's art market, and through a wide network of correspondents, among them the Dresden Kunstakademie director Christian Friedrich von Hagedorn.

As a draughtsman Wille developed an original style in pen and brush or, as here, with chalk. We know that he made sketching trips with his students from Paris into the countryside. There he recorded mainly country scenes with staffage, as in this sheet made in Vernon, 67 kilometers northwest of the capital. A woman and child are shown beside a thatched cottage built around a circular core, possibly the entrance to a cellar or a huge communal oven. Wagon wheels, bundles of brushwood, rails, poles, and a barrel are picturesque motifs familiar from seventeenth-century Dutch landscape paintings and etchings. Spirited short, thick red chalk hatching and reserves of blank paper reproduce the lively interplay of light and shadow. He indicated thistles, weeds, grass, and branches with a system of zigzagging strokes that allow an illusionistic depiction of quivering leaves. In this respect he was a forerunner of Adrian Zingg, who was among his students in Paris and brought his technique to Dresden, where it flourished well into the nineteenth century. AS-F

PROVENANCE
George Encil. W. M. Brady, purchase by the Museum, 2013

LITERATURE
Sotheby's London, July 4, 2012, no. 78; George Encil, *Experience and Adventures of a Collector*, Paris, 1989, p. 248

Dessiné par Wille a Vernon 1761

ADAM FRIEDRICH OESER

23 *Nymph of the Source,* from Johann Gottfried von Herder's *Zerstreute Blätter,* n. d.

Black chalk, brush and brown and grayish-brown washes on cream laid paper, 29.5 × 36.9 cm
Crocker Art Museum, E. B. Crocker Collection 1871.1060

Inscriptions: graphite, lower right corner: *A. F. Oeser*; mount, black chalk, below center: *die Nymphe des Quells. / Schöpfe schweigend!*; mount, black chalk, lower right: *aus Herders zerst. Blätter*; mount, dark brown ink, lower right corner: *Oeser f / 2901.*; verso, black chalk, lower right: *Oeser*; verso, blue crayon, lower right: *11*; verso, black chalk, lower right corner: *113-*; verso, black chalk, lower right quadrant: *Oeser*

The artistic movement of Neoclassicism, with its orientation towards ancient Greek ideals of beauty, naturally influenced landscape painting as well. Adam Friedrich Oeser (1717–1799), director of the Leipzig Kunstakademie from 1764, was one of the artists who shaped contemporary taste with invented, park-like nature views with Arcadian or emotive, idyllic staffage figures.[1] His landscapes were populated with nymphs and shepherds.

The Dresden professor of moral philosophy and history Wilhelm Gottlieb Becker described Oeser's landscapes in the following way. "[Everywhere were] scenes of past times. Even when he only copies, he paints poetically. But he ventures at last to borrow scenes from this natural world and arranges them with others, enlivens them with tasteful images of antiquity…. Thus he becomes a romantic landscape painter, and gives friends of nature and art more reason to travel to enjoy his paintings; he furnishes material for contemplation as well as for feeling" ([*Überall waren*] *Scenen der Vorwelt. Dann auch, wenn er nur nachahmt, malet er dichtend. Aber wer wagt es endlich, Scenen aus dieser Natur zu borgen und sie mit andern zu ordnen, belebt sie mit den geschmackvollen Bildern des Alterthums … So wird er zum Landschaftsmaler romantischer Gattung, und giebt dem Freunde der Natur und der Kunst noch mehr Bewegungsgründe, sich seiner Gemälde zu erfreuen; er liefert ihm Stoff zur Betrachtung, wie für Empfindung*).[2] The term "romantic" here is used to mean that nature becomes enriched by human additions and loaded with history and stories, in order to offer the viewer that much more visual enjoyment,

emotional attention, and instruction. This concept differs from that of Romantic landscape painters at the beginning of the nineteenth century such as Caspar David Friedrich and his circle, who represent every natural place, object, and emotionally charged atmosphere as a symbol for a human psychological state.

Here a nude young woman sits on a stone underneath a tree and commands silence with a finger raised to her lips, while pointing with her other hand to a stream. This is the depiction of the Nymph of the Source, a figure from Johann Gottfried von Herder's *Blumen aus der griechischen Anthologie gesammelt* (Flowers gathered from a Greek Anthology), the 'Scattered Leaves' (*Zerstreute Blätter*), in which he writes:

Schöpfe schweigend.
Warum?
So schöpfe nicht.
Und warum nicht?
*Nur dem stillen Genuß ström ich erquickenden T*rank.

Draw water in silence.[3]
Why?
Then do not draw it at all.
And why not?
Only for silent enjoyment do I, the refreshing draught, flow.[4]

In the center of the landscape there sits a young woman in a rather unstable position, her soft, plump limbs typical

PROVENANCE

Adam Friedrich Oeser; his sale, Leipzig, Weigel (not Rost), February 3, 1800, no. 1137. Edwin Bryant Crocker, by 1871; gift of his widow Margaret to the Museum, 1885

LITERATURE

Kaufmann 2004, p. 144; Kaufmann 1989, no. 46; Crocker 1971, p. 158; Alphons Dürr, *Adam Friedrich Oeser, ein Beitrag zur Kunstgeschichte des 18. Jahrhunderts*, Leipzig, 1879, p. 235; Oeser sale, Leipzig, Weigel (not Rost), February 3, 1800, no. 1137

of the artist's work. The turf and bushes also have a soft and well-padded effect, providing a harmonious *locus amoenus* for the figure as well as for the observer exploring the landscape with his gaze. Oeser's stippled brush technique in heavily diluted brown ink is noteworthy. Light and shadow, as well as a sort of aerial perspective in the brightly lit distant landscape, are produced by superimposing many patches of color. This manner of coloring and application of wash was typical of Oeser's work and also influenced his pupils, among them the talented landscape painters Johann Sebastian Bach the Younger and Christoph Nathe. Bach the Younger in particular ended up surpassing his master in the virtuoso handling of this artistic medium. Christoph Nathe and others also depicted this popular subject. AS-F

24 *View of Pontiano near Mount Soracte*, 1776

Brush and brown washes over black chalk on cream laid paper, 38.2 × 47.3 cm
Crocker Art Museum, E. B. Crocker Collection 1871.78
Inscriptions: black ink, top margin at right: *Vuë de Pontiano sur le mont Soractes. 1776.*

Looking out from a promontory, the viewer has a commanding view of the curves of the Tiber river flowing into the distance. In the middle ground, the wooded slopes fall gently to the river valley, while, at the horizon beyond smaller mountains, the nearly conical Mount Soracte juts into the sky.

In the foreground at left a tree trunk blocks the viewer's gaze. Beyond it, by gradually diluting the intensity of the brown washes, the artist conveys the enormous expanse of the famous landscape, one often visited by artists. As the travel writer Carl Gottlob Küttner said, "The place is as attractive for landscape painters as it is interesting for Classical scholars and enthusiasts of the ancient world. The entire stretch of land is among Italy's most romantic" (*Das Land ... ist ebenso anziehend für den Landschaftsmaler, als es für den classischen Gelehrten und den Liebhaber der Altertümer interessant ist. Der ganze Strich gehört unter die romantischsten von Italien*).[1]

The similarity between this kind of brown-ink brush drawing and Adrian Zingg's landscapes is not coincidental. When Jacob Philipp Hackert (1737–1807) was in Paris from 1765 to 1768 to study under Johann Georg Wille, Zingg had already been active in his circle for some years. Both developed into significant landscape painters under the same influences in Wille's orbit.

Like Zingg, Hackert used the technique of creating the contours of treetops with closely-spaced hooks and filling in the intervening spaces with brush and brown wash, also known as the Aberli manner after the Swiss printmaker. These curved lines appear less strong when done in graphite, as here, rather than in pen and ink. The method of creating long grasses with quick strokes of the brush, as at lower left, recalls Franz Kobell's drawings.

In 1768 Hackert, originally from northern Germany, traveled from Paris to Italy. There he created his most important contribution, a comprehensive *oeuvre* of paintings, drawings, and prints. Goethe, for example, held Hackert's views of Classical landscape in high esteem and, during his 1786 journey to Naples, he attended a drawing school led by Hackert. He collected Hackert's works and honored him in a biography written after the artist's death in 1811. It was the young Christoph Heinrich Kniep who, in his own work, adhered most closely to Hackert's method of composing scenes, pictorial motifs, and drawing techniques.[2] AS-F

PROVENANCE

Edwin Bryant Crocker, by 1871; gift of his widow Margaret to the Museum, 1885

LITERATURE

Kaufmann 2004, p. 107; Crocker 1971, p. 152; Scheyer 1949, no. 36; Trivas 1941, no. 68

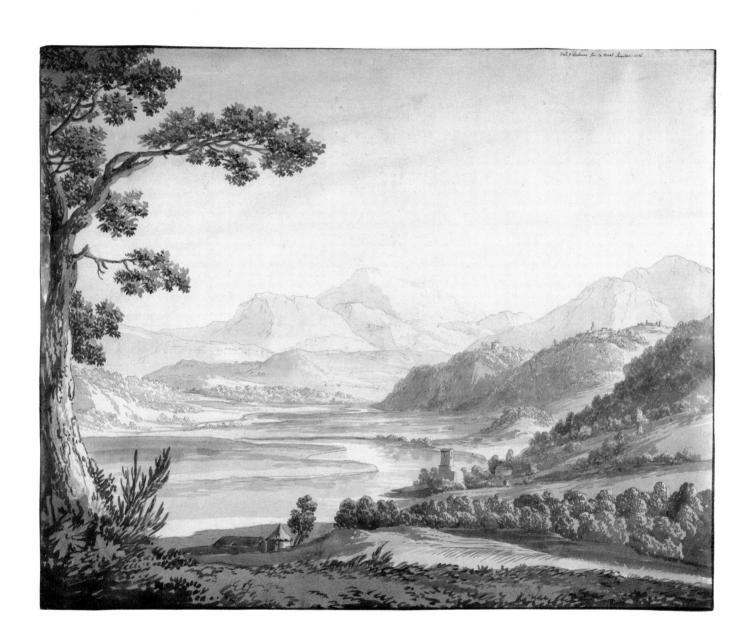

25 *Landscape with Sheep*, n. d.

Pen and gray ink, brush and brown washes on cream laid paper, 17.2 × 29.7 cm
Crocker Art Museum, E. B. Crocker Collection 1871.988
Inscriptions: black chalk, upper right corner, signed: *f. Kobell*; brown ink, on rock at bottom margin left of center,
signed: *Kobell*; verso, black chalk, lower right corner: *Ad:*

Ferdinand Kobell's (1740–1799) familiarity with seventeenth-century Dutch landscape painters is unmistakable in this drawing. A path winding its way to the riverbank or lakeshore, boughs, rocks and plants in the foreground, a herder with his cattle unobtrusively placed in the center of the composition, as well as picturesque cabins surrounded by expressive tree trunks, all belong to a specific inventory of seventeenth-century Dutch landscape motifs that were recombined again and again in German art of the eighteenth century. Though the teachable tradition of depicting landscapes was just as important, it goes without saying that Kobell's landscape was based on countless nature studies.

In this case the draughtsman created a diagonal composition that rises to the right, so that the bright, airy and (so to speak) impalpable distance at left and the close, tangible details depicted with darker strokes at right merge together. Reality flows forward, as it were, from the deepest part of the pictorial space towards the viewer and solidifies as a village landscape. This is a thoroughly worked-up sheet suitable for sale; the mastery demonstrated here ensures that nothing disturbs the harmony or the realistic impression. Light gray pen lines and patches and expanses of wash complement each other in depicting different surface textures in sunlight or shadow.

As the teacher of his brother Franz and his son Wilhelm, Ferdinand Kobell founded a dynasty of painters. It is interesting that, in sheets like the present one as well as in his etchings, he developed a similar aesthetic to artists such as Johann Christian Klengel working in faraway Dresden.

Moving in Johann Georg Wille's circle in Paris, Ferdinand Kobell was exposed to the same influences as Adrian Zingg, who later worked in Saxony. Their works are testimony to a special sensitivity to emotional response in the depiction of nature. AS-F

PROVENANCE
Edwin Bryant Crocker, by 1871; gift of his widow Margaret to the Museum, 1885

LITERATURE
Kaufmann 2004, p. 123; Crocker 1971, p. 154; Scheyer 1949, no. 76

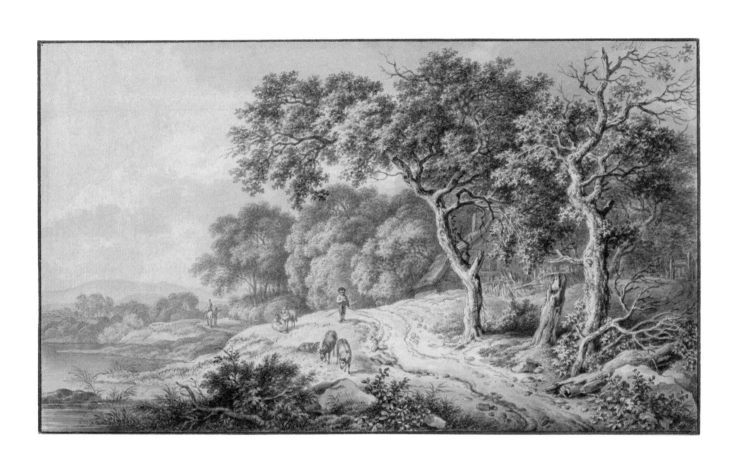

26 *Landscape with Cattle*, n. d.

Pen and brown and dark brown ink and gray wash, brush and gray wash, black chalk on cream laid paper, 38.6 × 51.8 cm
Crocker Art Museum, E. B. Crocker Collection 1871.1077
Inscriptions: black chalk, lower margin at left, signed: *M. Cath. Prestel*; mount, black chalk, lower right:
M[...] *C*[...] *Prestel geb. H* (?)

The daughter of a Nuremberg merchant, Maria Katharina Höll, later Prestel (1747–1794), followed an unusual path through life. After early training in drawing, she acquired a comprehensive artistic education in painting, drawing, and printmaking techniques in the studio of her future husband, Johann Gottlieb Prestel. After their marriage in 1772, they founded a printmaking workshop, in which she worked as a respected etcher and engraver, both from her own designs and, more often, from Old Master drawings found in a variety of German collections.[1] Their promising publishing business failed, however, and she moved to London with two of their four children. There she worked almost exclusively as a printmaker, creating colored reproductions of contemporary paintings.

The essential requirement for reproductive printmakers such as Maria Katharina Prestel was excellence in draughtsmanship. In this case the artist studied an unremarkable district in which bushes and trees grow between meadowed hills. The foreground and sky are indicated only with a few light strokes of the pen and are otherwise empty, while the foliage is outlined in pen and shaded with brush and wash. Maria Katharina used a similar technique of lines and tinted areas in her aquatint landscapes.

The pasture seems to be drenched in bright light. The path, the terrain, and the cottage show that this is not a complete wilderness, and the group of herders points to the idyllic quality of this rural vignette. As with every good drawing its essence is in the viewer's imagination which completes the scene. Thus, the path along the bushes appears to lead around the hill to the house, increasing the landscape's spatial depth. The fact that the drawing remains unfinished, as indicated by the barely sketched cattle, is just a small part of its charm. AS-F

PROVENANCE
Edwin Bryant Crocker, by 1871; gift of his widow Margaret to the Museum, 1885

LITERATURE
Kaufmann 2004, p. 290; Crocker 1971, p. 160

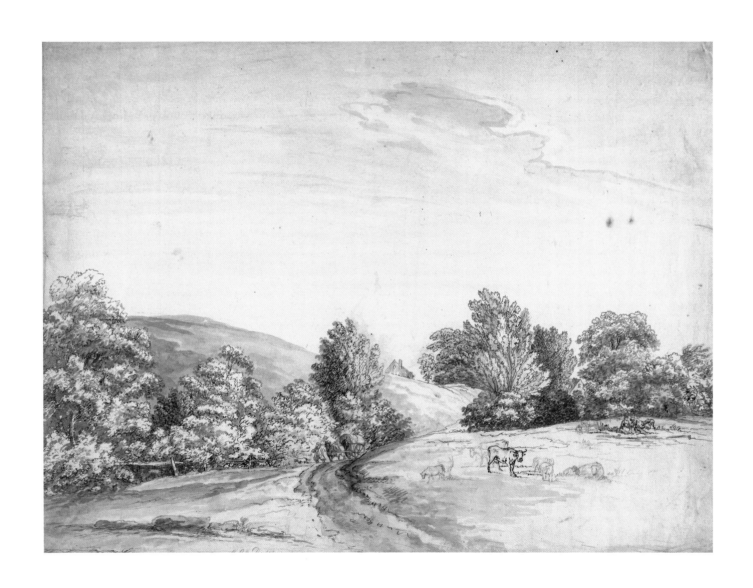

27　*A Waterfall*, n. d.

Pen and dark brown ink, brush brown ink and brown and gray washes, greenish, pinkish, orange,
yellow watercolor and white opaque watercolor on cream laid paper, 20.0 × 31.8 cm
Crocker Art Museum, E. B. Crocker Art Collection 1871.1065

Like his brother Ferdinand Kobell, his first drawing master, Franz Kobell (1749–1822) studied at the Mannheim Zeichnungsakademie. Since instruction at the Drawing Academy included copying after plaster casts but not landscape drawing, both brothers should be regarded as self-taught in that genre. They trained themselves by exploring the Dutch seventeenth-century paintings collection of the Wittelsbach Elector Karl Theodor of the Palatinate and Bavaria. The Elector sponsored Franz Kobell's 1778 trip to Italy, where the artist remained for six years. There he created idealizing landscapes which Goethe among others purchased in great numbers. These landscapes, such as this depiction of a waterfall, provide an example of Kobell's characteristic technique of extended pen strokes, which create an attractive contrast with the expanses of softly tinted watercolor.

Here Kobell composed his visual space by overlapping pictorial fields. The left bank of the falls, especially, creates a forceful contrast with the overlying middle ground. The dark sky and the heavy drooping tree branches cropped at the top of the sheet contribute to the drama of the landscape as much as the waterfall, emphasizing the dynamic quality of nature.

Kobell employed a variety of hatching and hooked lines to indicate rocks, treetops, and flowing and churning water, recalling the Aberli manner discussed in relation to Hackert (cat. no. 24). Placed in front of the pale frothy wavecrests, these lines gain liveliness and decorative value. This use of pen and brush relates the landscape to part of Christoph Nathe's oeuvre, as does the use of warmer and cooler tones of brown. AS-F

PROVENANCE

Edwin Bryant Crocker, by 1871; gift of his widow Margaret to the Museum, 1885

LITERATURE

Kaufmann 2004, p. 125; Crocker 1971, p. 154

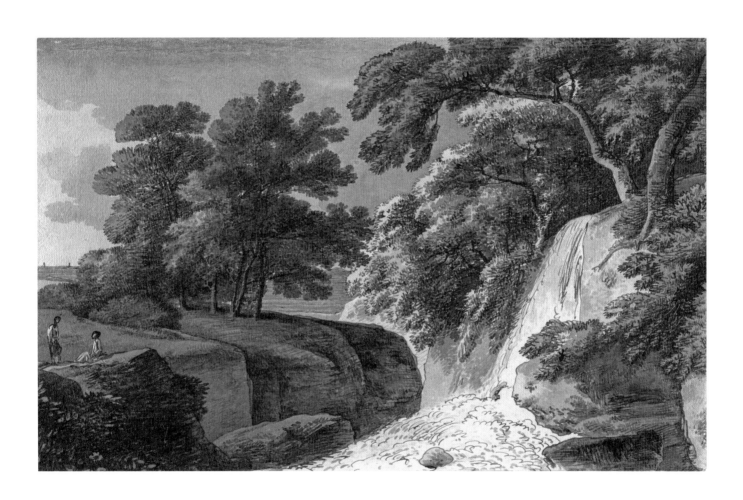

28 *A Farmstead*, n. d.

Black chalk, brush and brown ink and brown washes on cream laid paper, 18.1 × 29.4 cm
Crocker Art Museum, E. B. Crocker Collection 1871.80

Johann Christian Klengel (1751–1824) was the most distinguished pupil of Christian Wilhelm Ernst Dietrich. He lived in Dietrich's household from the age of seventeen to twenty-two, until the elder artist's death in 1774. During this period Klengel trained as a painter of animals and landscapes. He developed an early manner very close to that of his master, as seen in this sheet, in which the composition and specific motifs share their sources with Dietrich's peasant genre scenes and village landscapes. The thatch-roofed farmstead, with its old-fashioned high masonry gables, is originally a Dutch type Klengel would have been acquainted with from the paintings of Adriaen van Ostade or Rembrandt. Artists in Dresden knew such works primarily from the rich collections owned by the city's court and private citizens. Dietrich himself had gathered an extensive collection of them and was well known for his paintings in the style of his Dutch precursors.

This predilection for the masters of the past, so effortless in his master Dietrich's hands, appears in Klengel's work as a careful grouping of background motifs such as the ruins, the wheel, or the gate hanging crooked from its hinges. These motifs can also be found in his etchings, for example an early series of etchings from 1771[1] and another series from two years later entitled "Twelve different subjects after Dietrich's drawings, etched by his pupil Johann Christian Klengel, 1773" (*XII verschiedene Gegenstände, nach den Zeichnungen*

Dietrichs Radiert von seinem Schüler J. Ch. Klengel, 1773). Comparison with these etchings shows Klengel's closeness to his master; some include thatched cottages which likewise have poles leaning against the roof.[2] Other watercolors of this sort have also come down to us in which the landscape is similarly observed from a rather high point of view.[3]

It is interesting that the young draughtsman organized the space with a narrow, darkly inked foreground and multiple gradations in the middle ground, where brightly lit areas such as that surrounding the hens alternate with shaded parts such as the orchard behind the horseman and cart at right. Here he used brush and dark brown wash over graphite just as he used his etching needle in the prints to emphasize the thatched roof, the gable, and the dappled light of the treetops—the last by leaving the paper blank between his strokes. He depicts the furrowed field at left only with light strokes of the brush, creating a kind of aerial perspective as the dark fades towards the background.

Sheets such as the present one are typical for the young Klengel, but were not appreciated by his contemporaries since they betrayed too much of his teacher's influence. Later in his career, Klengel would develop his visual language further with his own observations and inventions. In deploying his new material, he found the rules of landscape painting he had learned by studying and copying Dietrich quite useful. AS-F

PROVENANCE
Edwin Bryant Crocker, by 1871; gift of his widow Margaret to the Museum, 1885

LITERATURE
Kaufmann 2004, p. 116; Crocker 1971, p. 154; Scheyer 1949, no. 65; Crocker 1939, no. 67

29 *Darmstadt Sketchbook*, circa 1785

Volume with sixteen black chalk and graphite drawings, one with brush and brown, green,
reddish, gray watercolor, on cream laid paper, 23.3 × 17.7 cm
Crocker Art Museum Purchase with funds provided by Anne and Malcolm McHenry, 2016.66

Inscriptions: graphite, front flyleaf: *Dieses Skizzenbuch zeigt die / charakteristische Handschrift von / Johann
Christian* Klengel. / *geb. 1751 in Kesselsdorf b. Dresden.* / gest. 1824 in Dresden. / *Es war in der Sammlung P.
Bergfred, / Dresden, aus der es als Geschenk an / Frl. Anna Köhler, Hirschberg i. Rgb., gelangte. / Dr. Erich Wiese.*;
black chalk, first page: supplies and sums for a sketching trip including the destinations Pirna, Königstein,
and Bad Schandau

Johann Christian Klengel's Darmstadt Sketchbook contains sixteen drawings with studies of fences, walls, and portals, as well as farmsteads surrounded by gardens and unpaved village roads. The notes for expenditures for a trip through Pirna and Königstein to Bad Schandau and back make it certain that the artist saw and recorded at least some of the scenes along this route, though the drawings are all unlabeled. They show the half-timbered houses with thatched roofs that are common in that district, whereas, further east, tiled roofs and arched supports for the upper floors are more usual.

On fol. 8r, however, a pair of columns with figures atop is shown. These oversized pillars, which serve as the eastern gate to the main avenue in Dresden's Große Garten, were erected in 1720 and belong to the original sculptural decoration of the garden. Created in 1719 by the sculptor Johann Christian Kirchner, a pupil of the famous Balthasar Permoser, who worked at Dresden's Electoral Saxon court, they show Meleager and Atalanta as well as Aphrodite, Adonis, and Eros. But the sculptures did not attract the draughtsman's closest attention, as he depicted them from below, perspectively distorted, and rather summarily because of the distance. He preferred to sketch an overall impression of the state of the Große Garten after the Seven Years' War, destroyed, looted and in the end neglected and forgotten. Behind the pillars saplings are growing, while in front a pathway leading away from the flat space through the fields is indicated.

Even if this Dresden scene, like the depiction of an overgrown wall with an arch above it on fol. 4r, is at odds with the village scenes elsewhere, the difference in subject is outweighed by the common points, allaying any possible doubts as to authorship. Firstly, ruins left by the Seven Years' War are also depicted on fol. 5r. Secondly, all the sheets reveal not only the same draughtsmanship, but were also created in the same period. The main focus, most often an impressive farmhouse, is always depicted in the middle ground in its village setting, with the road, embankment, fence, garden, and fruit trees. A few details stand out, such as a tree trunk, fence rails, stonework, poles left leaning against it, a wellhouse, a sundrenched curved sandstone gate, all depicted lighter or darker than their surroundings to attract the eye.

A network of lines is used on the majority of sheets to depict buildings, vegetation, and earth quickly but accurately, and the pencil strokes are thinner towards the lower margin. Reserves of blank paper are used to represent the bright sky and daylight. Here the energetic and sensitive landscapist's typical draughtsmanship stands out; he approached even homely subjects in nature and country life with interest and an unprejudiced eye. Comparison with other drawings from Klengel's hand indicates a date in the mid-1780s.

Because of his training with Christian Wilhelm Ernst Dietrich, Klengel was familiar with Dutch seventeenth-century landscape painters. Unlike his teacher, however, who expressly imitated seventeenth-century paintings, Klengel

PROVENANCE

P. Bergfred. Anna Köhler. Erich Wiese.
Grisebach, November 30, 2016, no. 161;
purchase by the Museum, 2016

LITERATURE

Anke Fröhlich in Grisebach, November 30,
2016, no. 161; Heino Maedebach, unpublished
manuscript in Staatlichen Kunstsammlungen
Dresden, no. Z260

examined his actual, contemporary surroundings through seventeenth-century eyes. Through continually studying and sketching from nature, he achieved a visual directness that is effective even today. In these sketchbook pages free of idyllic, or idealizing arcadian, or Romanticizing elements, he adhered to real visual facts and gave them freshness and quiet dignity.

In addition, Klengel often chose portals, garden gates, walls, fences, and farmsteads as well as fruit trees as repeated motifs, not only for his paintings but also for his etchings. Working with this familiar treasury of motifs in a modern-seeming style, he left a strong impression among his followers. Christoph Nathe especially devoted himself to following in Klengel's footsteps with his own graphite, pen and brush drawings of village scenes in Saxony, but Caspar David Friedrich's early work is also unmistakably marked by Klengel's lively interest in the material realities of village subjects. Beside the developing artistic movement of early Romanticism, this artist stood at the beginning of a new concept of realistic landscape depiction. AS-F

JOHANN CHRISTIAN KLENGEL

30 *Landscape with Bathers*, n. d.

Black chalk, brush and brown ink and brown washes on cream laid paper, 15.9 × 20.8 cm
Crocker Art Museum, E. B. Crocker Collection 1871.1070
Marks: lower right corner: Lugt 2237 (Rolas du Rosey)

Following the early achievements of Johann Alexander Thiele and Christian Wilhelm Ernst Dietrich, which lasted until the middle of the eighteenth century, Johann Christian Klengel belonged to a younger generation of artists in Saxony whose style and choice of subject paralleled those of contemporary literature. Both literature and art reflected a trend towards the idyllic, the artistic representation of the local northern European landscape, and a view of nature that is concerned with natural science and Romantic sensation at the same time.

Idyllic pastoral landscapes such as the present drawing may have their origin in thematic models Klengel found in Dietrich's work, but he developed his own stylistic idiom which he varied in his many paintings, drawings, and prints, and which his students and followers adopted. Dietrich depicted mostly mythological scenes of bathing goddesses or nymphs. Klengel, on the other hand, made the bathing maidens into shepherdesses and placed them in a contemporary world. His audience recognized the riverbanks and gently rising hills taken from Dresden's immediate surroundings as well as from the Elbe river valley and smaller valleys nearby.

The artist repeatedly varied his practical vocabulary of bare and leafing trees, meadows, hills, sheep, herders, and maidens, as well as background towers and ruins, to lend the scenery a timeless quality reminiscent of Classical idylls. The sky and bodies of water form the background in gently flowing colors, while in the foreground a fanciful tree branch or tumbledown building serves as a compositional device to attract the eye. Light shines through the foliage of the tree at right; Klengel developed a particular brushstroke to depict it. Somehow the southern landscape seems real, and the typically Saxon landscape type—reflecting a longing for the South—appears Italian.

In composition and detail, this drawing corresponds to Klengel's painting *Italian Landscape with a Hilltop Ruin and a Shepherdess* now in the Nasjonalgalleriet in Oslo, which came from the collection of the Romantic artist Johann Christian Dahl.[1] The title *Italian Landscape* for a German scene is unusual. The composition, even though it was modeled on the Elbe valley, was received by the public as an intensely Classicizing idyll. AS-F

PROVENANCE

Carl Freiherr von Rolas du Rosey, by 1862; his sale, Leipzig, Weigel, September 5, 1864, no. 5322. Edwin Bryant Crocker, by 1871; gift of his widow Margaret to the Museum, 1885

LITERATURE

Kaufmann 2004, p. 114; Crocker 1971, p. 154; Rosey sale, Leipzig, Weigel, September 5, 1864, no. 5322

31 *Scene of Hills*, n. d.

Pen dark brown ink, brush and brown and gray washes, greenish, bluish, pinkish, yellowish, orange watercolor over black chalk on cream laid paper, 29.1 × 42.8 cm
Crocker Art Museum, E. B. Crocker Collection 1871.68

Inscriptions: gray wash, right of center: *Mupiler*[?]; verso, black chalk, lower right corner: *J. F. L. O., frühe Zeit* / *8/3* / *N. 3164*; black chalk, lower left corner: *i2s*

Johann Friedrich Ludwig Oeser (1751–1791) first studied at the Leipzig Kunstakademie under his father Adam Friedrich (see cat. no. 23) and then became his assistant. In 1774 he moved to Dresden, where he was active as a member of the city's Kunstakademie after 1780. In addition to what he learned from his father, he was clearly influenced by younger artists such as Johann Christian Klengel and Christoph Nathe, who also created vivid watercolor landscapes over long strokes of graphite underdrawing.

In comparatively restrained subjects such as this one, Oeser used great skill to make the fore-, middle-, and background clear enough while avoiding sharp divisions. He unified the pictorial fields with winding paths and plants stretching upwards while at the same time creating a convincing impression of deep space that the eye can wander through and that the viewer's mind can enrich with his own imaginings.

The younger Oeser knew such devices from contemporary writings on art. Using another device that was recommended, he contrasted the trunks and crowns of the trees at right foreground with empty sky. In the sky, a curiously formed cloud attracts the eye. The entire scene appears to be "constructed," or intentionally composed. Especially the stage-like meeting-place of light and shadow in the middle ground prevents the gaze from gliding through a continuous pictorial space. This could be a reason for the inscription on the verso, which notes the early period: *J. F. L. O., frühe Zeit.*

Oeser had specific technical means at his disposal when working with chalk, pen, and brush: short, sketchy strokes or graphic abbreviations, sweeping curves as when he described the clouds, or moist stipples in the manner of his father, and the use of large areas of wash. He placed patches of reddish-brown and light-blue wash against each other as the Romantic landscape painters did in their cloud studies, for example. Many see the stylistic devices of the late eighteenth and early nineteenth centuries colliding and combining in his work. Despite the highly constructed elements of the composition, an illegible place name at the center of the image points to the fact that the watercolor depicts a real view. AS-F

PROVENANCE

Edwin Bryant Crocker, by 1871; gift of his widow Margaret to the Museum, 1885

LITERATURE

Kaufmann 2004, p. 144; Steadman and Osborne 1976, no. 45; Crocker 1971, no. 96, p. 38 and 158; Lawrence 1956, no. 41; Scheyer 1949, no. 98; Trivas 1941, no. 73; Crocker 1939, no. 54

32 *View of the Münster Valley*, 1780

Black chalk, charcoal, white chalk on blue laid paper, 30.2 × 20.9 cm
Crocker Art Museum, E. B. Crocker Collection 1871.1073
Inscriptions: dark brown ink, across bottom margin: *gegend aus dem Münsterthal /*
seinem Freund zum Andencken von Franz Schüz 1780 / gezeichnet / in Genf.

Franz Schüz (1751–1781) was born to a family of artists in Frankfurt am Main, and is considered its most talented member. Besides a small number of paintings he left many landscape drawings, mostly of Swiss subjects, many of which are now in the collections of the Städel in Frankfurt and the Albertina in Vienna.[1] The original sketches for them are the product of the artist's trips in the company of his patron, the Basel merchant Johann Rudolf Burckhard. He usually completed full pictorial compositions such as this one in the studio, however. Schüz spent the last year of his life in Geneva, where he died at the age of thirty.

This drawing, dedicated as a keepsake to an unknown friend, was made in Geneva and is dated a year before his death. He depicted two anglers, a staffage motif typical of eighteenth-century landscape painting, at the foot of the mountain at left. The tree at the left margin, like the picturesque tree stump in the right foreground, is a similarly traditional element of late Baroque landscape painting. Using compositional lines within the drawing that follow the course of the river, the tree leads the viewer's eye into the upper pictorial distance, under the bridge across the sparsely wooded, steep slopes to the alpine peaks. The artist's use of an upright format divided into three zones serves to strengthen the perception of deep expanses in the landscape's pictorial space.

Learned from his printmaker father Christian Georg, Schüz's regular, densely undulating line served him for the concise and faithful description of water, foliage, rocks, and clouds. However, it is not the lines alone, but rather the areas and pictorial zones with varying surfaces that come together to produce the landscape. Like the use of blue paper and white highlighting, these pictorial strategies give the drawing an atmospheric, painterly quality. AS-F

PROVENANCE

Edwin Bryant Crocker, by 1871; gift of his widow Margaret to the Museum, 1885

LITERATURE

Breazeale et al. 2010, no. 50; Kaufmann 2004, pp. 168-69; Crocker 1971, p. 163

gegend nach dem Münsterthal seinem freund zum Andenken Hans Franz Schütz 1790 Kreuzspit-
 tenf.

33 *A Rugged Peak*, circa 1778–81

Black and white chalks on blue laid paper, 41.5 × 57.5 cm
Crocker Art Museum, E. B. Crocker Collection 1871.1280
Inscriptions: verso, red chalk, lower right corner: A. 1633

A steep mountain range formed by glaciers and waterfalls rises powerfully before the eyes of the viewer. From a slightly raised viewpoint we look out over an extensive valley with gardens, fields, and lines of trees until our eye meets the sharp cliffs thrusting through the overgrown slopes. At the foot of the mountain, a country lane is defined with straight, tightly quivering lines.

Lacking any connection to the foreground, the view appears as if through a telescope, since details such as trees, rail fences, stone cottages, and the tower at the right margin are reproduced with great precision, unaffected by the distant haze. A lively network of lines, with serrated and rounded outlines for the trees' foliage, and piercing, sharp lines for grasses or rocky ridges, allowed the draughtsman to give an impression of rich, dense and varied reality. No conventional staffage figures are present to distract the gaze. The powerful rock formations created over the ages and the inhospitable yet fertile valley satisfied the interest in geology and topography on the part of the artist's contemporaries, just as they awakened devotion to impressive, even frightening, nature.

In this respect Franz Schüz is part of a tradition common to Caspar Wolf, Johann Heinrich Wüest, Johann Ludwig Aberli, and Adrian Zingg. As his contemporary Christoph Nathe did in a different way, Schüz, most familiar with the Swiss lowlands, invented an impressive, unique pictorial language for typically alpine landscapes. AS-F

PROVENANCE
Rudolph Weigel? Edwin Bryant Crocker, by 1871; gift of his widow Margaret to the Museum, 1885

LITERATURE
Breazeale 2008, p. 223; Kaufmann 2004, pp. 167-68; Crocker 1971, p. 163; possibly Weigel 1838-66, no. 7631

ADRIAN ZINGG

34 *The Ruins of Blankenstein Castle in Bohemia*, 1785

Pen and black ink, brush and brown wash on cream laid paper, 50.7 × 65.0 cm
Crocker Art Museum, purchase with funds provided by Malcolm McHenry 2018.52
Inscriptions: pen and brown ink, lower margin at right: *Zingg del. 1785*

Born in St. Gallen, Adrian Zingg (1734–1816) trained as a printmaker firstly with Johann Rudolf Holzhalb in Zurich and then in Bern with Johann Ludwig Aberli. There he encountered the technique of black-line printmaking supplemented with hand-applied color. In 1759 he went with Aberli to Paris, where he met many artists in Johann Georg Wille's printmaking studio and drawing academy. Among them were Johann Eleazar Zeißig, called Schenau, and Jacob Philipp Hackert.

In mid-1766 Zingg arrived in Dresden as instructor of landscape etching at the city's newly refounded Kunstakademie. Over the next five decades he became a pivotal artistic figure whose understanding of landscape was influential well into the nineteenth century. Zingg left the Saxon capital, heavily damaged in the Seven Years' War, for the surrounding countryside as often as he could. At first in the company of his Swiss friend and artistic colleague Anton Graff, and later with his students, the artist made sketches on these trips in graphite and pen and ink, adding brush and gray or brown wash in the studio afterwards. He elaborated such sketches into large compositions as well. The many nature studies he completed in the context of his sketching trips are the core of his art and established his fame as a splendid landscape draughtsman. In the course of his activity in Dresden, he created landscape views of a territory stretching from the Meissen lowlands and the Saale valley in the west to the Elbsandsteingebirge and even northern Bohemia in the east. His artistic travels also led him further northeast, to the Lusatian mountains, and southwest to the Erzgebirge.

In the Erzgebirge Adrian Zingg recorded views of all the points of interest on the main route through the Sächsische Schweiz, or Saxon Switzerland, the so-called *Malerweg* or painter's pathway. Many of these vistas first became famous through his works and were depicted again and again by his students and followers in a variety of ways. In this respect he influenced public perception of the region and established a lasting appreciation of its beauty.

In his views of fortresses, castles, and hilltop ruins lining extensive valleys, Adrian Zingg used a recurring technical device. This was a system of abbreviated lines depicting the different contours of treetops, grasses, and rocks. It was easily learned and most easily transferred to etching. He also staggered the foreground, middle ground, and background or, as here, overlapped them with one another. This late Baroque landscape technique, reminiscent of a stage set, is moderated and unified through a sort of atmospheric perspective created in brown wash, so that receding objects appear less substantial through the use of strong light. The artist used this technique to draw attention to the dominant motif in the distance. Here the focus is the ruins of the medieval fortress of Blankenstein, in Czech Blansko, near Aussig (Ústí nad Labem), rising above a 545 meter high mountain. A second, similar version of the scene is in the Albertina in Vienna.[1] Only parts of the massive outer walls of the fortress remain, which Zingg elevated to an ideal ornament for a mountaintop. Staffage in the foreground and people walking in the distance accent the pleasure of encountering nature, just as carefully executed plants, bushes, and trees complete the representation of a harmonious pictorial world. AS-F

PROVENANCE
Dr. Hartmut Völckerling, Tübingen. August Laube Kunsthandel; purchase by the Museum, 2018

LITERATURE
Weisheit-Possél 2010, p. 126

124

CHRISTOPH NATHE

35 *Landscape near Görlitz*, 1786

Brush and brown ink and brown washes over black chalk on cream laid paper, 38.0 × 51.4 cm
Crocker Art Museum, E. B. Crocker Collection 1871.85
Inscriptions: brown ink, upper right, signed: *Nathe. 1786.*; verso, black chalk, lower right: *3. duk.*

This brush drawing shows not only Christoph Nathe's (1753–1806) mastery as a landscape draughtsman, but also the strong influence that Adrian Zingg had on the concept of landscape in eighteenth-century Saxony. Foreground and distance, horizontal and vertical motifs work together in an exciting way. The eye is led from an idyllic, sunny resting place in the foreground back to the even lighter distance, with barely discernible boats plying a river. Besides the work of Zingg, Nathe was aware of Johann Christian Klengel, who often includes a resting shepherd or wanderer in his landsacpes. The vibrant exchange between light and shadow, indicated with varyingly stippled brush and brown ink over a spare graphite underdrawing, and the decreasing intensity of color to indicate spatial recession, demonstrate Nathe's intent to imbue the traditional composition with lively energy. The fact that the artist ignored the possibilities of line work as taught by Zingg, preferring to indicate the dark tones only with spots and areas of ink and wash, points to his training under Adam Friedrich Oeser. Even the students at Nathe's drawing academy in Görlitz used the brush in the same way.

At the time he created this sheet, Christoph Nathe lived in Leipzig, where he made drawings for publishers, worked as a printmaker, and even tried his hand at oil painting. In addition, in October 1786, he had agreed with the founders of the Oberlausitzische Gesellschaft der Wissenschaften (Upper Lusatian Association for the Sciences), Adolf Traugott von Gersdorf and Karl Andreas Meyer zu Knonow, "to supply these two collectors drawings and watercolors in return for a yearly stipend based on his own list of prices" (*gegen ein jährliches Fixum diesen beiden Sammlern nach eigener Preistabelle Zeichnungen und Aquarelle zu liefern*).[1] This arrangement allowed the artist to create a splendid oeuvre of landscape drawings of the Sächsische Schweiz, the Zittau mountains and the Riesengebirge, the Harz, and the Swiss Alps. In these drawings he combines topographical and geological concerns with a pre-Romantic sympathy for emotional atmosphere. Whether this view of a river near Görlitz can be identified, as the traditional title indicates, or if it is really an invention by the artist, as the picturesque cliffs suggest, must remain an open question, as in many of his surviving works. AS-F

PROVENANCE

Edwin Bryant Crocker, by 1871; gift of his widow Margaret to the Museum, 1885

LITERATURE

Kaufmann 2004, pp. 140–41; Kaufmann 1989, no. 99; Crocker 1971, p. 158; Ernst Scheyer, 'Christoph Nathe und die Landschaftskunst des ausgehenden 18. Jahrhunderts,' in his *Schlesische Malerei der Biedermeierzeit*, Frankfurt am Main, 1965, p. 256; Scheyer 1949, no. 95; Trivas 1941, no. 72; Crocker 1939, no. 72

CHRISTOPH NATHE

36 *An Arcadian Scene*, n. d.

Pen and gray and dark brown ink, brush and dark brown ink and brown and grayish-brown washes
over black chalk on cream laid paper, 37.7 × 50.4 cm
Crocker Art Museum, E. B. Crocker Collection 1871.1281

Inscriptions: brown ink, lower right corner: *Nathe inv*; gray ink, lower left on urn: *ΕΚΑΣ / ΕΣΤΙ / [...]ΘΡΟΣ*

Adam Friedrich Oeser, the director of the Leipzig Kunstakademie, was a skilled pedagogue who "penetrated souls" (*in die Seelen drang*), as his drawing student Johann Wolfgang von Goethe put it.[1] Thus it is not remarkable that, following the examples of Oeser and his favorite student Johann Sebastian Bach the Younger, Christoph Nathe (1753–1806) also chose literary subjects for his landscapes. Among these were many that the Swiss painter and poet Salomon Gessner had brought to the public's attention with his sentimental 'Idylls.' Gessner's tales, popular at the time, were transposed to a "Golden Age," an imaginary Greek Arcadia. With their homage to grace, innocence, sympathy, and virtue, they appeared as an utopian alternative to the reality of the Seven Years' War of 1756–63 and the famines that followed it, as well as all of the political and intellectual agitation and upheaval before and after the French Revolution of 1789.

Echoes of Gessner's classicizing subjects are found in this landscape with its tombstones under tall trees, where women in antique dress care for a child and a temple occupies the middle ground. The landscape's multiple layers with dense stands of trees, a sun-filled meadow, and a distant hill, create an imaginary *locus amoenus* and intensify the utopian effect. To achieve the illusion of pictorial depth, the artist overlapped the light and dark areas. In addition, he created the bushes and treetops from drifts of short brushstrokes that give the impression of foliage in motion, a technique he had learned from Oeser and Bach and mastered as his own. AS-F

PROVENANCE

Edwin Bryant Crocker, by 1871; gift of his widow Margaret to the Museum, 1885

LITERATURE

Kaufmann 2004, pp. 141–42; Crocker 1971, p. 152

37 *The Grimma Gate, Leipzig*, n. d.

Pen and gray ink, brush and brown and gray washes and greenish, magenta, pinkish watercolor over black chalk on cream laid paper, 19.0 × 27.2 cm
Crocker Art Museum, E. B. Crocker Collection 1871.1072

Inscriptions: black ink, bottom margin left of center, signed: *N.f.*; verso, brown ink, lower left corner: *Nathe fecit*; verso, brown ink, bottom margin at right, same hand: *Das Grimische Thor, mit dem Prospect gegen die Stadt.*; verso, brown ink, lower right corner: *1/A 502.*; verso, black ink, center lower right: *N.o.r.r.*; verso, graphite, lower right: *2478 / Nathe w.*

Marks: verso, lower right: Lugt 358 (unidentified)

In May 1774 the young Christoph Nathe left Görlitz in Upper Lusatia to study in Leipzig. After the end of the Seven Years' War in 1763, commerce blossomed in the historic city with its annual fair, its university, and its publishing industry. In the course of rebuilding Saxony, art academies were founded in 1764 in Dresden and Leizpig to provide solid formal education for local artists. Adam Friedrich Oeser, the director of the Leipzig Academy in the Pleißenburg, was Nathe's formative teacher.

Between 1782 and 1786 the artist lived in Leipzig again, interrupted only by trips to the Harz mountains and Switzerland. "Here I found more intellectual stimulation, often missing for me in the field of art in Lusatia, which is why I like being here again" ([*Hier*] ... *hab ich mehr Geistesnährung, an der mirs im Kunstfache in der Lausitz oft fehlte, deswegen gefällt mirs wieder hier*), he wrote to his friend and patron Karl Andreas von Meyer zu Knonow. He continued: "I am also busier than I have ever been in my life, and study morning to night the whole week through" (*Auch bin ich so fleißig als ich in meinem Leben noch nie gewesen bin, und studire von Morgen bis in die Nacht in Einem die ganze Woche durch*).[1] Among his friends and colleagues in Leipzig were the publisher Georg Joachim Göschen, the poets Friedrich Schiller and Johann Gottfried Seume, and the landscape painter Johann Christian Reinhart, with whom he had shared rooms in 1779.

During his time in Leipzig, Nathe created many city views in addition to his other work. Thus, a sketchbook includes another view of the Grimma Gate, and it is even from the same viewpoint.[2] In the present wash drawing, the artist, as is typical, enlivens the brown tone only with a touch of red. He indicates expanses of sand, the buildings, and the clouded sky with brush and wash, lending the sheet a charming brightness. The figures in the foreground are elongated and incorporeal, as in the artist's other works. He depicted the area in front of the city gate, divided from civic life in the bustling city of commerce, as almost empty of buildings and people. Outside the city, bushes and trees, meadows and paths dominate the scene, lending a rural atmosphere to the landscape with the distant towers of the Thomaskirche, the Nikolaikirche, and the Rathaus (the churches of Saint Thomas and Saint Nicholas and the city hall). AS-F

PROVENANCE

Edwin Bryant Crocker, by 1871; gift of his widow Margaret to the Museum, 1885

LITERATURE

Kaufmann 2004, pp. 138-39; Crocker 1971, p. 158

38 *Landscape in Lusatia*, n. d.

Pen and dark brown and gray ink, brush and dark brown ink and gray and brown washes
and gum arabic on cream laid paper, 34.5 × 53.0 cm
Crocker Art Museum, E. B. Crocker Collection 1871.84

Inscriptions: verso, black chalk, lower right corner: *Nathe del.*; verso, black chalk, lower right: *OEx* (cancelled and erased)
/ *LOX* / *E_*; verso, black chalk, lower right: *Von das Wasserpforte beij Goerlitz* / ~~*An der schwarzen Neisse in Böhmen*~~

"Finally, it should not escape mention that parts of Upper Lusatia are equipped with natural beauties whose depiction and reproduction offer not unimportant benefits to art itself and to art-lovers. The landscape painters Wehle and Nathe of recent memory supplied proof of this, and at the same time put down new evidence of what genius and strong will can achieve, even in the absence of favorable outside circumstances" (*Endlich is auch nicht unbemerkt zu lassen dass die Oberlausitz theilweise mit Naturschönheiten ausgestattet ist, deren Darstellung und Nachbildung sowohl für die Kunst selbst als für die Liebhaber derselben keinen unbedeutenden Gewinn darbietet. Proven davon haben die nicht vor langer Zeit verstorbenen Landschaftsmaler Wehle und Nathe geliefert, und zugleich einen neuen Beweis abgelegt, was Genie und ein kräftiger Wille auch ohne günstige äußere Verhältnisse zu leisten vermögen*).[1]

This brush drawing with its dense, poetic atmosphere could serve as an example of the "genius" the correspondent mentions, which was itself never really forgotten in the land of its origin, Upper Lusatia. Christoph Nathe studied landscape painting first in Leipzig with Adam Friedrich Oeser and later in Dresden under Johann Christian Klengel. Oeser was a varied artist, active as sculptor, painter, and draughtsman in all genres, but as a landscape painter he was not an especially strong or original talent. This is surprising, since the best of his pupils chose landscape as their specialization. Often his landscapes were unclear as regards space, and vegetation was depicted rather sketchily. But it must be acknowledged that, in the hands of his pupils, the same intentional simplicity with materials became a way to achieve pictorial richness.

Christoph Nathe long stood in the shadow of his more famous colleagues, especially the early Romantic landscape painters of the nineteenth century. Nonetheless, brush drawings such as the present one place him among the precursors of the Romantics, certainly in Upper Lusatia and the Riesengebirge in Silesia. He not only identified picturesque and beautiful districts for the artistic community, but also developed a characteristic drawing style, whether in pen and brown or black ink, in brush and watercolor or, as here, with dense brown brush stippling. His intense observation of nature on his extensive sketching trips, combined with his research into geology and weather, enabled him to reproduce his models with good effect, creating a specific mood with light and light effects.

By avoiding long strokes of the pen and arranging the stipples into surfaces and volumes, he evoked a softly harmonious atmosphere. Despite restricting himself to brown ink, the artist here creates a painterly impression of this meadowed riverbank. The inscription on the verso indicates that the houses are typically Lusatian, with their arched lower levels, as seen from the bank of the Neiße near his native town: "From the water gate near Görlitz" (*Von der Wasserpforte beÿ Goerlitz*). A girl with her dog, a single figure who appears comparatively small in the picture, intensifies the elegiac tone. Nathe's figures are often so small and thin that they nearly seem to disappear in the surrounding space. On a formal level this can be read as a sign that the opposition between a contemplative being and surrounding nature, between the individual and the world, has not yet emerged as sharply as would later be the case with Caspar David Friedrich. However inconspicuous, Nathe's figures nevertheless represent the viewer's relationship with the natural world. AS-F

PROVENANCE

Edwin Bryant Crocker, by 1871; gift of his widow Margaret to the Museum, 1885

LITERATURE

Kaufmann 2004, pp. 139–40; Ruda 1992, no. 68; Kaufmann 1989, no. 100; Crocker 1971, p. 158; Ernst Scheyer, 'Christoph Nathe und die Landschaftskunst des ausgehenden 18.

Jahrhunderts,' in his *Schlesische Malerei der Biedermeierzeit*, Frankfurt am Main, 1965, p. 256; Scheyer 1949, no. 96; Trivas 1941, no. 71; Crocker 1939, no. 71

JOHANN HEINRICH MENKEN

39 *Cattle by a Woodland Pool*, n. d.

Pen and brush and dark brown ink, brush and brown washes over red chalk on cream laid paper, 40.7 × 59.8 cm
Crocker Art Museum, E. B. Crocker Collection 1871.1282
Inscriptions: verso, black chalk, lower right corner: F.c / ~~1990~~

After early training in his native city of Bremen, the talented Johann Heinrich Menken (1766–1839), son of a merchant, studied at the Dresden Kunstakademie under Johann Christian Klengel from 1792. As an animal and landscape artist, aquatint printmaker, and illustrator, he made copies after works by seventeenth-century Dutch artists, as well as producing his own designs for animal illustrations. Above all, however, he was the first to depict the northern German landscape near Bremen in paintings. The city's senate named him professor of fine arts in 1818. He was also a member of the Bremen Kunstverein, founded in 1823.

With this depiction of a forest pond, the artist places himself in the tradition of Jacob van Ruisdael's followers. The Dutch artist's canvas *The Hunt* in the Electoral paintings gallery in Dresden was repeatedly copied or imitated by students of landscape.[1] Menken's brush drawing in fact resembles the famous painting though, rather than a hunt,

only a guard dog is shown startling a flock of herons. The herders have just forded the pond with their cattle, and in the background a herd bustles along the bank of the pond. At the same time, Menken includes a motif he knew from Salomon van Ruisdael's landscape paintings, the tree trunk leaning far over the mirror-like water.

The sheet shows Menken's virtuoso handling with pen and brush: a system of abbreviated pen lines reproduces blades of grass, reeds, branches, and foliage, while the artist creates deep and lighter shadows that enhance the impression of three-dimensional space. The alternation of dark and light lends a vivid effect to the river landscape, with its picturesque tree trunks reaching up to a mass of clouds. Such animal and landscape scenes, with their refreshingly varied combinations of elements, established Menken's reputation. AS-F

PROVENANCE

Edwin Bryant Crocker, by 1871; gift of his widow Margaret to the Museum, 1885

LITERATURE

Kaufmann 2004, p. 224; Crocker 1971, p. 156

40 *Sketch of Trees*, n. d.

Black and white chalks, stumped, on green laid paper, 27.6 × 21.1 cm
Crocker Art Museum, E. B. Crocker Collection 1871.580

As the eldest son and successor to the art business of his parents Johann Gottlieb and Maria Katharina Prestel (see cat. nos. 15 and 26), Christian Erdmann Gottlieb Prestel (1775–1818) became a publisher and artist himself. From the age of twenty he lived for twelve years in London, before taking over his father's dealership in Frankfurt am Main. In 1816 he traveled with Ludwig Emil Grimm to Rome and Naples.

Both his parents and his sister Ursula Magdalena Prestel, later Reinheimer, painted and drew landscapes. This study shows that Christian Erdmann Gottlieb was likewise an experienced artist in this genre. Here, he reproduced a sunlit bush at the edge of the woods and two trees projecting above with sweeping strokes of the chalk, while the foreground remains completely unpopulated. He employs the same illusionistic technique to depict foliage using short, rhythmic strokes of the chalk. Longer hatching indicates shading. He captures the appearance of the treetops with black, brown, and white chalk on bluish paper, blending them softly and using sharp contours only along the tree trunks. Modern for its time, the sheet confirms that this artist tried out techniques and ways of seeing in the intimate medium of drawing that were not yet possible in contemporary painting and printmaking. AS-F

PROVENANCE

Edwin Bryant Crocker, by 1871; gift of his widow Margaret to the Museum, 1885

LITERATURE

Kaufmann 2004, p. 232; Crocker 1971, p. 160

41 *Landscape near Frankfurt*, n. d.

Pen and black ink, brush and brownish-gray washes and white opaque watercolor on cream wove paper, 29.8 × 50.2 cm
Crocker Art Museum, E. B. Crocker Collection 1871.90

Born in 1777, Ursula Magdalena (d. 1845), the daughter of Johann Gottlieb and Maria Katharina Prestel (see cat. no. 26), was trained in drawing and reproductive printmaking. She later became a noteworthy portrait, landscape, and flower still-life artist. At twenty-two years old, she collaborated with her father on copies and engravings.[1] In 1805 she married his pupil Johann Georg Reinheimer.

This landscape is a handsome example of Ursula Magdalena Reinheimer's draughtsmanship. She often depicted prominent stands of oak in the neighborhood of Frankfurt. At the horizon, obscured by treetops stretching towards the sky, the outline of her native city on the banks of the Main river, seen from Sachsenhausen, is just recognizable.

Left of the tall leafy tree that breaks the horizon line, we see the notable Eschenheimer Turm (Eschenheim Tower), a late medieval gate in the city's defensive walls and even now an emblem of the city. Beside it is the Baroque spire of the St. Katharinen-Kirche (Church of Saint Catherine), where, incidentally, Johann Wolfgang von Goethe was baptized on August 29, 1749. To the right of the treetop the Kaiserdom St. Bartholomäus (Imperial Cathedral of Saint. Bartholomew) is shown, with its later Late Gothic spire that was completed only in 1877 during the church's restoration. Beside the small garden building with a columned portico at extreme right is very likely the so-called Willemer-Häuschen (Willemer's cottage).[2] The tower-like octagonal pavilion was purchased in 1809 by the banker Johann Jakob von Willemer. His friend Goethe also met Marianne von Willemer here, whom he would go on to immortalize in his 1819 poem cycle *West-Östlicher Diwan*.

The artist preferred this specific view of the city. She combined the precise depiction of her city's landmarks under an empty expanse of sky with a brief rendering of the foreground with horsemen and resting figures between stands of trees and a forest. While she depicted the latter with a system of varied, swift hooks and short lines, she used brush and brown wash to shade the treetops in a simple manner and used the wash differently for wider areas. Because the sheet is only partially developed, it seems likely that a more finished view of Frankfurt was planned. AS-F

PROVENANCE

Edwin Bryant Crocker, by 1871; gift of his widow Margaret to the Museum, 1885

LITERATURE

Kaufmann 2004, p. 291; Crocker 1971, p. 160; Scheyer 1949, no. 105; Trivas 1941, no. 74

NOTES

CAT. NO. 1

1 Both points are made with more detail in Bruno Bushart, 'Johann Georg Bergmüller 1688–1762, Maler und Freskant', in *Lebensbilder aus dem bayerischen Schwaben*, vol. XIII, 1986, pp. 176–78.
2 Strasser 2004 as in Literature above, p. 11.
3 Epple and Strasser 2012 as in Literature above, pp. 22ff.
4 Georg Christoph Kilian quoted in Epple and Strasser 2012 as in Literature above, p. 14.
5 Epple and Strasser 2012 as in Literature above, no. G 32.
6 Städel, inv. no. 14280, pen and brown ink, brush and brown wash and blue, pink, and green watercolor, 39.2 × 23.5 cm.
7 Epple and Strasser 2012 as in Literature above, p. 70.
8 Epple and Strasser 2012 as in Literature above, nos. G84 and G103 respectively.
9 Bushart 1986 as in note 1 above, pp. 182–83.
10 Hütter and Epple 2002 as in Literature above, pp. 73–74.

CAT. NO. 2

1 Mick 1984 as in Literature above, p. 8.
2 Ibid., p. 9.
3 Quoted in Braun et al. 2010 as in Literature above, p. 29.
4 Alois Epple, *Johann Georg Bergmüller, 1688–1762, zur 300. Wiederkehr seines Geburtsjahres*, exh. cat. Türkheim, Weissenhorn 1988, p. 91.
5 Reproduced in the wrong sense in Mick 1958 above.
6 A painted version, Braun et al. 2010 no. 50, misinterprets one of the woman as a male figure.
7 Bartsch 6 and 5 respectively.
8 Braun et al. 2010 as in Literature above, p. 298.
9 Mick 1958 as in Literature above, pp. 92–93.
10 Ernst Neustätter, *Johann Evangelist Holzer (1709–1740)*, Ph.D. dissertation, Munich, 1933, pp. 86ff., quoted in Lorenz Dittmann, 'Über Johann Evangelist Holzers Farbe und Helldunkel', in Braun et al. 2010, pp. 103–04 [102-13].
11 Ibid., under cat. no. 52.
12 Ibid., cat. no. 50.
13 Ibid.
14 Mick, Neustatter and Dittmann as in note 10 above.
15 As in note 10 above.
16 Braun et al. 2010, p. 298.
17 Mick 1984 as in Literature above, p. 99.

CAT. NO. 3

1 Josef Strasser, *Johann Wolfgang Baumgartner 1702–1761, Veduten hinter Glas*, exh. cat. Augsburg, Munich, 2012, p. 11.
2 For example the *Vision of a Saint* also in the Crocker, inv. no. 1871.67; Breazeale et al. 2016, no. 14.
3 Letter to Roger Clisby, April 25, 1976, Crocker curatorial files.
4 Ibid., letters of May 24, 1976 and March 19, 1992.

CAT. NO. 4

1 G. L. Bianconi, *Elogio storico del cavaliere Anton Raphael Mengs, con un Catalogo delle opere da esso fatte*, Milan, 1780, p. 61.
2 Breazeale et al. 2008.
3 Inv. no. 18395; Röttgen 1999 as in Literature above, her cat. no. Z110; inv. no. 1928,1016.10, ibid., her cat. no. Z61.
4 Kaufmann 2004 includes a misreading of Röttgen both on this point and on the Iris figure mentioned above.
5 Herwarth and Steffi Röttgen to John Mahey, February 5, 1972, Crocker curatorial files.

CAT. NO. 5

1 *Teutsche Academie der edlen Bau- Bild- und Mahlerey-Künste*, Nuremberg, 1675. This awoke in him the desire to go to Italy—he supposedly started on the journey as a youth but ran out of money: Georg August Wilhelm Thienemann, *Leben und Wirken des unvergleichlichen Thiermalers und Kupferstechers Johann Elias Ridinger*, Leipzig, 1856, pp. XII–XIII.
2 Thienemann 1856, p. XIV.
3 Still the best resource for his activity is the 1856 Thienemann catalogue in note 1 above.
4 Thienemann 1856, pp. XVI-XVII.
5 *Lehrreiche Fabeln aus dem Reiche der Thiere, zur Verbesserung der Sitten zund zumal dem Unterrichte der Jugend*, Augsburg, 1744.
6 Kaufmann 2004, p. 149.

CAT. NO. 6

1 Preiss 2000 as in Literature above, p. 16.
2 Pavel Preiss mentions drama involving his housekeeper as the reason: Preiss 2000 as in Literature above, p. 20.
3 *Abbildungen böhmischer und mährischer Gelehrten und Künstler, nebst kurzen Nachrichten von ihren Leben und Werken*, Prague 1782, vol. IV, p. 103.
4 Ruda 1992.
5 Preiss 2000 as in Literature above; Kaufmann 1989 as in Literature above
6 *Archangel Gabriel from the Annunciation*, perhaps 1730, graphite on cream laid paper, 20.2 × 14.0 cm, inv. no. K1180; see

Alena Volrabová, ed., *101 Masterpieces of the Collection of Prints and Drawings at the National Gallery in Prague*, Prague, 2008, no. 84.

CAT. NO. 7

1 Dresden, Kupferstichkabinett, inv. no. Ca 49g 146.
2 Petra Schniewind Michel, *Christian Wilhelm Ernst Dietrich, genannt Dietricy 1712–1774*, Munich, 2012, pp. 23–24.
3 "… zeither nur wenig gefunden, das der Mühe einer Reise lohne und nicht ebenso gut oder besser in der Sammlung des Königs zu Dresden angetroffen werde", quoted in J. F. Linck, *Monographie der von dem vormals K. Poln. und Churfürstl. Sächs. Hofmaler und Professor etc. C.W.E. Dietrich radirten, geschabten und in Holz geschnittenen malerischen Vorstellungen, nebst einem Abrisse der Lebensgeschichte des Künstlers*, Berlin, 1846, p. 9.
4 Michel as in note 2 above, p. 28.
5 Petra Schniewind Michel discusses this in the context of art theory in her *Christian Wilhelm Ernst Dietrich 1712–1774 und die Problematik des Eklektizismus*, Munich, 1984, especially her discussion of Dietrich and the Academy's director Christian von Hagedorn, pp. 69ff.
6 Photo from before 1930, no. 230.079, in the Bildarchiv Foto Marburg, available now on www.bildindex.de (accessed September 28, 2018).
7 Howard and Kaufmann as in Literature above.
8 In Breazeale et al. 2008, no. 51.

CAT. NO. 8

1 Johann Wolfgang von Goethe, *Dichtung und Wahrheit*, vol. II, book 20, quoted in Christina Kröll, *Der Maler Georg Melchior Kraus*, exh. cat. Goethe-Museum, Düsseldorf, 1983, p. 30.
2 According to his close friend and collaborator Friedrich Justin Bertuch, not 1737 as commonly thought; see Kröll as in note 1 above, p. 30.
3 Wolfgang Huschke, 'Der Maler Georg Melchior Kraus (1737–1806), ein Frankfurter Landesmann Goethes in Weimar, Herkunft und Familienkreis,' in *Festschrift für Heinz F. Friedrichs*, Neustadt, 1980, p. 127.
4 For the vom Stein connection, see Kröll as in note 1 above, pp. 4–5.
5 Städelmuseum, inv. nos. 6104 and 6107, 37.1 × 25.6 and 39.7 and 20.1 cm respectively.
6 Museen für Kunst und Kulturgeschichte der Hansestadt Lübeck, Sammlung Dräger/Stubbe, 20.4 × 16.1 cm; see Thorsten

Albrecht et al., *Zum Sehen geboren, Handzeichnungen der Goethezeit und des 19. Jahrhunderts, die Sammlung Dräger/Stubbe*, Leipzig, 2007, pp. 170–71. Note that the entry does not address the fact of the autograph date, treating the drawing as from 1776 not 1766.

7 Black and white chalk on blue paper, 23.2 × 21.2 cm, Städelmuseum, inv. no. 6102.

8 See Kaufmann 2004, p. 127.

CAT. NO. 9

1 Scheyer 1949.

2 Heinrich Keller, *Nachrichten von den in Dresden lebenden Künstlern*, Leipzig, 1788, p. 103.

3 Hans Heinrich Füssli, *Allgemeines Künstlerlexikon*, Zürich, 1806, vol. II, p. 693.

4 N. d., pen and brown and black ink, brush and brown washes, 38.6 × 49.2 cm, inv. no. C 1937-983.

5 1776, brush and black ink and gray washes, pen and black ink on blue-gray paper, 41.8 × 33.8 cm, inv. no. 24445.

6 1633–34, oil on canvas, 153.4 × 211.8 cm, inv. no. 5597.

7 Kaufmann 2004; Adrienne Edens in Howard et al. 1973.

CAT. NO. 10

1 Fröhlich-Schauseil 2018, nos. GA 1 to GA 12.

CAT. NO. 11

1 Fröhlich-Schauseil 2018, nos. Z225 and Z252.

2 Heinrich Friedrich Füger, *Portrait of Johann Eleazar Zeißig, called Schenau*, 1772, black chalk on cream laid paper, 24 × 15.5 cm, Klassik Stiftung Weimar, Graphische Sammlungen, inv. no. KK 512; see Manfred Altner et al., *Dresden, von der königlichen Kunstakademie zur Hochschule für bildende Künste, Geschichte einer Institution*, Dresden, 1990, ill. p. 52.

3 Moritz Stübel, ed., *Chodowiecki in Dresden und Leipzig, das Reisetagebuch des Künstlers vom 27. Oktober bis 15. November 1773*, 2nd ed., Dresden 1920, p. 57.

CAT. NO. 12

1 Wolfgang Schlegel in Ingrid Sattel Bernardini, *Friedrich Müller 1749–1825, der Maler*, Landau, 1986, p. 28.

2 Rissel 2006 as in Literature above, p. 28 [23-30].

3 Stefan Wulf, *33 Singeries*, exh. brochure, Leipzig Antiquariatsmesse 2017.

4 Rissel 2006 as in Literature above, pp. 23, 26.

5 Ibid., p. 27.

CAT. NO. 13

1 Renate Jacobs, *Das graphische Werk Bernhard Rodes*, Münster, 1990, p. 14.

2 See Anna Schultz, *Turmbewohner: Entwurfs-zeichnungen von Daniel Chodowiecki and Bernhard Rode für den Gendarmenmarkt*, exh. cat. Alte Nationalgalerie, Berlin, 2014.

3 Jacobs 1990 as in note 1 above, p. 2.

4 Ibid., pp. 20–23, she discusses this in detail.

5 Perhaps part of the shadow on Rode's reputation comes from the fact that so much of what we know of him comes from Chodowiecki's own writings or those of his friends.

6 Howard et al. 1976, p. 41.

7 2009,7112.1, 22.7 × 37.5 cm.

8 Quoted in Jacobs 1990 as in note 1 above, p. 76.

9 Ibid., pp. 77ff.

10 Karl und Faber, 26 April 2013, lot 139, red chalk, 49.5 × 30.6 cm, for which a 1780 print exists.

CAT. NO. 14

1 Quoted in Rebecca Müller, *"Die Natur ist meine einzige Lehrerin, meine Wohltäterin," Zeichnungen von Daniel Nikolaus Chodowiecki 1726–1801 im Berliner Kupferstichkabinett*, exh. cat. Berlin, 2000, p. 10.

2 Robert Violet, *Daniel Chodowiecki 1726–1801, eine verschollen geglaubte Autobiographie*, Bad Karlshafen, 2010, p. 24.

3 Müller 2000 as in note 1 above, p. 8.

4 Ibid., p. 9.

5 Drawings for a calendar series depicting scenes from André Chénier's *La nuit de Saint-Bartholomée*, used in the Göttinger Taschen-Kalender for 1791, are in the Crocker collection, inv. nos. 1871.487–498.

6 Violet as in note 2 above, p. 64.

7 Wolf Stubbe, 'Daniel Chodowiecki, "Buchkupfer" und Aufklärung,' in Jens-Heiner Bauer, *Daniel Chodowiecki, das druckgraphische Werk, die Sammlung Wilhelm Burggraf zu Dohna-Schlobitten*, exh. cat. Hanover, 1984, p. XII.

8 Griffiths and Carey 1994 as in Literature above.

9 Wilhelm Engelmann, 'Nachtrag und Zusätze zu Daniel Chodowiecki's samtliche Kupferstiche ...', in *Archiv für die zeichnenden Künste*, vol. V, 1859, p. 254, uniquely identifies them as such.

10 Violet as in note 2 above, p. 22.

CAT. NO. 15

1 Georg Christian Braun, 'Einige Züge aus dem Leben Johann Gottlieb Prestels,' quoted in Kiermeier-Debre and Vogel 2008, n. p. [160].

2 Kiermeier-Debre and Vogel 2008, p. 13.

3 Prestel's printmaking skills and career are discussed fully in Wiebel 2007, pp. 255–66.

4 *Praunsche Kabinett*, 1776–80; *Schmidtsche Kabinett*, 1779–82; *Kleine Kabinett*, 1782–85.

5 Discussed in Diana Feßl, "'A.D. Prestel

ad vivum," idealisiertes Wunschbild und überlieferte Realität,' in Kiermeier-Debre and Vogel 2008, pp. 9ff.; example Herzog-Anton-Ulrich Museum, inv. no. JGPrestel V3.4395, plate 28.6 × 20.4 cm, sheet 30.0 × 21.6 cm.

6 Example Karl und Faber, 13 November 2015, lot 217, plate 26.0 × 19.0 cm.

CAT. NO. 16

1 Fröhlich 2005, p. 19.

2 Heinrich Keller, *Nachrichten von allen in Dresden lebenden Künstlern*, Leipzig, 1788, p. 87.

3 Fröhlich 2005, p. 44.

4 In his *Deutsche Zeichnungen des 18. Jahrhunderts*, exh. cat. Gießen, 1942, p. 34.

5 Museum der bildenden Künste, Leipzig, inv. no. 1738 and Staatliche Kunsthalle, Karlsruhe, inv. no. 2822, respectively.

6 Thanks to my co-author for her kindness in sharing this information.

CAT. NO. 17

1 Black chalk and graphite, brush and gray wash, 18.2 × 19.0 cm, inv. no. Handschriften, XXI C 19; found in an *album amicorum* of the artist Jacob Smies, dated 1794–96.

CAT. NO. 18

1 Bettina Hagen, *Antike in Wien, die Akademie und der Klassizismus um 1800*, exh. cat. Vienna, Mainz, 2002, p. 24.

2 Hagen 2002 as in note 1 above, p. 25.

3 More about Neoclassicism in Vienna and Füger's role is in Hagen 2002 as in note 1 above, pp. 21ff., and Wolf Eiermann, 'Ein Zeitreise mit Füger in der Klassizismus,' in Marc Gundel, ed., *Heinrich Friedrich Füger 1751–1818, zwischen Genie und Akademie*, exh. cat. Heilbronn, 2011, pp. 22-35.

4 Gundel et al. 2011 as in note 3 above, p. 190.

5 Keil 2010 as in Literature above, based on a letter from the printmaker Friedrich John to the publisher Georg Joachim Göschen, in Stefan Füssel, *Repertorium der Verlagskorrespondenz Göschen 1783 bis 1818*, Berlin and New York, 1996, no. 2405.

6 See William Breazeale et al., *Reuniting the Masters, European Drawings from West Coast Collections*, exh. cat. Sacramento, published San Francisco, 2016, p. 74, which includes a second Wieland subject in the Crocker collection, *The Three Graces Discovering Cupid*.

7 Lois Perkins in Howard et al. 1972, no. 38; Campbell 1993 as in Literature above, no. 102.

8 Keil 2010 as in Literature above.

9 Dated 1801, pen and brush and gray ink, gray wash, white opaque watercolor on blue laid paper, 46.3 × 35 cm, inv. no. 2010.276.

CAT. NO. 19

1 *Collection of Engravings from Ancient Vases of Greek Workmanship discovered in Sepulchres in the Kingdom of the Two Sicilies … now in the possession of Sir Wm. Hamilton …*, Naples, 1791–97.

2 Now Landesmuseum für Kunst und Kulturgeschichte Oldenburg, described in Jörg Deuter, *Johann Wilhelm Tischbein als Sammler, europäische Kunst 1500–1800*, exh. cat. Oldenburg, 2001.

3 Identified as the tyrant Polycrates by Stefano Corsi, 'Dal "Lecto de Policrate" al "Letto di Policleto," prime ipotesi sulla genesi di un'attribuzione,' in *Prospettiva*, nos. 117–18, January-April 2005, pp. 145–48.

4 Ibid., p. 145.

5 Gudrun Körner, *Cottas Homer, Zeichnungen nach Antiken von Johann Heinrich Tischbein*, Marbach am Neckar, 2006.

6 In Dieter Richter and Uwe Quilitzsch, *Lady Hamilton, Eros und Attitüde, Schönheitskult und Antikenrezeption in der Goethezeit*, exh. cat. Rome and Wörlitz, Petersberg, 2015; Goethe's visits pp. 155–56; painting, *Orestes and Iphigenia*, in Bad Arolsen, 1788, pp. 154–58.

7 Hamburger Kunsthalle, Kupferstichkabinett, inv. no. 1951-233; Prange 2007 as in Literature above; painting Großherzoglisches Schloß Eutin.

8 *Collection* 1791–97 as in note 1 above, plate no. not specified by Prange; the only Cassandra subject is vol. II, plate 11, which is not of Ajax's rape of her.

9 Kaufmann 2004.

10 Howard et al. 1972.

11 *Ajax and Cassandra*, plaster in a gilded paper frame, 3.7 × 3.3 cm, Staatliche Kunstsammlungen Dresden, Skulpturensammlung, inv. no. ASN 5881,25. Many thanks to my co-author who kindly shared this information with me..

CAT. NO. 20

1 Johann Wilhelm Veith, *Notizen aus dem Leben von Jakob Merz, Mahler und Kupferäzer*, Tübingen, 1810, p. 76. Though a sometimes sentimental eulogy of the young man, it is the primary source for Merz's biography..

2 'Leben Jakob Merzens von Buch,' in *Siebentes Neujahrstück, herausgegeben von der Künstler-Gesellschaft in Zürich auf das Jahr 1811, enhält das Leben und die Charakteristik Jakob Merzens von Buch im Canton Zürich*, Zürich, 1811, p. 4.

3 Winterthur, 1775–78.

4 Vienna, 1806.

5 Veith 1810 as in note 1 above, pp. 73ff.

6 Ibid., p. 74.

7 Ibid.; 'Leben' 1811 as in note 2 above.

8 Heinrich Thommen, *Sulamith und Maria, Beziehungen zwischen Friedrich Overbeck, Franz Pforr und den Schwestern Regula und Lisette Hottinger*, Basel, 2018, p. 205 n. 50.

9 Howard 1981 as in Literature above, p. 46; Robert Flynn Johnson and Joseph Goldyne, *Judging by Appearance: Master Drawings from the Collection of Joseph and Deborah Goldyne*, San Francisco, 2006, no. 12.

10 As Howard proposes, Howard 1981 as in Literature above, p. 46.

11 Weigel 1838-66.

CAT. NO. 21

1 See *'Wie über die Natur die Kunst des Pinsels steigt', Johann Alexander Thiele (1685–1752). Thüringer Prospekte und Ideallandschaften*, exh. cat. Schlossmuseum Sondershausen and Schlossmuseum Arnstadt, Weimar 2003.

2 See Heinz Mansfeld, *Mecklenburgische Zeichnungen und Prospekte von J. A. Thiele 1685–1752 im Staatlichen Museum Schwerin*, exh. cat. Schwerin, 1952.

3 Moritz Stübel, *Der Landschaftsmaler Johann Alexander Thiele und seine sächsischen Prospekte*, Leipzig and Berlin 1914.

4 Oil on canvas, 85 × 162 cm, Staatliche Kunstsammlungen Dresden, Gemäldegalerie Alte Meister, inv. no. 3717, in Harald Marx, ed., *Die schönsten Ansichten aus Sachsen: Johann Alexander Thiele (1685–1752) zum 250. Todestag, Katalog der Gemälde in der Dresdener Gemäldegalerie Alte Meister; mit einem Verzeichnis der Zeichnungen und Radierungen im Dresdner Kupferstich-Kabinett*, exh. cat. Dresden 2002, no. 25.

5 I thank Herr Jochen Rascher of the Arbeitskreis Bergbaufolgen for this information in his email of April 20, 2018.

6 Marx 2002 as in note 4, nos. 18, 19, and 20; see also Dieter Schräber, 'Johann Alexander Thieles Prospekte aus der Freiberger Region – Zeitzeugnisse aus der Mitte des 18. Jahrhunderts,' in *Mitteilungen des Freiberger Altertumsvereins 97. Heft 2005 (26. Heft Neue Serie)*, Freiberg 2005, pp. 11–25.

CAT. NO. 23

1 Vogel 2017.

2 Wilhelm Gottlieb Becker, *Führer durch das berühmte Seifersdorfer Thal*, Leipzig and Dresden 1792, p. 6f.

3 Pun: *schöpfen* = draw water from a well or create.

4 Thanks to Alexander von Baeyer and Emanuel von Baeyer for help with this translation.

CAT. NO. 24

1 Quoted in Hubertus Gaßner et al., *Jakob Philipp Hackert. Europas Landschaftsmaler der Goethezeit*, exh. cat. Klassik Stiftung Weimar and Hamburger Kunsthalle, Ostfildern, 2008, p. 139.

2 Georg Striehl, *Der Zeichner Christoph Heinrich Kniep (1755–1829). Landschaftsauffassung und Antikenrezeption*, Hildesheim, Zürich and New York, 1998, p. 144.

CAT. NO. 26

1 Wiebel 2007, pp. 254–68; Kiermeier-Debre and Vogel 2008, pp. 213–20.

CAT. NO. 26

1 Fröhlich 2005, nos. G1 to G41.

2 Fröhlich 2005, nos. G4, G7, and especially G60.

3 Fröhlich 2005, nos. Z737 to Z744.

CAT. NO. 30

1 Fröhlich 2005, no. M56.

CAT. NO. 32

1 Maren Grönig and Marie Luise Sternath, *Natur und Heldenleben. Deutsche und Schweizer Zeichnungen der Goethezeit*, Vienna 1997, pp. 237–43, nos. 788-815.

CAT. NO. 34

1 Grönig and Sternath 1997 as cat. no. 32 note 1, no. 1015.

CAT. NO. 35

1 Ernst-Heinz Lemper, *Adolf Traugott von Gersdorf 1744-1807, Naturforschung und soziale Reformen im Dienste der Humanität*, Berlin 1974, pp. 62ff., 65–68.

CAT. NO. 36

1 In a letter of February 20, 1770 to Oeser's friend Philipp Erasmus Reich, quoted in Jahn 1849, p. 217.

CAT. NO. 37

1 Letter of November 20, 1782 to Karl Andreas von Meyer zu Knonow, quoted in Fröhlich 2008, p. 52.

2 In his *Sketchbook*, fol. 3 recto: "*Pauliner Kirche in Leipzig nebst ein Theil des Grimaschen Thors / ao. 1783 nach der Natur*"; see Fröhlich 2008, p. 317.

CAT. NO. 38

1 Karl Gottfried Herrmann writing from Bautzen to the Dresdener Akademie der Bildenden Künste on November 20, 1814, quoted in Christina Bogusz and Marius Winzeler, eds., *Im Reich der schönen, wilden Natur, Der Landschaftszeichner Heinrich Theodor Wehle 1778–1805*, exh. cat. Bautzen, Dessau and Görlitz, Bautzen 2005, p. 28.

CAT. NO. 39

1 Circa 1678/79, oil on canvas, 107 × 147 cm, Staatliche Kunstsammlungen Dresden, Gemäldegalerie Alte Meister, inv. no. 1492.

CAT. NO. 41

1 Kiermeier-Debre and Vogel 2008, p. 19.

2 According to the kind email of March 5, 2019 from Frau Dr. Petra Schniewind, whom I thank for this information.

In date order

Fröhlich-Schauseil 2018
Anke Fröhlich-Schauseil, *Schenau, Monografie und Werkverzeichnis der Gemälde, Handzeichnungen und Druckgrafik von Johann Eleazar Zeißig, gen. Schenau, (1737–1806)*, Petersberg 2018

Vogel 2017
Gerd-Helge Vogel, Adam Friedrich Oeser, Götterhimmel und Idylle, Berlin 2017

Breazeale 2010
William Breazeale, with Stacey Sell, Cara Dufour Denison, and Freyda Spira, *A Pioneering Collection: Master Drawings from the Crocker Art Museum*, exh. cat. Sacramento, London, 2010

Weisheit-Possél 2010
Sabine Weisheit-Possél, Adrian Zingg, *Landschaftsgraphik zwischen Aufklärung und Romantik*, Münster, 2010

Breazeale 2008
William Breazeale, Susan Anderson, Christine Giviskos, Christiane Andersson, *The Language of the Nude: Four Centuries of Drawing the Human Body*, exh. cat. Sacramento, London, 2008

Breazeale 2008a
William Breazeale, "Old Masters in Old California: The Origins of the Drawings Collection at the Crocker Art Museum," in *Master Drawings*, vol. XLVI, no. 2, Summer 2008, pp. 205–26

Fröhlich 2008
Anke Fröhlich, *'Einer der denkendsten Künstler unserer Zeit'. Der Landschaftszeichner Christoph Nathe (1753–1806) – Monographie und Werkverzeichnis der Handzeichnungen und Druckgraphik*, Bautzen 2008

Kiermeier-Debre and Vogel 2008
Joseph Kiermeier-Debre, Fritz Franz Vogel, *Kunst kommt von Prestel. Das Künstlerehepaar Johann Gottlieb und Maria Katharina Prestel. Die Sammlung Dr. Walter Prestel*, Schwelm, Cologne 2008

Wiebel 2007
Christiane Wiebel, *Aquatinta oder 'Die Kunst mit dem Pinsel in Kupfer zu stechen'. Das druckgraphische Verfahren von seinen Anfängen bis zu Goya*, Munich and Berlin 2007

Fröhlich 2005
Anke Fröhlich, *'Glücklich gewählte Natur'. Der Dresdner Landschaftsmaler Johann Christian Klengel (1751–1824) zwischen Spätbarock und Romantik. Monographie und Werkverzeichnis der Gemälde, Zeichnungen, Radierungen und Lithographien*, Hildesheim, Zürich, New York 2005

Kaufmann 2004
Thomas da Costa Kaufmann, *Central European Drawings in the Collection of the Crocker Art Museum*, Turnhout, 2004

Ruda 1992
Jeffrey Ruda, *The Art of Drawing: Old Masters from the Crocker Art Museum, Sacramento, California*, exh. cat. Flint, 1992

Kaufmann 1989:
Thomas da Costa Kaufmann, *Central European Drawings 1680–1800*, exh. cat. Princeton, 1989

Schulze-Altcappenberg 1987
Hein-Thomas Schulze-Altcappenberg, *'Le Voltaire de l'art,' Johann Georg Wille 1715–1808 und seine Schule in Paris, Studien zur Künstler- und Kunstgeschichte der Aufklärung*, Münster, 1987

Howard et al. 1983
Seymour Howard et al., *Saints and Sinners in Master Drawings, Selected from the Collection of the Crocker Art Museum*, exh. cat. Sacramento, 1983

Reno 1978
Sven Loevgren, *Master Drawings from the E. B. Crocker Art Gallery at the Church Fine Arts Gallery, University of Nevada, Reno*, exh. cat. Reno, 1978

Howard et al. 1976
Seymour Howard et al., *New Testament Narratives in Master Drawings, Selected from the Collections of the E. B. Crocker Art Gallery*, exh. cat. Sacramento, 1976

Steadman and Osborne 1976
David Steadman and Carol Osborne, *18th-century Drawings from California Collections*, exh. cat. Claremont, 1976

Howard et al. 1973
Seymour Howard et al., *Old Testament Narratives in Master Drawings, Selected from the Collections of the E. B. Crocker Art Gallery*, exh. cat. Sacramento, 1973

Howard et al. 1972
Seymour Howard et al., *Classical Narratives in Master Drawings, Selected from the Collections of the E. B. Crocker Art Gallery*, exh. cat. Sacramento, 1972

Crocker 1971
John Mahey, intro., *Master Drawings from Sacramento*, exh. cat. Sacramento, 1971

Schulz 1968
Jürgen Schulz, *Master Drawings from California Collections*, exh. cat. Berkeley, 1968

Crocker 1959
Frank W. Kent, intro., *Drawings of the Masters, E. B. Crocker Art Gallery*, exh. brochure, Sacramento, 1959

Lawrence 1956
Edward A. Maser, intro., *German and Austrian Prints and Drawings of the Eighteenth Century*, exh. cat. Lawrence, 1956

Scheyer 1949
Ernst Scheyer, 'Goethe and the Visual Arts,' in *The Art Quarterly*, vol. XII, 1949, pp. 227–50

Trivas 1941
Numa S. Trivas, *Three Centuries of Landscape Drawing*, exh. cat. Sacramento, 1941

Crocker 1939
Alfred Neumeyer, intro. Harry Noyes Pratt, *Old Master Drawings from the E. B. Crocker Collection, the German Masters 15th to 19th Centuries*, exh. cat. Sacramento, 1939

Weigel 1838–66
Rudolph Weigel, *Kunstlager-Katalog*, 35 parts in 5 vols., Leipzig, 1838–66

Hagedorn 1771
Christian Ludwig von Hagedorn, *Historische Erläuterungen und den Zustand der Künste in Sachsen vor und nach Errichtung der Churfür. Akademie der Künste betr., mit unterthänigstem Gutachten.* Manuscript, March 1771, Sächsiches Hauptstaatsarchiv Dresden, Acta Die Kunst-Academie und Zeichen-Schulen betr: / Anno 1769, 10026 Geheimes Kabinett, Loc 894/7

Hagedorn 1762
Christian Ludwig von Hagedorn, *Betrachtungen über die Mahlerey*, 2 vols., Leipzig, 1762

Hagedorn 1755
Christian Ludwig Hagedorn, Lettre à *un amateur de la peinture avec des eclaircissements historiques sur un cabinet et las auteurs des tableaux, qui le composent*, Dresden, 1755

PHOTOGRAPHIC CREDITS